THE
INSTANT
ARTIST

THE
INSTANT
ARTIST

IAN SIDAWAY

COLLINS & BROWN

Each project featured in this book has been colour coded according to the genre of the artwork: still life, landscape or figure. You'll find the following colours in the top corner of each page:

Still life	Landscape	Figure

First published in Great Britain in 2001
by Collins & Brown Limited
64 Brewery Road
London N7 9NT

A member of Chrysalis Books plc

Distributed in the United States and Canada by
Sterling Publishing Co.,
387 Park Avenue South, New York, NY 10016, USA

1 3 5 7 9 8 6 4 2

British Library Cataloguing-in-Publication Data:
A catalogue record for this book is available from the British Library.

ISBN 1 84340 063 4

Publisher: Roger Bristow
Copy-editor: Ian Kearey
Creative Director: Anne-Marie Bulat
Designer: Roger Daniels
Illustrations: Ian Sidaway
Photography: Ben Wray

Reproduction by Global Colour Ltd, Malaysia
Printed and bound by C & C Offset Printing Company, Hong Kong

Contents

Introduction 6

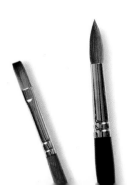

PART 3 Developing Your Skills 46

Introduction

BEING ABLE TO DRAW and paint is a skill which is well within most people's reach. As children, we freely practise drawing and painting, unencumbered with any of the feelings of failure, inadequacy or inhibition which usually tend to burden our artistic efforts as adults. Having a highly acute visual sense is something I believe to be intuitive and instinctive, but this is often forgotten as the more pressing, socially required skills of reading, writing and arithmetic take precedence. For many art is simply a skill forgotten before it has had a chance to fully form.

Observing and seeing

As adults, we constantly make assumptions about how we believe things to be, without really looking. But with regard to the skills required for drawing and painting, these preconceptions of how things should look cloud our judgement and prevent us from seeing things as they really are. Learning to truly observe things includes developing a heightened sense of colour, composition, scale, texture, form and tone – but this is only part of the story. Development as an artist also depends on developing a vocabulary of techniques which enable you to translate and represent what you have seen onto a two-dimensional, flat surface using a variety of media. This requires practice, and choosing the right materials, mixing the appropriate colours and making the best marks all require patience.

Techniques

Being technically proficient does not necessarily turn you into a great artist; however, mastering and

having a relatively sound knowledge of the techniques and materials at hand enables you to concentrate on your vision. Having lofty ambition is admirable , but try not to run before you can walk: all artists fail constantly. Learn from your failures and mistakes, and take what you learn forward to the next work, which in turn should be just a bit more successful.

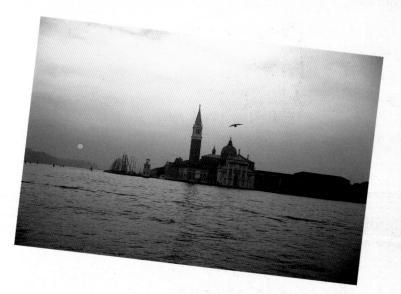

Acquiring skills

This book is divided into four parts. Part 1 deals with the tools and materials which have been used in the projects, and are available from most art stores. Buy the best materials that you can afford, as costly materials really do perform noticeably better. Part 2 outlines eight basic disciplines, which need to be understood regardless of the material you are working with or the subject matter you are working from: line, tone, colour, texture, composition, linear perspective, aerial perspective, and measuring and proportion. Part 3 is all about acquiring skills, and this is done through following the projects and using the techniques and the materials listed. Whatever your skill level or ambitions, be methodical, take your time – and have fun.

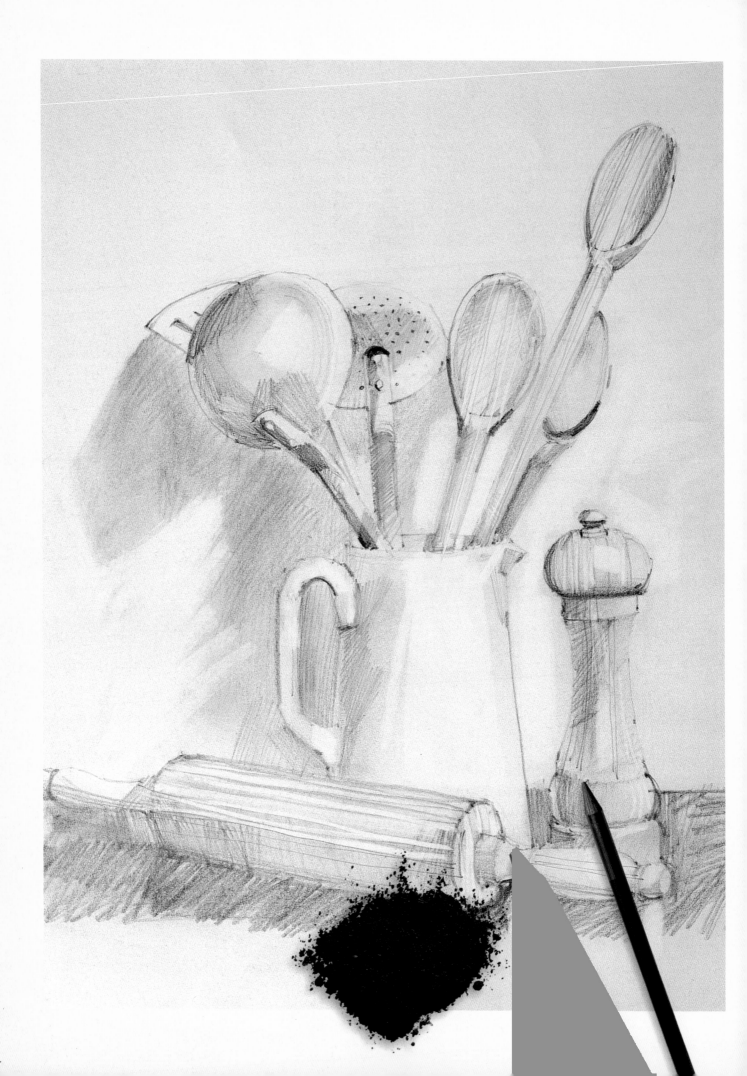

PART I

Tools
and
Materials

Part 1 looks at the drawing and painting
materials that are used in the projects featured
in Parts 2 and 3. It contains information and advice
on choosing from the huge variety of materials
available, from charcoal, pencils and graphite, pastels
and chalk and pen and ink, to watercolour and acrylic
paints and the type of support suitable for the medium
you decide to work with. There are details in the
projects to show you the different effects created
by each medium, advice on colour, and information
on paper and supports. To get you off to the right start,
Part 1 ensures you have the right equipment
to create the best possible images.

Charcoal, Pencils and Graphite

CHARCOAL IS THE most basic material for making marks. The process for making charcoal is simple: wood is heated in kilns until it is carbonized, and is prevented from bursting into flames by excluding oxygen from these kilns. Several close-grained woods are used, including vine, olive, beech, maple and willow. Charcoal made from different woods makes slightly different coloured marks: willow and beech have a blue cast, vine a brown one.

Charcoal sticks, graded as hard, medium and soft, are available in varying thickness in lengths up to 6in (150mm). Rectangular blocks and sticks as thick as a thumb are called extra-thick or scene-painters' charcoal.

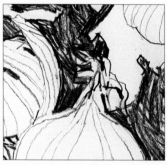

Getting started
Fine charcoal sticks give a range of simple lines and tones that are ideal for a beginner to control.

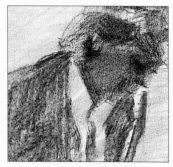

Differing weight
With charcoal sticks a range of weights allow the user to develop a wide variety of expressive techniques.

Compressed Charcoal

Compressed charcoal is made from powdered charcoal soot held together with a binder. The sticks are stronger than natural charcoal and less prone to shattering. It is graded according to hardness, and is available in the form of round or rectangular sticks, or as pencils encased in wood. It leaves a slightly more permanent mark than natural charcoal, and is marginally more difficult to erase.

Sharpening Charcoal

Sharpen natural charcoal and compressed charcoal with a knife, or by rubbing on fine glasspaper. The dust can then be transferred to the drawing to lay in areas of tone. Jars of charcoal dust can also be purchased.

Keeping Yourself Clean

Using charcoal can be a messy business. If you find this a problem, with your hands and fingers becoming progressively dirtier, try wrapping a little silver foil around the stick. Alternatively, plastic or metal holders, into which the stick can be inserted, are available .

Lead Pencils

Although traditionally known by the term 'lead', these pencils are in fact made from graphite. Pencils are graded according to hardness. H, HB and B are the middle grades and are good all-round drawing pencils. The scale runs from 9H, the hardest, to 9B, the softest.

Each grade of pencil is only capable of achieving a certain depth of tone, and no amount of pressure will make the tone any darker. If you want to create darker tone, you will have to switch to a softer grade of pencil.

The graphite strip is encased in wood, with most pencils this tends to be cedar. The wooden casing is either round or hexagonal in shape. Round pencils are easy to rotate between the fingers, thereby making fluid

NATURAL CHARCOAL STICKS
Thin Medium Thick

Compressed Paper-covered
charcoal stick charcoal pencil

CHARCOAL PENCILS OF
DIFFERENT WEIGHTS
HB B 2B

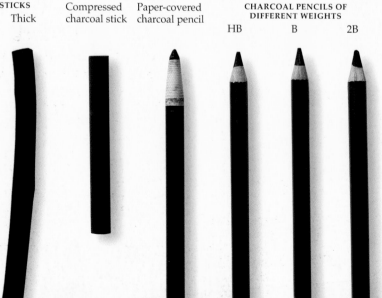

Capturing details
Careful use of charcoal can give a surprising range of fine detail and delicate tones.

strokes easy to apply. Hexagonal pencils are easier to hold and offer a more stable grip. Wooden pencils are best sharpened with a knife, which enables the point to be fashioned into a number of shapes.

Graphite Sticks
Graphite sticks are made using the same materials as conventional pencils: the difference is that they are thick, solid strips of graphite without a wooden case.

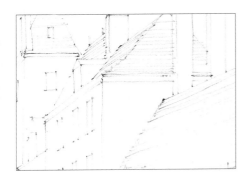

Precision
Here a 6B pencil has produced an even grey tone whilst the fine lines have accurately depicted the perspective of the building.

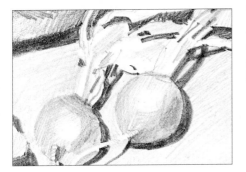

Tone
HB and 4B pencils can show a full range of tones from black to near white.

They are usually given a plastic or painted coating to keep the hands clean; this coating is removed as the stick is sharpened. Pencil-shaped graphite sticks are round in profile. Shorter, thicker sticks are hexagonal in shape, and pastel-sized, rectangular sticks are also available. Sticks are graded in the same way as

traditional pencils for relative softness. As is the case with charcoal, jars of graphite dust are also available. Keep graphite sticks sharp by using a pencil sharpener, or by rubbing the stick on fine glasspaper.

Fixing
Charcoal and soft graphite drawings are easily smudged and need to be protected by a process known as fixing. Fixative comprises resin dissolved in a colourless spirit. When sprayed onto a drawing the spirit evaporates, leaving a thin coating of resin that fixes the drawing in position. Fixative can be applied from an aerosol, by spraying the liquid from a hand-operated spray bottle, or by using a spray diffuser through which you blow out the material.

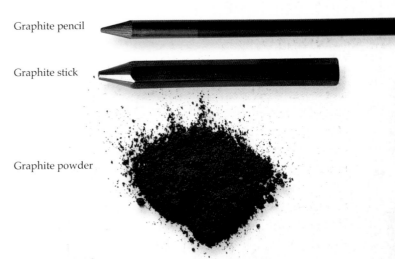

Graphite pencil

Graphite stick

Graphite powder

Erasing Marks
Soft drawing materials can be removed with a soft cloth, or by using a stiff brush. To erase more precise marks, there are many types of eraser available: they are inexpensive, and the most adaptable is the kneaded, or putty, eraser that can be shaped to a point.

COLOURED PENCILS				LEAD PENCILS			
				HB	2B	4B	6B

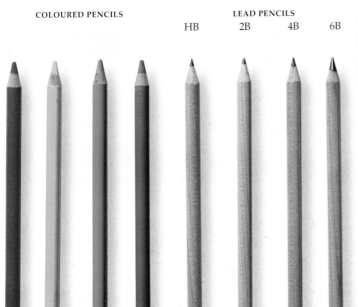

ERASERS
Plastic erasers are used for rubbing out hard pencil marks; putty is best for charcoal and soft pencil.

Plastic eraser Putty eraser

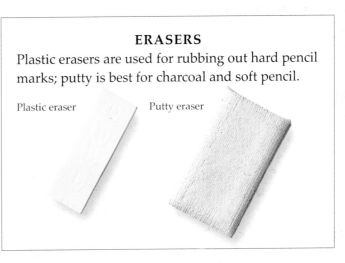

Pastels and Chalk

PASTELS ARE MADE by mixing pigment powder with an extending agent such as French chalk, and they are held together with a weak binding substance made from gum tragacanth. The more binding substance added, the harder the pastel. Soft pastels are usually round and wrapped in paper to help prevent them from crumbling. Hard pastels are invariably square in profile. Pastel pencils are encased in wood and are useful for line work and detail.

Strong colour
There is a range of pastel colours to suit every subject. Here the pastels have not been blended too much, so they retain their intensity and brightness.

Holding Pastels
Holding the pastel like a pencil, with just the end touching the paper, results in a linear stroke. Breaking off a piece of pastel, peeling away the paper, and using it on its side will produce a thick stroke. Pull the pastel across the paper lengthways for long, straight lines.

Pastels
To begin working with pastel you can buy starter kits containing the basic range of colours.

Cleaning Pastels
Pastels can become dirty very quickly. Colours rub one against the other in boxes, and fingers transfer colour from one pastel to another. Fill a box or glass jar approximately half-full with rice and drop in the dirty pastels. Shake the jar lightly for a few minutes and the abrasive action removes the dirty areas and reveals the clean colour beneath.

Blending Colours
Pastels are mixed and blended on paper. However, less blending results in fresher-looking work, so pastel

manufacturers produce huge ranges of colours, tints and tones. Pastels are easily blended using a stiff brush, blending stump/torchon, cotton wool bud or finger.

Fixing Pastels
Many artists dislike fixing pastels, as this tends to dull the colours. One solution is to fix the work when it is nearing completion, leaving the final layers of pastel marks unfixed so that they retain their brilliance.

Making Corrections
Pastel can be covered easily by applying more pastel. Scrape away excess pastel with an erasing knife or scalpel blade. If the paper seems smooth after scraping, spray a little fixative over the area. Once this has dried, you can rework the area.

Pastel pencil
Pastel pencils can be especially effective for sketching and drawing the figure.

BASIC RANGE OF PASTELS

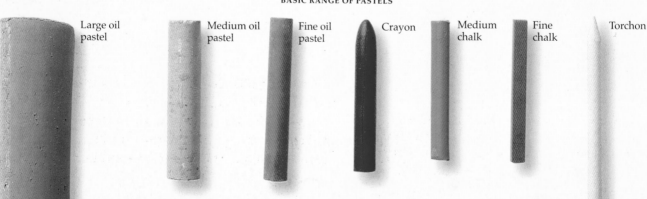

Large oil pastel Medium oil pastel Fine oil pastel Crayon Medium chalk Fine chalk Torchon

Pen and Ink

Ink was first used in China where it achieved something of a high art form. The qualities of ink are such that it requires a little planning and a sure hand, indecisive and tentative work is easily spotted. Both waterproof and non-waterproof inks can be diluted with water, and non-waterproof inks remain soluble when dry, which makes it easier to correct. With waterproof ink, mistakes are often best ignored or incorporated into the finished work.

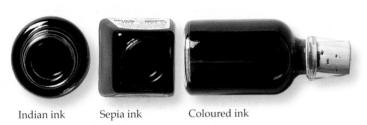

Indian ink Sepia ink Coloured ink

Indian Ink
Traditional Indian ink is made by rubbing a stick of carbon mixed with size on an abrasive stone with water. Adding different amounts of water produced a range of inks with different tones. Today, bottled ink, made from soot suspended in a resin, is more easily found.

Coloured Inks
Waterproof inks are shellac-based and made from dyes; this means that they could fade with time if the work is subjected to strong light. In contrast acrylic inks, which are made from pigment suspended in resin, are permanent and can be thinned with water.

Pure line
Ink and a simple dip pen will produce beautiful drawings with varying line qualities.

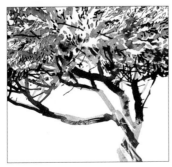

Mixing tools
Ink can be applied with all watercolour and acrylic brushes, here we've used a brush and pen.

Pens and Brushes
Inexpensive dip pen holders are made in wood and plastic, and accommodate a wide range of steel nibs in a variety of sizes and thickness. If a new nib is reluctant to accept ink, rub a little water onto it. Rinse the nib when you have finished, and try not to drop it onto its point. Some bamboo pens are cut to have a different-

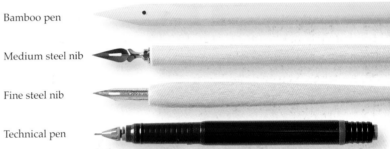

Bamboo pen

Medium steel nib

Fine steel nib

Technical pen

sized nib at each end, and produce a line with a dry, broken quality, especially good for textural effects. Reed pens have a flexible nib that often needs re-cutting, as

Diluting ink
Ink can be diluted with water and used in much the same way as a watercolour. Here large areas of ink washes are used in conjunction with candle resist.

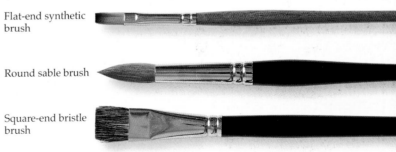

Flat-end synthetic brush

Round sable brush

Square-end bristle brush

do feather quills. Chinese or oriental brushes should be held in a perpendicular position and at right angles to the paper. Keep the hand clear of the drawing surface, and apply strokes with the arm in a stiff posture; movement should come from the elbow and shoulder.

Watercolour

WATERCOLOUR'S QUALITIES AND characteristics demand an approach that follows a few rigid principles. It is a transparent material and is made lighter by adding more water rather than white paint. This thins the paint and allows more light to reflect back through the wash from the white paper. Watercolours are built up using a series of semi-transparent washes. The painting is worked from light washes first, progressing to the darkest washes last. Each wash modifies the one beneath it, altering its colour or tone. This technique requires a degree of forward planning to ensure that dark washes are not allowed to cover those areas intended to remain white.

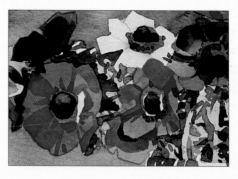

Layering colour
Complex subjects require planning and forethought. Here each layer has been allowed to dry before applying the next, keeping the flowers in focus.

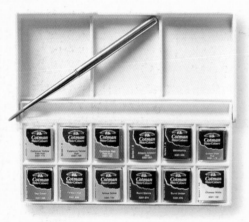

Basic watercolours
Watercolours are available in basic sets, covering a range of colours or as individual pans, tubes and bottles.

Different Types of Paint

Watercolour paint is available in the form of semi-moist pans, half pans and in tubes. Pans are easier to use when working on smaller-scale works. Tube colour is better if working on large paintings that require greater quantities of paint. Liquid watercolour is supplied in bottles with dropper caps. The range of brilliant colours are, however, of limited use. Originally intended for use by illustrators, they are made using dyes, not pigment, and are therefore not permanent. Pans are economical; it is all too easy to squeeze too much out of a tube. However, if the paint is always placed in the same place on a permanent palette, it can be reused when dry simply by re-wetting. Watercolour paint is sold in two standards: one for students and one for artists. The quality aimed at artists tends to be stronger, mixes easily and merits the additional cost.

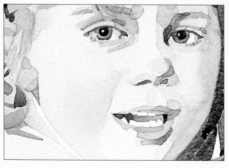

Subtle tones
Watercolour can be especially effective when painting the subtle tones and colours of a child's skin.

Palettes

Many watercolour boxes have built-in palettes for mixing, but these provide very little space. There are a wide range of palettes available in plastic, ceramic or enamelled metal. Divided into separate wells and compartments to hold paint and mixes, they can be easily cleaned by washing in the sink. You will need a deep well to mix a sufficient wash to cover a large area.

Different Types of Watercolour Brushes

Brushes are made from synthetic polymer, nylon fibre or natural hair and bristle from a range of animals. The best brushes are made from hair taken from the tail of the sable and the very best, and most expensive, from

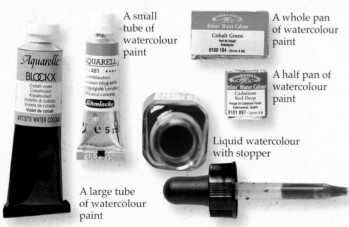

A small tube of watercolour paint

A whole pan of watercolour paint

A half pan of watercolour paint

Liquid watercolour with stopper

A large tube of watercolour paint

the Kolinsky sable found in Northern Siberia. Whichever type of brush you choose, it should hold its shape and point. A good brush should also hold a decent quantity of paint, and have a firm but pleasant spring to it when applied to the paper.

Brush shape is of equal importance, and there are three options to choose from. Round brushes are most often used, and a good one can make a wide variety of marks. Flat brushes are chisel-shaped, and are sometimes known as one-stroke brushes. Mop or

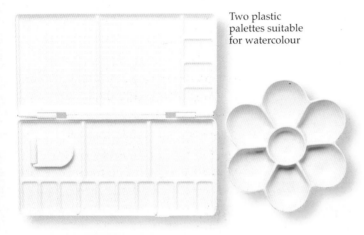

Two plastic palettes suitable for watercolour

wash brushes are used for covering large areas.

The size of the brushes you choose should reflect the scale on which you work, and the subject matter. As a rule of thumb use the largest brush possible for the job.

A good selection might include a No 4 or No 6 round brush for detail, a No 10 or No 12 round brush for blocking in washes over larger areas, a small flat brush and a medium-sized mop.

Brush Care
Always clean your brushes in water after use. Wash out excess paint from the bristles, concentrating around the metal ferrule. A little detergent will help to remove any stubborn paint. Rinse the brushes well, shake off excess water, and reshape the bristles using your fingers. Store brushes resting on their wooden handles and avoid leaving them resting on their points for long periods of time in jars of water.

Mediums and Additives
Watercolour paint is mixed and thinned using water. There are also a number of additives that alter the handling characteristics of the paint. Adding gum arabic to the paint increases its transparency and depth of colour. It also increases the ability of dry paint to become soluble when it is re-wetted. This facilitates corrections and a number of textural effects.

Watercolour medium and gum water are also made using gum arabic. Ox gall is a wetting agent: adding a few drops to the mixing water has the effect of reducing its surface tension and improving its flow. This is

Gum arabic Masking fluid Ox gall

helpful when working on heavily sized papers as these tend to repel watercolour washes. Aquapasto adds body to the paint, and helps create texture. Masking fluid is painted directly onto the paper where, once dry, it protects the covered area from paint.

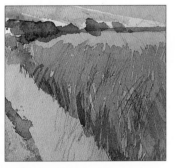 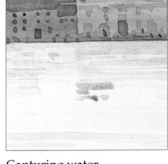

Selecting paper
Rough watercolour paper has been used here to help show the variety of textures.

Capturing water
The fluid qualities of watercolour make it very responsive when it comes to painting water.

Paper Weight
The weight of both handmade and machine-made paper indicates its thickness and is described in two ways: the first describes the weight of a sheet in grams per square metre; the second describes the weight in pounds of a ream (500 sheets) of that particular type and size of paper. Paper weights range from approximately 150gsm (72lb) up to 850gsm (400lb).

Three sable brushes: Nos 12, 6 and 4

A No 14 square-ended, flat bristle brush

Acrylics

ACRYLIC PAINT HAS only been commercially available since the 1950s. It is extremely versatile, so it is an ideal medium for the beginner, and has characteristics which are similar to both oil and watercolour paints. However, it is different from both in many respects, and should not be thought of as a substitute for either.

Acrylic paint is made by suspending pigment particles in an acrylic resin. When the paint is mixed with water and applied to the paper, the water evaporates, leaving the resin to hold the pigment permanently in place. Although acrylic paint can be thinned with water, it becomes

The paint, which can be used thin in transparent washes or thick and opaque, is available in tubes, jars or pots. Tube colour is of a toothpaste-like consistency, whilst the pot colour is slightly thinner to facilitate brushing out and covering large areas. Liquid acrylic is sold in small bottles. This is used for semi-transparent wash work in a similar way to watercolour.

Creating texture
The full potential of acrylic paint is realized when used in conjunction with texture paste and gel mediums to build texture.

Glazing with acrylic
Acrylic paint dries quickly, so you can produce a glazed painting in one sitting.

Location work
Acrylics are easy to handle and dry fast, making them an ideal medium for location work.

completely insoluble when dry, which happens within 15 to 20 minutes. This rapid drying time can be an advantage or a hindrance, depending on which method you happen to be working in.

Brushes

All brushes available in art shops and DIY stores can be used for acrylic work. Several manufacturers market ranges made from synthetic fibre for use specifically with acrylic paint. Natural bristle brushes are made from stiff hair taken from Chinese hogs. These hold paint well, have a good quality of spring, and are hard wearing. For fine work use smaller brushes made from synthetic fibres. Avoid using sable watercolour brushes as these can easily be ruined. Any brush will be ruined if paint is allowed to dry on it, so it is important to always clean brushes after use. Wash out in water excess paint from the bristles, concentrating on the metal ferrule. Detergent will help to remove any

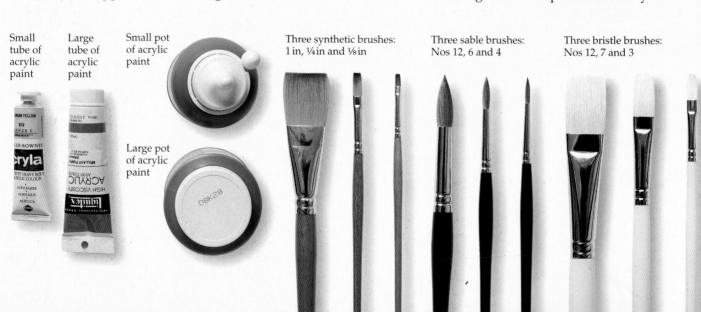

Small tube of acrylic paint

Large tube of acrylic paint

Small pot of acrylic paint

Large pot of acrylic paint

Three synthetic brushes: 1 in, ¼ in and ⅛ in

Three sable brushes: Nos 12, 6 and 4

Three bristle brushes: Nos 12, 7 and 3

Plastic palette
Whichever palette you decide to use it should be easy to hold and fully washable.

stubborn paint. Rinse the brushes well, shake off excess water, and reshape the bristles with your fingers. Store brushes resting on their wooden handles and avoid leaving them resting on their points for long periods of time.

The shape of the brush dictates the type of mark it can make. The three basic shapes are round, flat and filbert. Other brushes you may come across are brights, which are flat brushes with short bristles, and fan blenders.

Palettes

The quick-drying, insoluble qualities of acrylic paint mean that only palettes with an impermeable surface should be used. These can easily be washed as paint only dries to create a film on the palette surface. Glass, plastic, ceramic and melamine are all good choices, as are disposable palettes with tear-off paper sheets. Paint can be made to stay workable for longer by using a stay-wet palette. These keep the paint in a damp

atmosphere and prevent it from drying out. Remember to save and utilize old ceramic plates, yoghurt pots, tin cans and glass jars.

Mediums and Additives

The handling qualities of acrylic paint are easily altered by using any one of the available mediums or additives. These are added to the paint as it is used, and are soluble in water when wet but insoluble once dry.

Matt medium, as the name suggests, imparts a matt finish to the dry paint whilst gloss medium imparts a gloss finish. They can be mixed together giving varying

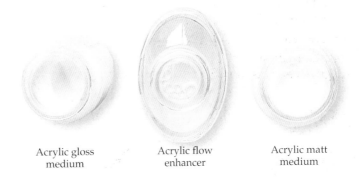

Acrylic gloss medium Acrylic flow enhancer Acrylic matt medium

degrees of gloss. Gel mediums, available in either gloss or matt finish, thicken and extend the paint. Flow mediums, on the other hand, reduce the water tension and improve the capacity of the paint for brushing out. Retarding medium slows the drying time. Texture gels and pastes can also be added which resemble various materials including sand, stucco and blended fibres. The work can be protected with matt or gloss varnish.

COLOUR THEORY

Four main terms are used to categorize colour: temperature, intensity, tone and hue. Temperature describes whether the colour tends towards red, when it is warm, or towards blue, when it is cool. Intensity indicates the brilliance or purity of the colour. Tone assesses the relative lightness, or darkness, of a colour. Hue is the general name given to a colour, such as red or blue.

Primary colours – red, yellow and blue – cannot be mixed from other colours. When mixed together, they produce a range of secondary colours. The colour wheel shown is an example of how primary colours mix to produce secondaries. The tonal range demonstrates how a colour can be altered by adding white to lighten or black to darken.

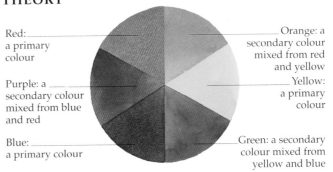

Red: a primary colour

Orange: a secondary colour mixed from red and yellow

Purple: a secondary colour mixed from blue and red

Yellow: a primary colour

Blue: a primary colour

Green: a secondary colour mixed from yellow and blue

THE TONAL RANGE
One colour can be changed significantly by adding white (or water) to lighten it, so producing tints, or by adding black, so producing shades.

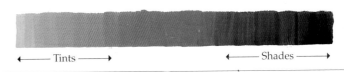

←——— Tints ———→ ←——— Shades ———→

Supports

CHARCOAL WORKS WELL on most papers that are not too smooth. It also works well on toned, tinted or coloured papers. Graphite produces better results on white paper, such as cartridge paper, or hot-pressed watercolour paper. Drawings can also be made on rough paper or card.

Pastels

Pastel requires a surface that has a sufficient tooth or texture to shave off the pigment from the pastel and hold it in place. Special pastel papers have the correct degree of tooth. Some have very special surfaces. Although these feel smooth and velvety to the touch, they accept the pastel remarkably

Cartridge paper
Cartridge paper is an ideal surface for producing graphite and pencil drawings.

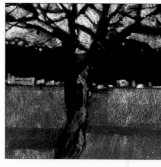

Pastel board
The dark grey pastel board used here gives the delicate structure of the tree a feeling of solidity.

well. Just as important as texture is colour: on white paper colours look pale and lack crispness. More effective are the toned and tinted papers made especially for pastel work.

Pen and Ink

Ink drawings made using a dip pen require a smooth paper to enable the nib to move smoothly over its surface. Smooth cartridge paper, hot-pressed watercolour paper, and illustration board are all suitable. On rougher papers, steel nibs can catch and tear the surface. The resulting blots and splashes add energy and immediacy.

Watercolour

Watercolour papers are made with three different surfaces. Rough papers have a rough or textured surface. They accept paint well, washes lie flat, and brisk brushwork looks vibrant and lively. The papers

Brown pastel paper

Green pastel paper

Grey pastel paper

Cream drawing paper

Fine board

Heavy cartridge paper

Light cartridge paper

Mark made on smooth-textured paper

Mark made on medium-textured paper

Mark made on rough-textured paper

Smooth hot-pressed watercolour paper

Medium not-pressed watercolour paper

Coarse not-pressed watercolour paper

Support for pastels
You may find it easier to work on a support which has a colour sympathetic to your subject.

Smooth paper
When using pen and ink select a smooth surface to allow the nib to move smoothly as you draw.

Cold-pressed, or NOT (not hot-pressed) papers fall between rough and hot-pressed, and have a reasonable degree of texture.

Acrylics

Acrylics can be used on canvas, card, paper and board which is not waxy, greasy or impermeable. Acrylic gesso and primers dry quickly, can be used on any surface, and can be thinned with water or tinted with acrylic paint.

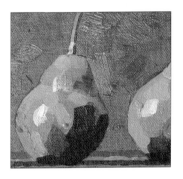

Pre-sized paper for acrylic painting

are usually capable of withstanding rough work, and techniques such as scratching into the paper surface.

Hot-pressed papers are smooth with very little texture. They are often more heavily sized than other papers which can cause washes to be repelled by the paper and settle in puddles.

Canvas board
Canvas boards are conveniently light to carry and large boards can easily be cut down into smaller ones.

Canvas board for acrylic painting

STRETCHING PAPER

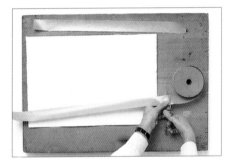

1 Cut the paper to the size required and lay it on the board. This board must be thick enough not to warp. Leave a margin around the edge for pieces of paper tape which should be cut to size.

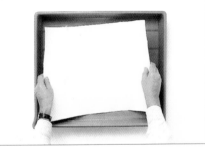

2 Soak the paper for a few minutes in a bowl or tray filled with clean water. When it is thoroughly wet, lift it out and allow excess moisture to drain off.

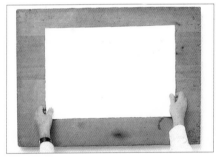

3 Lay the wet paper carefully on the board, making sure that it is flat. Use a sponge or clean rag if necessary to ease out any bubbles.

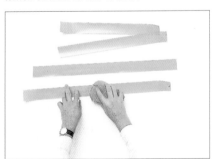

4 Take the four cut lengths of paper tape – one for each side of the paper. Each piece should overlap the ends of the paper slightly. Lay them on a separate surface and dampen with a clean sponge.

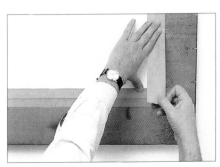

5 Take one of the longer tape pieces and stick it along the top edge. Repeat on the lower edge and the two shorter edges. Each length of tape must sit equally on the paper and board. Allow the paper to dry.

6 To make sure the paper does not lift the tape off the board as it dries, thumbtacks can be pushed into the four corners. These secure both the two overlapping strips and the paper.

PART 2

Basic Techniques

Part 2 covers the eight basic disciplines
that apply, whatever medium you are working
with or subject you wish to capture. These are
line, tone, colour, texture, composition, linear
perspective, aerial perspective and judging proportion.
Each aspect is illustrated by a step-by-step project for
you to follow at your own pace. The projects
cover still life, landscape and figure – use the colour
codes at the top corner of each page to
choose your style of working.

Drawing in Line

THE LINE SHOWS the shape of an object, and its quality is therefore very important. A line that is of a standard, regular thickness and density will show little more than the shape of an object. However, with practice, a simple line can be made to work harder and show far more. By varying the pressure applied and/or the speed with which the mark is made, the line can provide a number of factors, including: the angle at which a surface slopes; clues to the texture and contour of the surface; and, when you vary its thickness or density, a good indication of the direction and/or intensity of the light source. Using a combination of these line qualities distinguishes a good line drawing from a poor one.

A bulb of garlic is part of the composition; it has a more uneven shape which contrasts with the smoother profile of the onions

The onion has been sliced in half to reveal the inner pattern of lines

Still Life with Onions and Garlic

The simple fluid shapes and the linear texture and patterns on the dry, parchment-like onion and garlic skins make them a perfect subject for practising line control with a stick of charcoal. Notice that three objects have been used – arranging compositions using odd, rather than even, numbers, always seems to be easier.

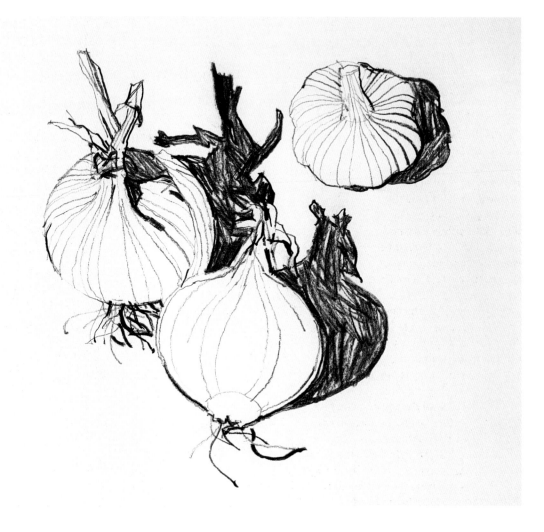

MATERIALS

- Cartridge paper
- Thin charcoal stick
- Fixative
- Paper towel

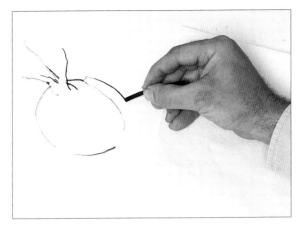

1 Sketching the shape of the first onion

Position the onions and garlic and then sketch in the shape of the left-hand onion, which is basically just a circle with a few wavy lines at the top. Alter the density of the line by applying more or less pressure. Use a thin light line on the side of the onion in the light, and make the lines on the side in shadow darker. Rest your hand on a paper towel to avoid smudges.

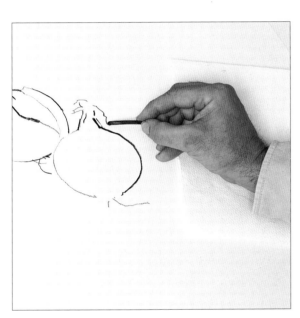

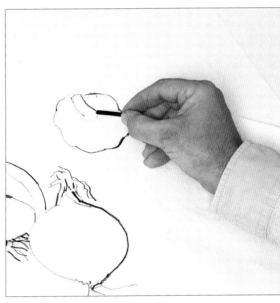

3 Positioning the bulb of garlic

Draw in the garlic, relating its position to the two onions. Try to keep the lines fluid; by altering the pressure applied mid-stroke the line will appear to show the transition from light to dark. Once the main elements are in place you can then apply a spray of fixative.

2 Adding the second onion
Draw in the second onion, paying attention to its position in relation to the first. When making dark marks hold the stick with your fingers closer to the paper, otherwise the stick is likely to shatter. If this does happen, do not panic; simply blow away the bits and continue.

4 Adding the finer details
Return to the first onion and lightly draw in the lines on the outer skin. Place them accurately, as they show the way in which the onion is facing. The second onion has been cut in two, and the half shown has its cut face upper-most; it is almost flat with only a few lines visible on its surface. Underplay these lines so the surface does not appear to be curved.

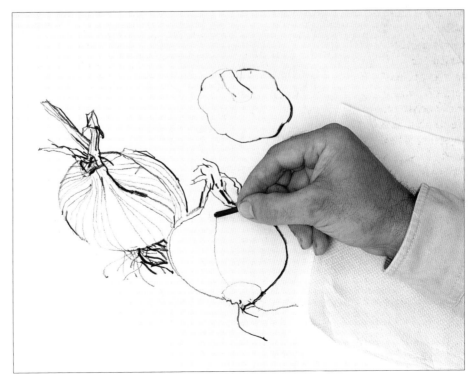

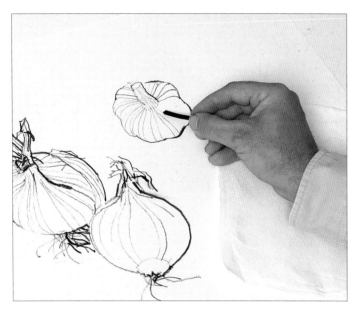

5 **Exploring new depths**
Apply the same drawing technique to the bulb of garlic. Make the linear marks work to indicate the shape of the cloves of garlic beneath the surface of the skin.

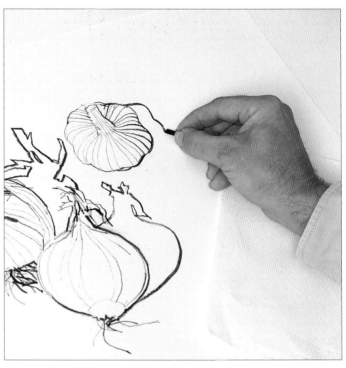

6 **Mapping out the shadows**
Draw in the shape and extent of the cast shadows with a basic linear outline.

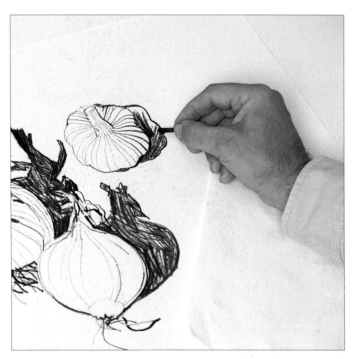

7 **Adding solidity**
To give the drawing more solidity, block in the shape of the shadows loosely. This immediately throws the onions and garlic into relief, and gives an exaggerated quality of depth to the work.

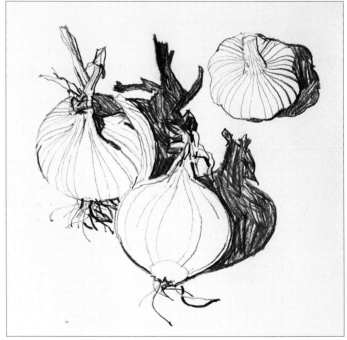

8 **Final drawing**
Apply a spray of fixative once you are satisfied. The drawing, although it consists of only a few lines, is a very convincing image of its subject. The loosely scribbled-in areas of shadow have an openness which maintains the quality of line work.

Understanding Tone

THE DEGREE OF LIGHT, together with the actual colour and texture of an object, determines its tone. The fall of light onto an object makes it appear to be three-dimensional and gives it form; this is an important consideration when choosing lighting conditions to use when painting or drawing.

Light, which falls consistently all over a subject, will make it appear flatter than it is in reality. This is due to a reduced range of tonal values, whilst stronger directional light, with a wide tonal range and a greater degree of contrast, has the effect of accentuating shape, form, contour and texture. Every colour has an equivalent tone, and this is best shown by looking at a black-and-white photograph. The lighter the colour, the lighter its equivalent tone; the darker the colour, the darker its equivalent tone. Certain colours that are close in intensity and hue can appear to be the same tone. Judging the tone of an object accurately can be a difficult task, as our eyes seem to be more receptive to colour.

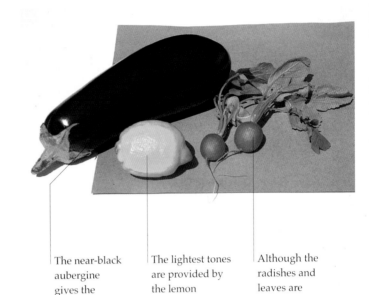

The near-black aubergine gives the darkest tone

The lightest tones are provided by the lemon

Although the radishes and leaves are different colours, they are both mid-toned

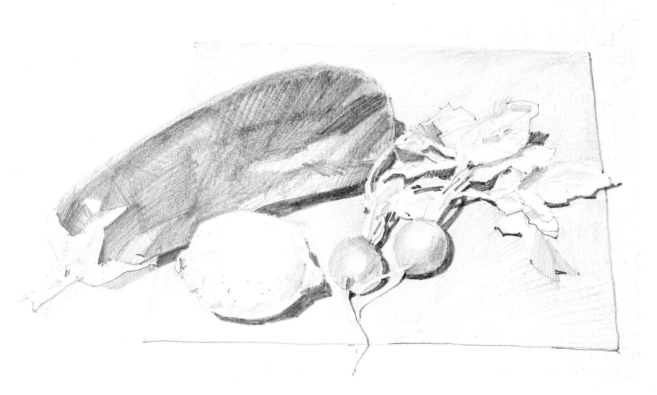

Still Life with Fruit and Vegetables

A few fruit and vegetables selected from the kitchen make the ideal subject for a tonal drawing. The aubergine must be one of the darkest vegetables, while the lemon is certainly one of the lightest, with the red and green radishes falling between the two tonally. The purpose of placing them on a sheet of grey paper is twofold: first, the group of objects is held together; and second, the grey colour increases the tonal depth of the shadow cast by the aubergine.

Still Life

MATERIALS

- Cartridge paper
- HB and 4B pencils
- Fixative

1 Sketching in the shapes
With the 4B pencil, use both light and heavy line work to indicate the fall and direction of light. Include the outline of the sheet of mid-grey paper, as its shape holds the composition together.

2 Putting in the basic tones
Start with the aubergine. Scribble in the tone, remembering that it is always far easier to darken an area of tone by adding to it than it is to lighten it by erasing marks.

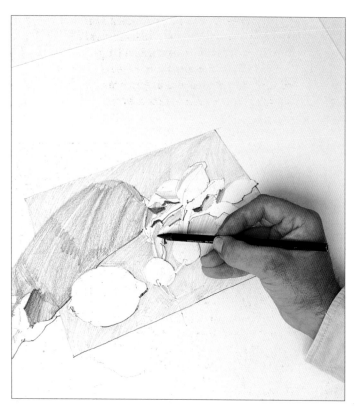

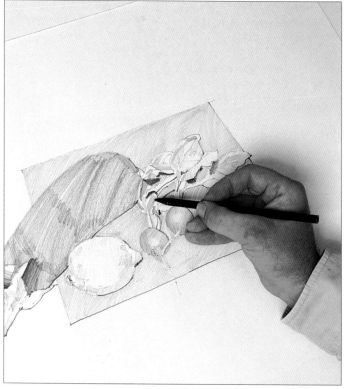

3 Blocking in the tone
Block in the uniform grey tone of the sheet of paper with the harder HB pencil. This makes the shape of the lemon more distinctive, but it is now apparent that the tone of the aubergine is too light and will need to be darkened at a later stage.

4 Establishing the overall tone.
Using the HB pencil, establish the overall tone of the lemon. Add a little texture and shadow to the underside of the lemon and scribble in the slightly darker tone of the radishes. Then draw in the detail on the radish leaves.

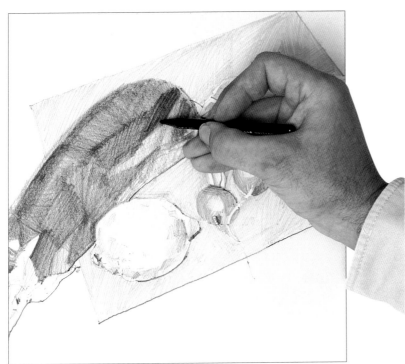

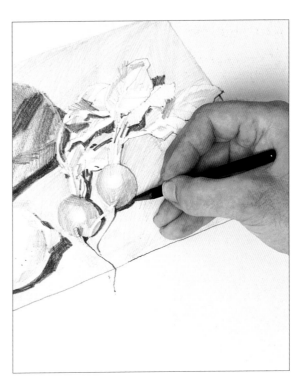

5 Darkening the tones
The aubergine now appears too light, and the image is flat, and has a limited tonal range. The solution is to darken the aubergine, making it several tones deeper than its background. This also has the immediate effect of making the lemon appear lighter in tone.

6 Drawing in the shadows
Using the softer 4B pencil with a little pressure, draw in the dark shadows beneath the vegetables. Where these fall on the grey paper they are the darkest tone in the picture, but note how much lighter the shadow is when it falls on the white.

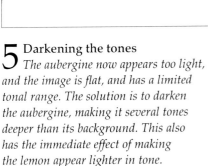

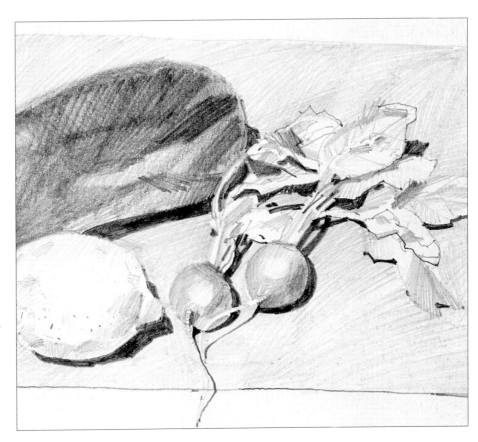

7 Final drawing
Complete the drawing by adding a little detail onto the radish leaves and the dimpled surface of the lemon. By keeping the marks loose and open, the drawing maintains a vitality which can often be lost by trying to make the tones too flat and consistent. Finally apply a spray of fixative to the work to prevent the graphite from smudging.

Basic Colour

COLOUR THEORY CAN seem complex and daunting, but once the basics are understood, it begins to make sense. The primary colours – red, yellow and blue – cannot be created by mixing other colours. The secondary colours – orange, green and purple – are made by mixing together two primaries. Tertiary colours have elements of all three primaries, and tend to echo those colours found in nature. Neutral colours are mixed using equal amounts of the three primaries, and by varying the bias, a range of browns and greys are produced.

Colours are considered to be either warm or cool, with the reds, oranges and yellows being warm, and the greens, blues and purples being cold. Colours which fall opposite one another on the colour wheel are known as complementary, and have a unique relationship. Mixed together they tend to neutralize one another, but, placed next to each other, they appear to increase in intensity. The best way to learn about colour theory is to experiment with a limited range of combinations.

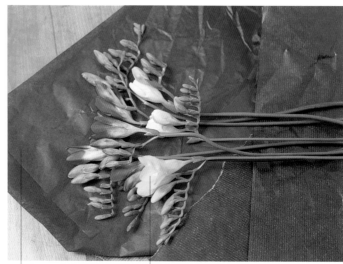

A muted blue tissue paper has been placed beneath the flowers to set off their brightly coloured petals

The flowers have been chosen for their array of intense primary and secondary colours

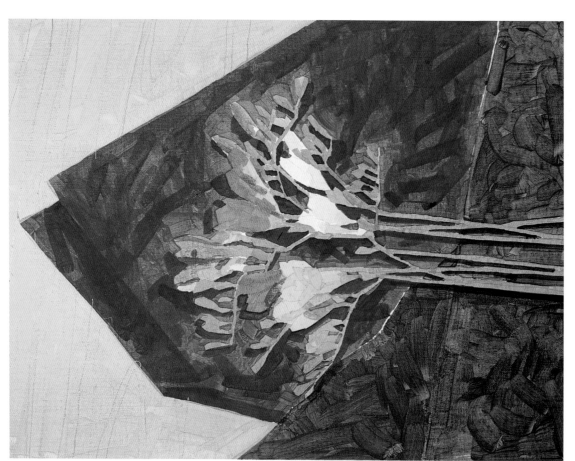

Still Life with Flowers
You can turn a bunch of flowers into a colourful still life simply by opening up the bunch and placing the flowers flat on a work surface. Not only can you avoid the clichéd image of flowers in a vase, but you can also include the bright blue tissue and dark green wrapping paper as part of the composition.

MATERIALS

● Canvas board

● 4B pencil

● Acrylic paints: alizarin crimson, cadmium red, cadmium lemon, cadmium yellow, ultramarine, cerulean blue, titanium white

● ¼in soft synthetic brush

1 Establishing the position
Sketch in the position of the flowers and the tissue wrapping on the canvas board using a 4B pencil.

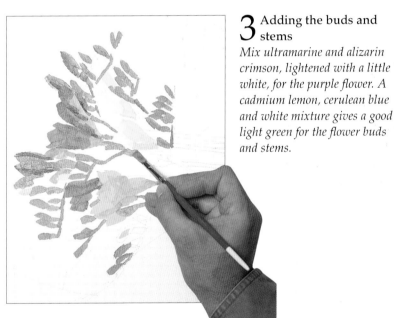

3 Adding the buds and stems
Mix ultramarine and alizarin crimson, lightened with a little white, for the purple flower. A cadmium lemon, cerulean blue and white mixture gives a good light green for the flower buds and stems.

2 Painting in the flower heads
Use a mixture of yellow, white and red to paint the flower heads with the brush. Cadmium red, and a mixture of alizarin crimson and ultramarine produce darker reds, while adding white and yellow lightens them.

4 Finishing off the stems
Add ultramarine to the light green mixture to complete the flower stems. Make the colour for the dark green wrapping paper by combining alizarin crimson, ultramarine and cadmium yellow.

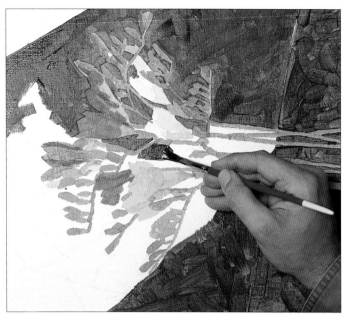

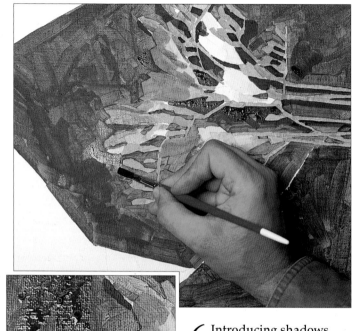

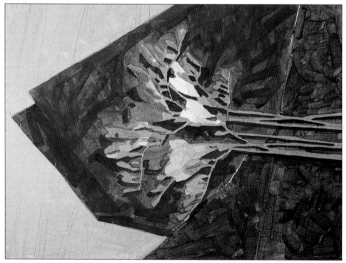

5 Painting in the tissue paper
Mix ultramarine and cerulean blue to create the colour for the paper wrapping.

6 Introducing shadows
As soon as the background is dry, darken the blue mixture by adding a little alizarin crimson. Use this colour for the shadows around the flowers.
Inset: *Use thin lines to create the creases on the tissue paper.*

7 Painting in the table top
Mix cadmium yellow, cadmium red, a little cerulean blue and titanium white to produce the colour for the wooden table top. Once this is dry, draw in the grain of the wood with the pencil.

8 Final painting
Very simple colour mixes can produce a lifelike image. This painting demonstrates the effect that can be created by variations based on only six colours and white.

Discovering Texture

TEXTURE DESCRIBES THE surface of an object. The texture is affected by several things including the quality and intensity of the light source, and by any colour or pattern which is also present. All but the smoothest or shiniest objects have a discernible surface texture, and artists are at constant pains to find ways of representing this texture without slavishly copying the original. Each artist thus develops a type of shorthand, which depends very much on the materials being used.

Artists' tools can make a wide variety of marks, but these are not infinite. So, when developing any mark-making shorthand, you should think not only in terms of the technical limitations of the tools and techniques being used, but also in terms of the way in which the marks are made. This could be sure, direct and firm or nervous, hesitant and timid: each particular mark brings to the work a distinct and different quality of its very own. In the same vein, the choice of support is vital, and should complement the medium being used; experiment to find the best combination.

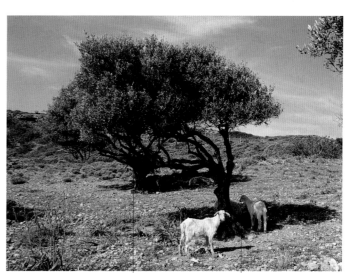

The arching shape of a gnarled tree neatly frames the goat below

The strong shadow cast by the tree gives definition and interest to the ground area

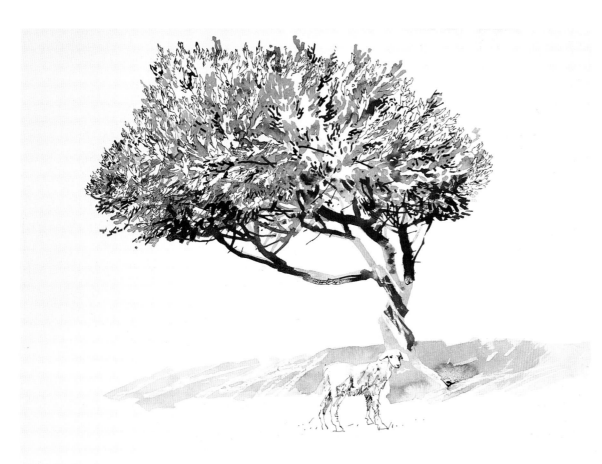

Landscape with Tree and Goat
The scene offered the opportunity to experiment with a number of textural effects to explore the different surfaces of foliage, a gnarled wooden tree trunk, stony earth and the fleece of the goat. Note that one of the goats was omitted from the drawing to simplify the composition.

Landscape

MATERIALS

- Hot-pressed paper
- 3B pencil
- Dip pen with medium and fine nibs
- No 4 round sable brush
- Bamboo pen
- Plain white candle
- Small piece of stiff card
- Indian ink
- Water
- Scrap paper

1 Making the first marks

Use a 3B pencil to make the light and loose, initial drawing. Then draw in the linear pattern of the leaves with the pen, using the medium nib. Do not fill in the area too much so that you will not have enough room for subsequent work.

2 Painting in the shadows

Dilute the ink with a little clean water. Use a No 4 brush to paint in the darker areas of foliage in deep shadow.

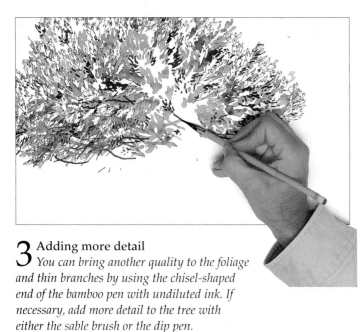

3 Adding more detail

You can bring another quality to the foliage and thin branches by using the chisel-shaped end of the bamboo pen with undiluted ink. If necessary, add more detail to the tree with either the sable brush or the dip pen.

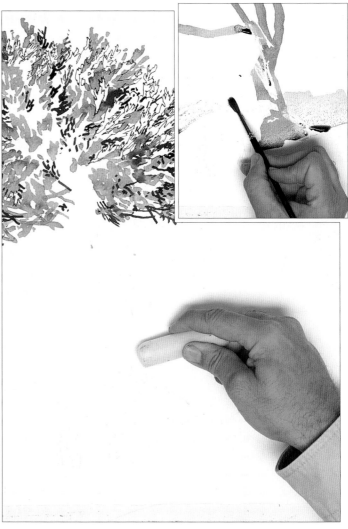

4 Drawing with a candle

Use a plain white candle to draw in the texture on the trunk of the olive tree, and on the shaded area of ground beneath it.
Inset: *Paint over these areas with water-diluted black ink; the candle acts as a resist, pushing the ink away from the waxy surface and creating an attractive textural effect.*

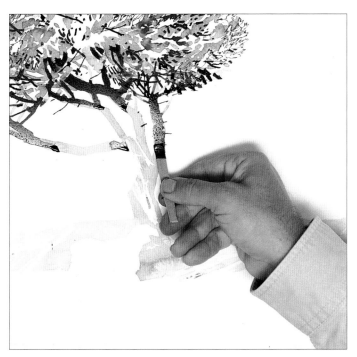

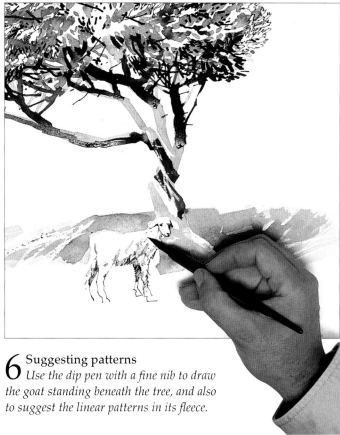

5 Drawing with card
To bring yet another quality to the work, dip a chisel-shaped piece of stiff card into the ink and then use it to darken and draw in the shaded branches. By drawing with one corner, or the edge, of the card, you can make lines of varying thickness.

6 Suggesting patterns
Use the dip pen with a fine nib to draw the goat standing beneath the tree, and also to suggest the linear patterns in its fleece.

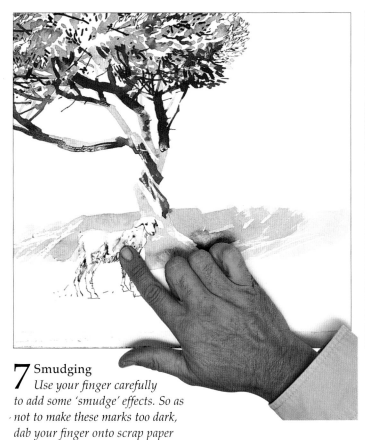

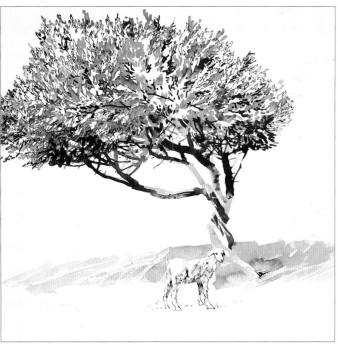

7 Smudging
Use your finger carefully to add some 'smudge' effects. So as not to make these marks too dark, dab your finger onto scrap paper after dipping it into the ink.

8 Final drawing
This drawing could have been made using only one tool and a single technique. However, using several methods adds interest, and each part seems to possess its own, distinctive textural quality.

Basic Composition

OMPOSITION IS ABOUT organizing the space within a picture to achieve a pleasing balance of all the visual elements. It also leads the eye into, and around, the painting. Composition can be simple and conventional, with the rules being strictly followed, although this can result in a work lacking any impact. Or the rules can be broken and risks can be taken, which often results in a work having a distinct edge.

Compositional possibilities are endless and have many alternatives: colour, texture, shape, size, perspective, position and proportion all play an important part in achieving a pleasing harmony. Over the years many formulae have been used to divide the picture area into an invisible grid upon which to construct the visual elements. A relatively simple way to begin composing your picture is to base it on the 'rule of thirds'. Divide the horizontal and vertical plains of the paper into thirds and place any important elements on these lines and intersections to achieve a compositional balance.

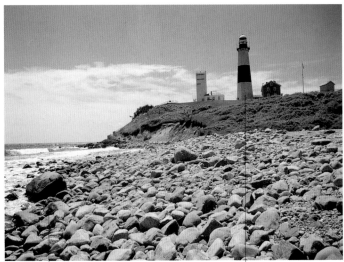

A striking change of scale to the picture's composition is given by the rocks in the immediate foreground

The low viewpoint adds drama to the towering shape of the lighthouse

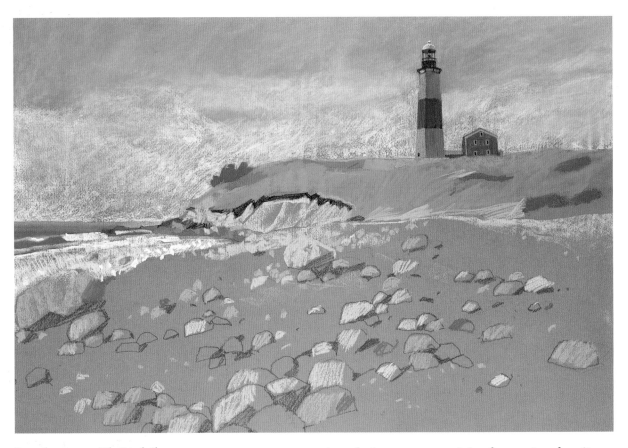

Landscape with Lighthouse
Several elements which are utilized to make a successful composition are present in this coastal view: the large expanse of sky, the curving shoreline, the detailed and textured foreground, and the positioning of the buildings and the headland.

MATERIALS

- Mid-green pastel paper
- Charcoal pencil
- Pastel pencils: cerulean blue, cobalt blue, white, black, brown, range of greys, range of greens, Naples yellow, yellow ochre
- Fixative

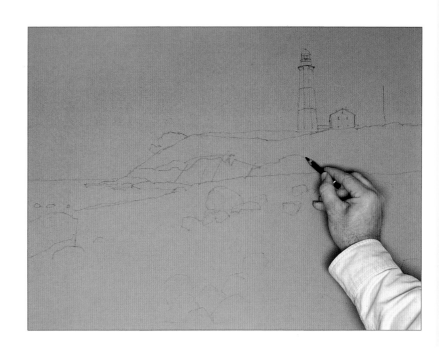

1 Sketching in the outline
Use the black charcoal pencil to position the basic elements of the composition on the pastel paper. If the paper were divided into thirds, the lighthouse and building would sit on the intersection of two lines. The headland runs across the painting a third of the way down, and ends a third of the way from the edge of the paper. The interest on this plane is balanced by the expanse and texture of the rocky shoreline.

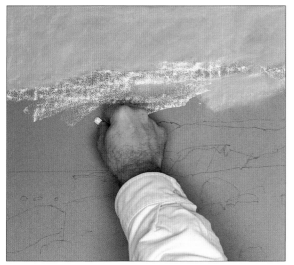

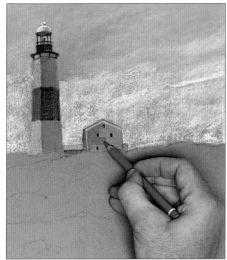

3 Adding the buildings
Draw in the lighthouse using black, brown and grey pastel pencils. Work over it again, using a darker grey and black to darken the side of the building in shade. Use a blue-grey pastel pencil to draw in the wooden building lying to the right of the lighthouse.

2 Blocking in the sky
Using both cerulean and cobalt blue pencils, draw in the expanse of sky. Then position and shape the clouds with a white pencil.

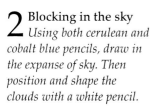

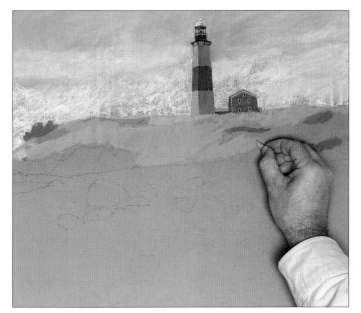

4 Adding the foliage
Use a range of greens to draw in the grass and foliage on the spit of land. Allow the mid-green colour of the paper to show through in places.

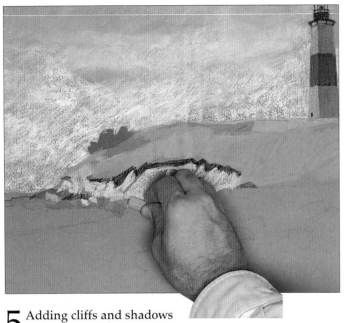

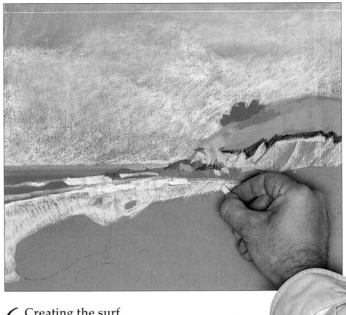

5 **Adding cliffs and shadows**
Use Naples yellow, grey and yellow ochre for the sandy-coloured cliffs, and black for the shadow cast by the grassy overhang.

6 **Creating the surf**
Select the same shades of blue as you used for the sky to draw in the sea. Scumble together white and cerulean blue for the surf.

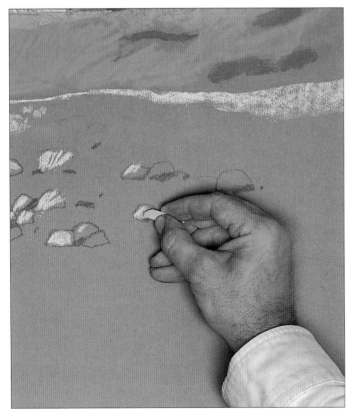

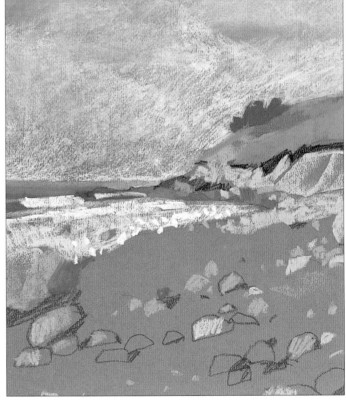

7 **Adding the last touches**
Draw in the rocks with a dark grey pastel before scribbling in the light surface with a light, warm grey one. Add darker passages between the rocks, and suggest sand, with a few strokes of the yellow ochre pastel. Finish by applying fixative.

8 **Final drawing**
While the beach is an important part of the picture, there is no need to overwork it. Suggesting a few of the rocks and stones, and their relative size, is more than enough to complete the painting and to give the foreground a sense of recession.

Linear Perspective

LINEAR PERSPECTIVE is a device whereby an illusion of three-dimensional space is created on a two-dimensional surface. This perspective can be highly complex or relatively straightforward, depending on your subject and on the viewpoint from which you choose to draw or paint it.

Although perspective is most often associated with depicting buildings and townscapes, you should bear in mind that its principles can – and should be – applied to everything. Simple one- and two-point perspective is based on the premise that when viewed at an angle, all lines which are parallel to each other will, when extended, converge at a common point in space, known as the vanishing point. The vanishing point is always on the horizon and the horizon remains at eye level regardless of your position. Every surface which has a different alignment will have a different vanishing point, and it is often the case, as in the example shown here, that there can be several vanishing points in one drawing.

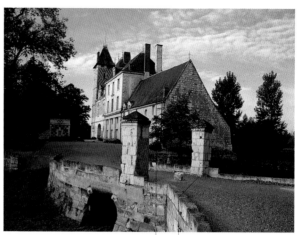

The extensive number of parallel lines that apparently converge on a common viewpoint make architecture an ideal subject for perspective studies

The two gateposts change noticeably in scale to each other, owing to the smaller being furthest from the viewer

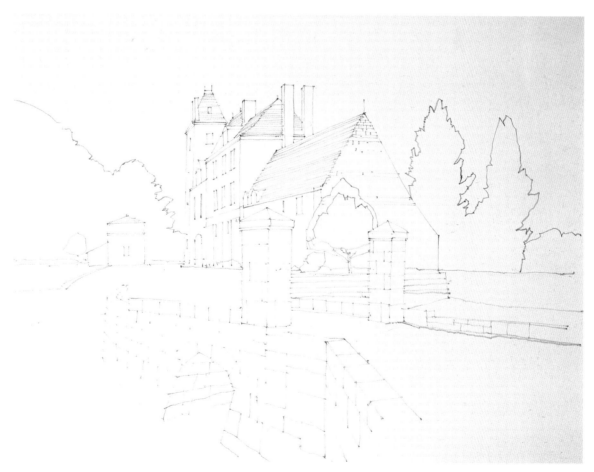

Landscape with Buildings
This view of a small château in France is typical of many older buildings that have several towers and extensions added on. All of these, if attached square to the original building, will have the same perspective. Any structure that stands on a different axis, like the gateposts, will thus have a different perspective.

Landscape

MATERIALS

- Cartridge paper
- 6B pencil
- Ruler
- Scrap paper

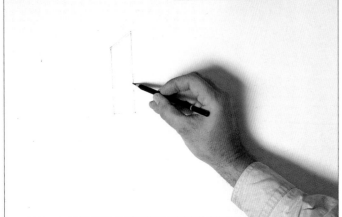

1 Plotting in the basic shapes
Sketch in the position of the buildings and trees. The horizon line, or eye level, runs more or less level with the base of the main building. Draw in the upright sides of the building, and then assess the angle of the roof line. Mentally extend this line, or use a light pencil line, until it hits the horizon. **Inset:** *Check the angles and extend the lines using a ruler.*

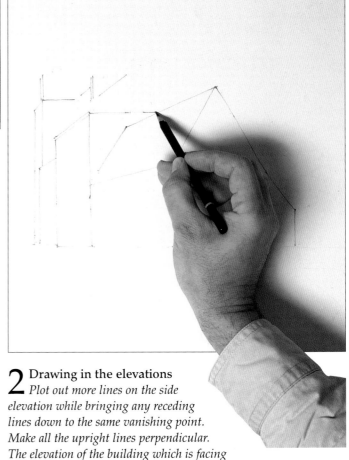

2 Drawing in the elevations
Plot out more lines on the side elevation while bringing any receding lines down to the same vanishing point. Make all the upright lines perpendicular. The elevation of the building which is facing the viewer is almost square.

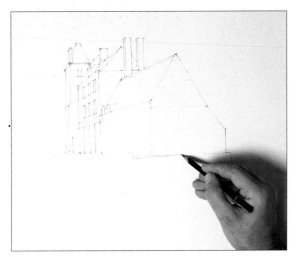

3 Adding the details
Continue to run lines down to each of these vanishing points, plotting the position of each building's chimneys, windows and doors until a convincing representation of the main building emerges on the paper.

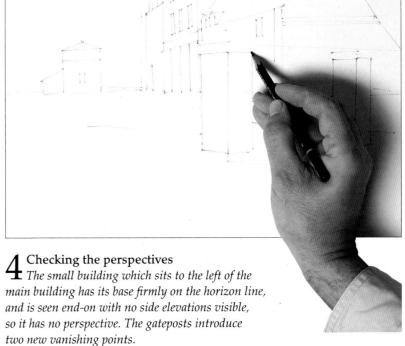

4 Checking the perspectives
The small building which sits to the left of the main building has its base firmly on the horizon line, and is seen end-on with no side elevations visible, so it has no perspective. The gateposts introduce two new vanishing points.

5 Checking the vanishing points
While the base of the building still sits fairly square on the horizon line, the lines at the top can be seen to angle down slightly; these lines meet the horizon line outside the area of the actual drawing. Use a ruler to plot this point on a sheet of scrap paper positioned at the side of the drawing paper.

6 Identifying the vanishing points
The lines of brickwork on the pillars extend to the same two vanishing points. The top of the curving wall has a single vanishing point to the left of the drawing, but it changes into one which is just to the right of the small building. The vanishing point of the wall in the immediate foreground is in the centre of the middle course of bricks on the left-hand pillar.

7 Adding detail
Draw in the stone and brickwork following the same basic principles, but remember that these are old buildings and so they may not be perfectly straight.

8 Adding the finishing touches
At this stage you can indicate the position of the trees and the shrubbery surrounding the buildings.

9 Final drawing
The use of linear perspective gives the drawing a sense of depth; if this were lacking, the impact of the piece would be severely reduced. Its application has ensured that the building and its surroundings read correctly, and also acts as a compositional device by leading the eye into the picture itself.
Inset: *Note how the parallel lines on each elevation extend to their respective vanishing points.*

Aerial Perspective

 AERIAL PERSPECTIVE IS also known as atmospheric perspective, and it is important to understand it if you are going to paint or draw landscapes, as it provides many clues to the principles of depth and recession. To achieve correct aerial perspective the artist must resort to using a number of naturally-occurring phenomena. There are four main points to remember.

First, textures and detail become less pronounced the further away they are from the viewer. Objects in the foreground appear sharper and more defined. Second, the tonal contrast between objects in the distance is less, resulting in a flattening out of tone. Objects in the foreground appear to have a full tonal range. Third, objects become smaller the further away they are. Last, the colour of objects in the distance seems cooler and more blue. The colour of nearer objects appears warmer with strong reds, oranges and browns.

All of these points are not always evident at the same time, but by exaggerating one or two of them, an otherwise mediocre landscape painting can become a much better one.

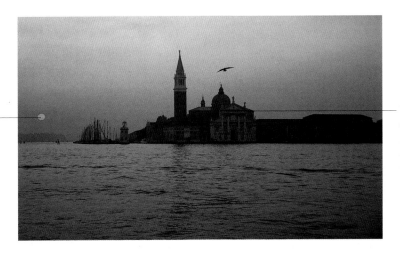

The low position of the sun softens the overall light in the scene

Backlighting exaggerates the flatness of the architectural shapes

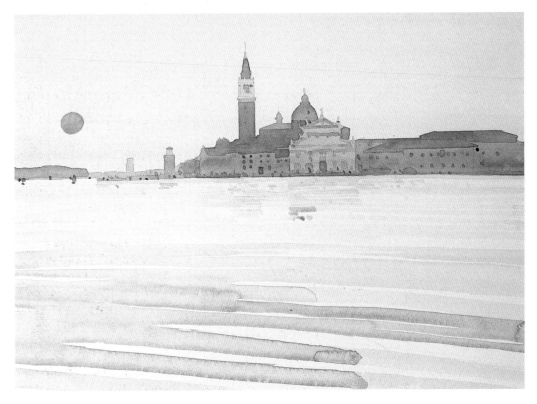

Landscape with Church and Tower

This view across the lagoon in Venice shows the atmospheric haze which is so often noticeable in the early morning and early evening when the sun is low. The light and shadows are less intense and pronounced than during the rest of the day.

MATERIALS

- Stretched NOT watercolour paper
- 6B pencil
- Water
- No 6 and No 12 sable watercolour brushes
- Watercolour paints: Paynes grey, cerulean blue, cadmium yellow, cadmium lemon, cadmium red

1 Sketching in the outlines
Use the 6B pencil to draw in the church and its surrounding buildings. Make the drawing dark enough to see, and do not include too much detail.

2 Filling in the sky
Mix cadmium lemon and cerulean blue with water. With the paper at a slight angle, load the No 12 brush and make a stroke across the full width. After a few further strokes, add more blue into the mix, and continue down to the horizon. Cut around the sun, leaving it as white paper.

3 Filling in the water
Allow the sky to dry. Make another mix using cadmium lemon and cerulean blue, and paint a wash from the horizon to the bottom. Once dry, use a No 6 sable brush to paint the distant waves.

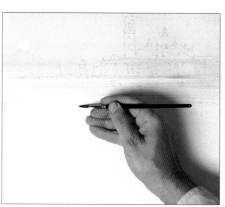

4 Deepening the colour
Add a little more cerulean blue into the mixture as you move towards the bottom of the painting. At the same time, increase the size of your marks.

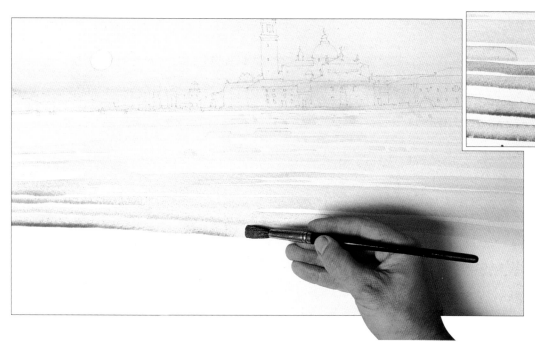

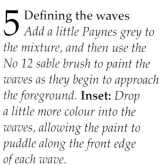

5 Defining the waves
Add a little Paynes grey to the mixture, and then use the No 12 sable brush to paint the waves as they begin to approach the foreground. **Inset:** *Drop a little more colour into the waves, allowing the paint to puddle along the front edge of each wave.*

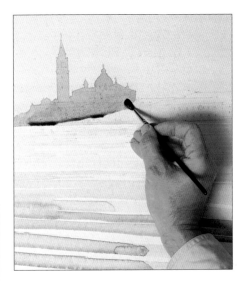

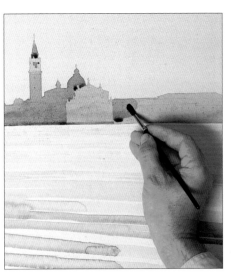

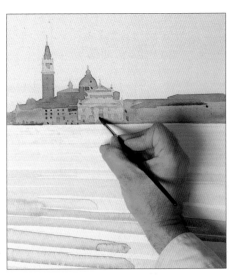

6 Painting in the buildings
Using the No 6 sable brush with Paynes grey, apply a flat wash to indicate the horizon and the buildings. Cut in carefully around the buildings and let the wash dry well.

7 Applying a second wash
Make a second wash using the same mixture as before. This wash picks up the darker areas on the band of trees to the left and the buildings, the shaded areas on the stonework at the top of the tower, and the facade of the church. Allow to dry.

8 Picking out the details
Add a little more Paynes grey to darken the mixture. Then add in a few details, including the wooden mooring and navigation posts sunk into the floor of the lagoon, and the windows and doors in the church and connecting buildings.

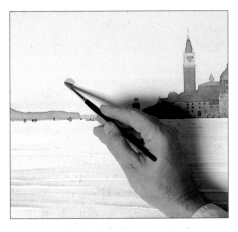

9 Painting in the sun
Mix a warm orange, using a mixture of cadmium red and cadmium yellow, to paint in the early morning sun.

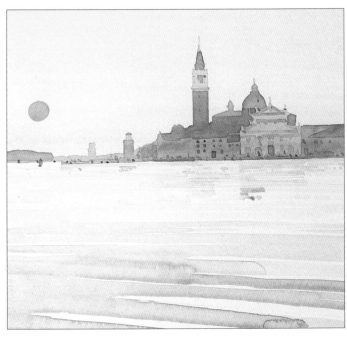

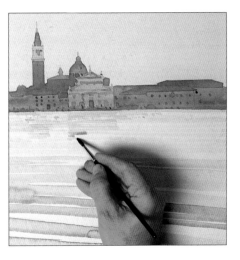

10 Painting in the reflections
Use the No 6 sable brush with a mixture of Paynes grey and a touch of cadmium red to indicate the darker reflections of the church and tower.

11 Final painting
The use of just five basic colours, and an approach which observes a few simple principles of perspective, can produce a very successful result. This painting has a convincing sense of depth, and portrays the still and cool atmosphere of the early morning before the sun has risen.

Judging Proportion

I N ORDER TO DRAW accurately, you need to be able to assess the relative proportion of an object, and how this relates to its surroundings and position in space. To do this artists take measurements. The distance between two points is usually measured by holding out a drawing implement at arm's length.

The artist looks past the pencil to the subject and aligns the top of the pencil with a point on the subject, the top of the head for example, then slides his or her thumb up or down to indicate another point, perhaps the tip of the chin. The thumb is kept in this position, and the unit is then used to estimate the length or height of the complete figure, or the length of an arm or leg. This is then transferred to the drawing. To make a drawing larger or smaller, change the size of the unit; as long as you are consistent, the measurements should be correct. Never take anything for granted, and always make a few simple measurements for any subject.

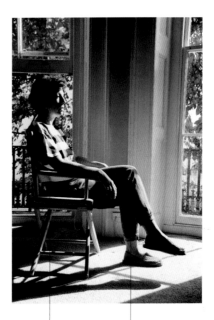

Strong lighting defines the figure's basic outline

A deliberately simple pose has been chosen for ease of assessment

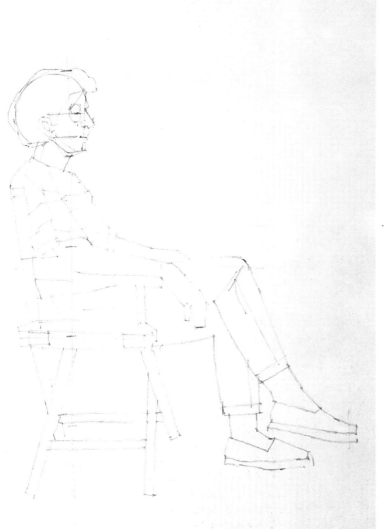

Still Life with Seated Figure
The rules as given above always apply, regardless of the pose or position adopted by your model. Always be guided by your measurement, and what you see, rather than what you may assume to be the correct view.

Figure

MATERIALS

- Cartridge paper
- Charcoal pencil

1 Measuring proportions

Measure the size of the head; this unit fits about four and a half times into the figure from the top of the head to the bottom of the chair's legs. Work against a vertical line which runs at a central point through the upright portion of the body. Mark off a single unit, which will indicate the size of the head on the drawing.

2 Working out the vertical

Mark off four and a half units on the vertical line. This will accurately plot the distance from the top of the head to the bottom of the chair's legs.

3 Working out the horizontal

Draw a horizontal line through the arm and leg. Measure the actual figure: you will see that about three head units reach a point on the toe of the raised foot, and that two units fall at a point on the knee. You now have the distance to the extremities.

4 Drawing in the outline

Start off with the head, taking measurements as you proceed, and plotting their equivalent position onto the drawing. Notice how the eyes align at a halfway point on the head, and also how far back the ear sits on the head.

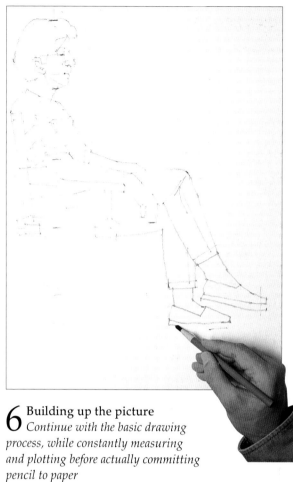

5 Comparing measurements
As you work, continue to take measurements and compare them. For instance, the distance from the neck line to the elbow is the same as the distance from the elbow to the wrist.

6 Building up the picture
Continue with the basic drawing process, while constantly measuring and plotting before actually committing pencil to paper

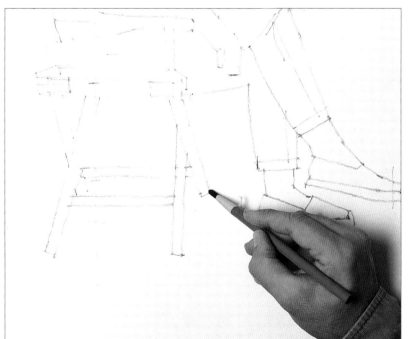

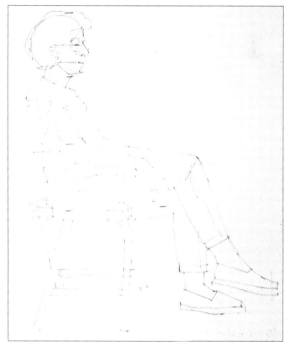

7 Adding the final touches
Plot and draw in the position, angle and size of the chair's legs.

8 Final sketch
This simple drawing is proportionally correct. It would provide a strong foundation for any subsequent work, whether elaborating the drawing with colour, for example, or for using it as the basis for a more finished drawing or painting.

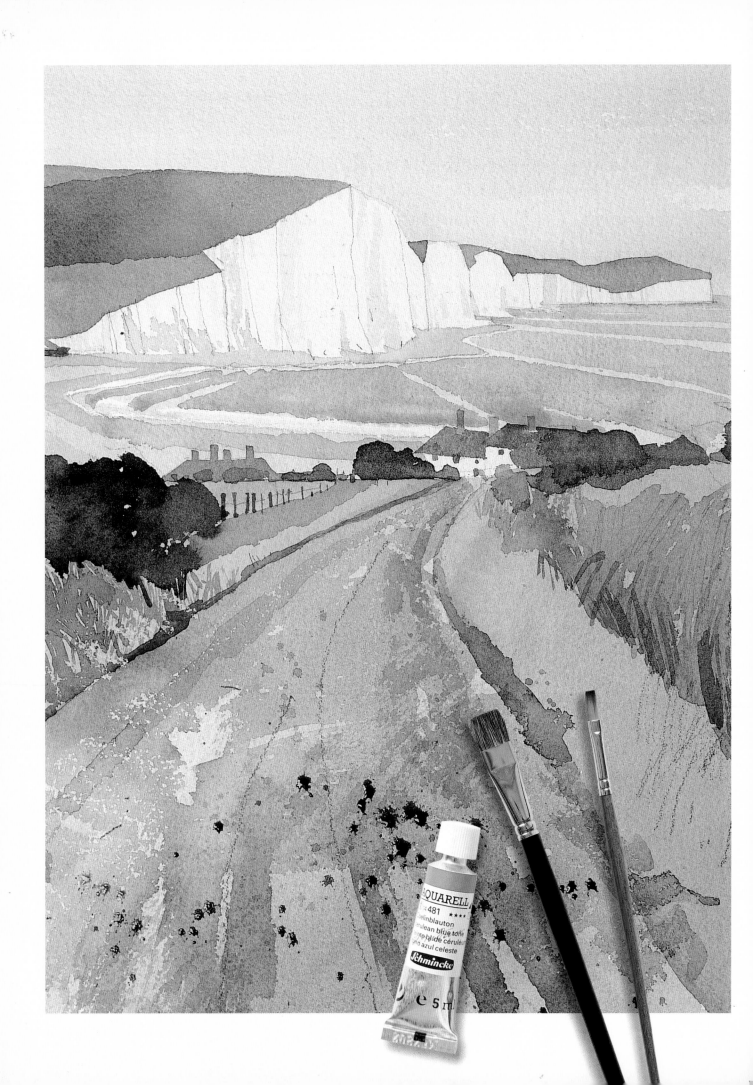

PART 3

Developing Your Skills

Practise the basic techniques you have already
learned by trying out the more complex projects
featured in Part 3. By following the step-by-step
guides you can develop your skills and apply them
across a whole range of subjects and materials.
The projects cover twelve still-life, ten landscape and
ten figure artworks, each of which can be adapted
to suit your own variations. Some of the techniques
you will develop include blending colour pastels
on brown paper to capture a shaded figure, displaying
a texture using frottage, and creating deep colour
and luminosity by glazing acrylic paints.

Manipulating Black

CHARCOAL IS A SIMPLE material to use. It makes a very positive mark which, as long as it remains unfixed, can be easily removed by using a soft brush or flicking with a soft rag. The residue of the charcoal mark not only adds to the drawing but also acts as a guide for later work. At first glance the marks made by a stick of charcoal may appear rather direct and lacking in subtlety – but it is a remarkably versatile material and an ideal medium for beginners who are learning to draw. One reservation often voiced is the apparent lack of capacity the medium has for detail. In fact charcoal can be used effectively for rendering detail, as long as you work in a broader manner than you would do if, for example, using a pencil.

When using charcoal, choose a paper which has a slight texture or tooth to the surface. On smooth papers the charcoal dust cannot take hold, and the charcoal stick seems to slide. The drawing will look grey and lack any depth, as it is almost impossible to make a full black mark, no matter how much pressure is applied. A reasonably substantial cartridge paper will suffice or, as used here, not watercolour paper.

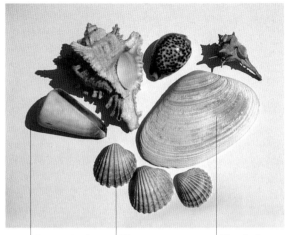

| Strong shadows throw the shells into relief | The pattern on this shell adds further visual interest | The shells have been chosen for their variety of shapes and textures |

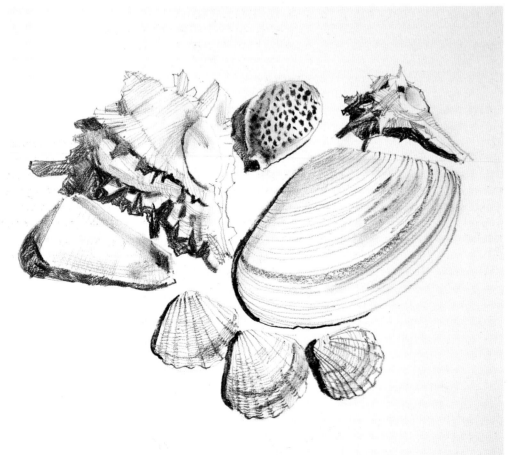

Still Life with Shells
Select shells of varying shapes and sizes for the contrast between those with smooth, flowing lines and those with sharp, angular edges. You will have to vary the qualities of your line work, and pick out the subtle forms with a range of tones, to draw them successfully and to show the differences between them.

MATERIALS

- NOT watercolour paper
- Thin and thick charcoal sticks
- Charcoal pencil
- Paper towel
- Fixative

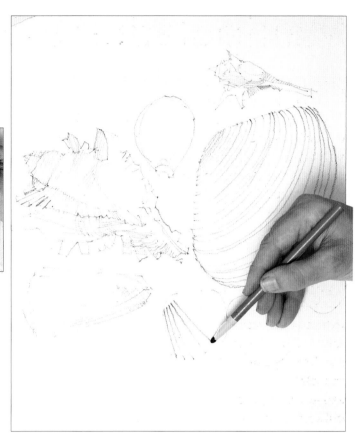

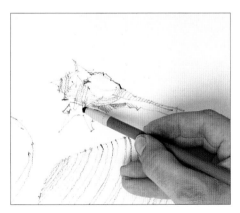

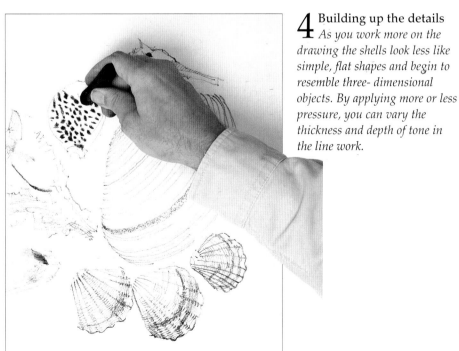

1 Sketching in the outlines
Sketch in the basic shapes with a thin stick of charcoal. These marks are only a guide and should be barely visible; if they appear too dark, dust the surface of the paper with a soft rag to lighten them.
Inset: *Rest your hand on a sheet of paper towel to prevent smudging.*

2 Adding the shells
Using the charcoal pencil, draw in each shell, paying particular attention to the spaces, shapes and distances between them. Do not apply too much pressure with the pencil, as this would make these marks too dense.

3 Identifying the details
Apply a spray of fixative to prevent any smudging, then draw the internal linear marks on the shell surface. These marks describe the surface texture, and also follow the overall shape of the shell and the direction of its surfaces.

4 Building up the details
As you work more on the drawing the shells look less like simple, flat shapes and begin to resemble three- dimensional objects. By applying more or less pressure, you can vary the thickness and depth of tone in the line work.

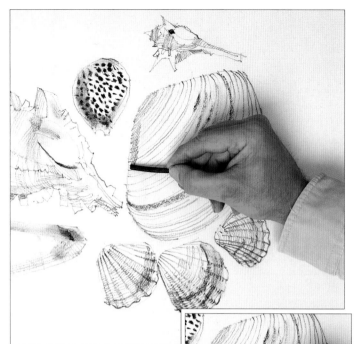

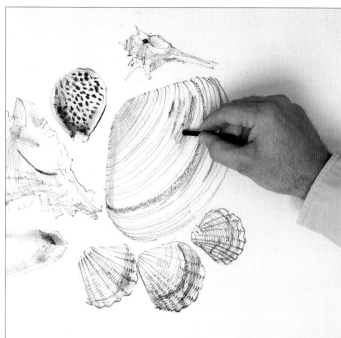

5 Adding texture

Use the thicker stick of charcoal in a loose and fluid manner to create textural quality. Always consider the surface direction of each shell and follow those contours. Then apply a spray of fixative.

6 Developing tone

Scribble in further detail using the thin stick of charcoal.
Inset: *Use your finger to blend and smudge the lines over the surface of the shells, creating tone and further texture.*

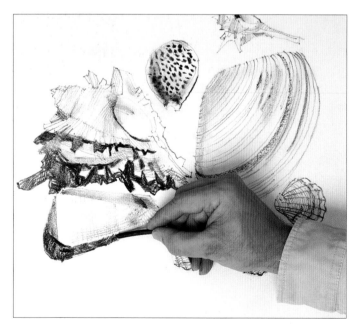

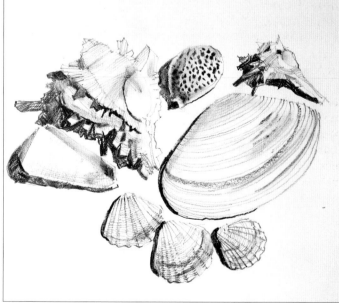

7 Sketching in the shadows

Once you are satisfied with the shells turn your attention to the shadows. Scribble these in carefully while observing where they fall as they consolidate the shape of the shells, and create a three-dimensional illusion.

8 Final drawing

Apply a final spray of fixative to the drawing. Working on a broader scale than usual has meant that the charcoal has been allowed to show its true potential without any sacrifice to detail; this has been hinted at rather than painstakingly drawn.

Refining Tone

GRAPHITE, IN THE FORM of sticks or pencils, is an easy and familiar material to use. Grades range from soft to hard, and the tools can be used to create tones from barely white to jet black. Soft pencils or sticks make a wider range of tones than harder ones, and it is easier to draw using softer pencils. Pencils can lay down scribbled tone very quickly, yet are capable of precise fine line work and are easily controllable. This is a combination which makes them an ideal drawing medium. Pencil drawings are not as delicate as charcoal, chalk or pastel drawings and do not always need to be fixed.

Soft, pencil-like charcoal will blend if rubbed with a finger, but changes in tone are better rendered by altering the pressure, or by building up layers of tone by overworking. Powdered graphite can also be used to build up tonal areas; this can be worked back by using more graphite, or by cleaning back to the paper with an eraser.

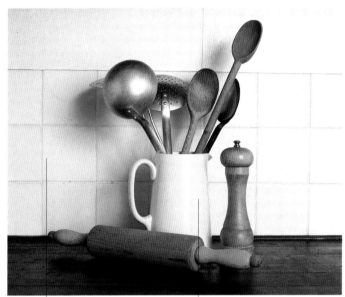

Although it does not appear in the final drawing, the simple grid of tiles is a useful aid in judging relative sizes

A head-on viewpoint reduces perspective distortion

Still Life with Kitchen Utensils

There is no need to search far for suitable objects to draw. Here a few commonplace kitchen utensils are gathered together. They did not need to be particularly colourful, as a monochromatic material was used.

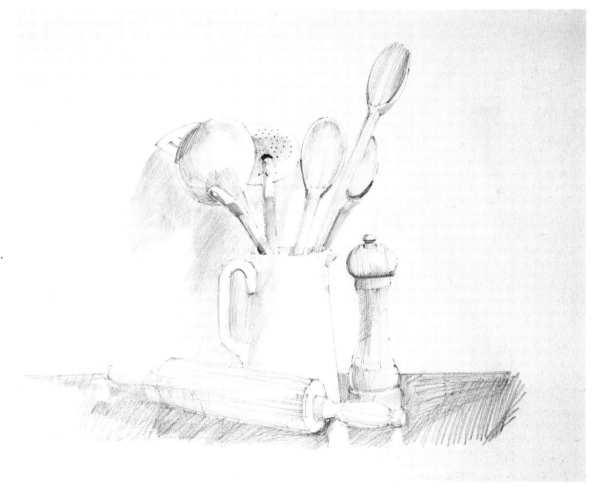

Still Life

MATERIALS

- Cartridge paper
- HB, 3B and 9B pencils
- Graphite powder
- Putty and plastic erasers
- Paper towel
- Fixative

1 Sketching in the outline
Use the 3B pencil lightly, paying particular attention to the angle at which the rolling pin rests; this helps to give an indication of depth and also draws the eye into the picture.

2 Strengthening the lines
Once you are happy with the composition, focus on the sides of the objects which are in shadow. Begin to suggest the darker tones, which will give the objects a strong sense of solidity.

3 Developing contour lines
Give shape to the utensils and the rolling pin by scribbling on further tone and adding contour lines. The dense tone applied to the background makes the jug and its contents appear in sharp relief. **Inset:** *Blend the loose shading by rubbing it with your finger.*

4 Adding tone
Dip a finger wrapped in paper towel into some graphite powder and spread this over the drawing. This creates a smooth mid-tone over all but the very lightest areas.

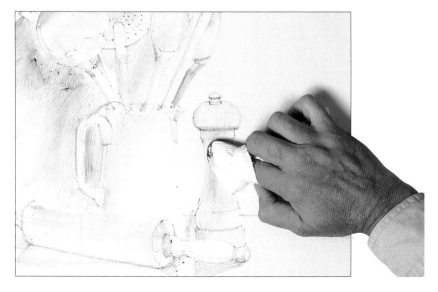

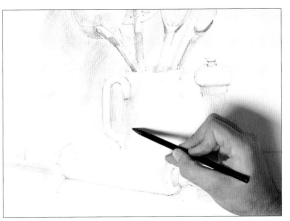

6 Rendering the darkest tones
Scribble on the heavy tone of the dark wooden kitchen surface with the 9B pencil. Use the same pencil for the dark areas on the steel and wooden utensils.

5 Developing the tones
Work loosely with the HB and 9B pencils to create further tones. Take care when you apply pressure to the 9B pencil, as the point can easily break.

7 Adding effects
Use a soft putty eraser to redefine the shape of the shadows, and to add highlights to the steel implements. Then, using the sharp edge of a plastic eraser, remove the grain of the wood from the rolling pin and the wooden spoons.

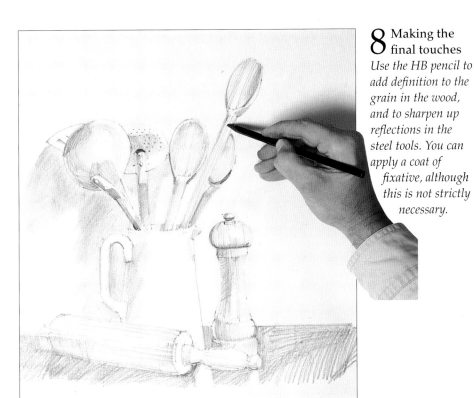

8 Making the final touches
Use the HB pencil to add definition to the grain in the wood, and to sharpen up reflections in the steel tools. You can apply a coat of fixative, although this is not strictly necessary.

9 Final drawing
Keeping the graphite work relaxed, together with the extra dimension added to the work by using erasing techniques, has resulted in a lively representation of what could be a clinical subject.

Still Life

Line and Tone

GOOD PEN AND INK drawings possess a clarity and spontaneity which set them apart from drawings made with other materials. Used with a dip pen, ink is a linear medium that seems to have limitations. However, a wide range of techniques and effects has been employed by artists keen to exploit its potential. Tone is achieved by using wash techniques, or by building up hatched lines, dots or dashes.

Like charcoal, pen and ink is an ideal material to use when learning how to draw. Unlike charcoal, it is difficult to erase marks or to make corrections. This restriction can appear intimidating but is in fact one of the main strengths of the medium, as it forces the artist to be decisive at the outset. To minimize problems, plan ahead carefully, work over a light pencil drawing as a guide, and use ink diluted with water.

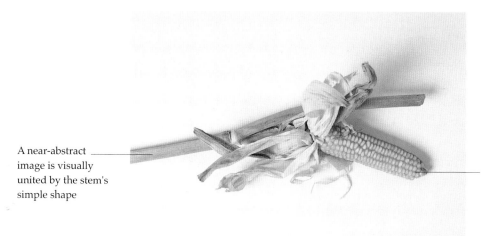

A near-abstract image is visually united by the stem's simple shape

The rounded shapes of the corn segments contrast well with the dry angularity of the leaves

Still Life with Corn on the Cob

Dried flowers and plants are marvellous objects to draw and paint. Here, the intricate shapes and folded-back dried leaves and covering on the corn present a special challenge. Note how the changes in direction and pattern on the leaves are followed closely to describe the object's shape. Take your time, as there is no danger of your subject wilting.

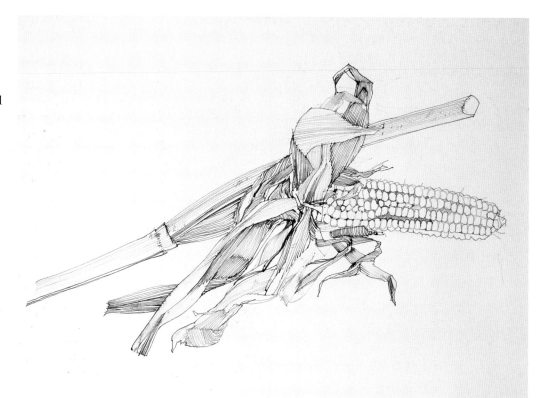

MATERIALS

- 3B pencil
- Cartridge paper
- Indian ink
- Dip pen with thin nib
- Water

1 Planning out the shapes
Using a sharp 3B pencil, sketch in the position of the corn, concentrating on the major shapes. Keep this drawing light as it serves only as a guide and will be erased as soon as you have finished the work.

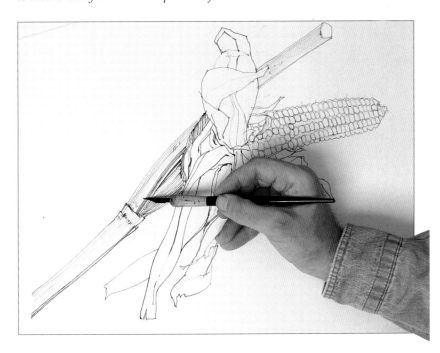

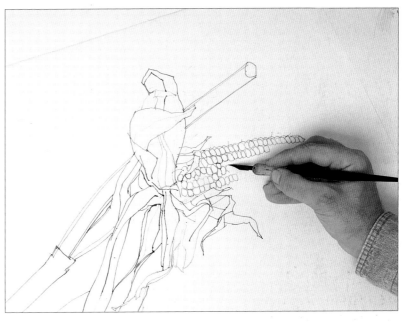

2 Adding ink marks
Dip the pen first into the ink and then quickly into the water: the ink should be diluted to a sufficient degree. Sketch in the stem and work on to the dry leaves which cover the cob. Work left to right across the paper to ensure that your hand is kept clear of wet ink.

3 Building up the image
Using the pencil drawing as a guide, work carefully to make sense of the jumble of dried leaves. Pay attention to abrupt changes in direction where the leaves are bent and crumpled. Draw in the corn, noting how it surrounds the cob.

4 Drawing the stem
Once the outline of the cob is more or less complete, return to the main stem and, using fluid yet direct lines, concentrate on each stem section in turn.

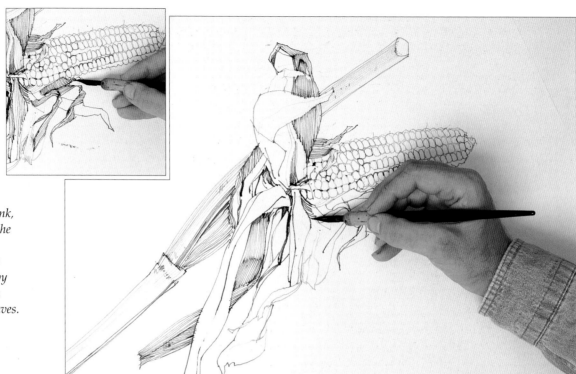

5 **Adding texture**
Using undiluted ink, search out and define the darker passages in the drawing. **Inset:** *Draw in the linear textures by following the direction and contours of the leaves.*

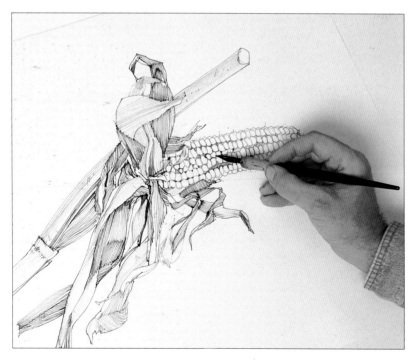

6 **Identifying the shadows**
Use varying combinations of diluted and undiluted ink to indicate the surfaces which appear to be in and out of shadow.

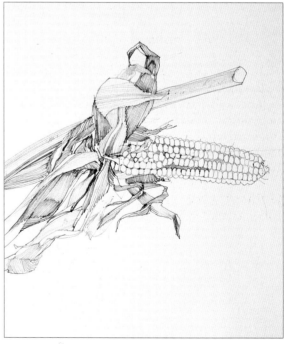

7 **Final drawing**
Once the ink drawing has been completed and the ink is dry, remove the pencil lines that are still visible with a soft eraser. Remember that thick and heavy lines can take longer to dry than you might assume, so allow plenty of time to elapse before using the eraser.

Using a Toned Ground

PASTEL WORKS ARE known as paintings, but the colours are not mixed on a palette. They are applied directly onto the paper, where they are blended together. However, the freshness and sparkle evident in the best pastel works is achieved by working in as direct a manner as possible, so pastel manufacturers offer a very wide range of colour tones.

Pastel paintings are best made on a tinted paper that is sympathetic to the subject, either in contrast, colour or tone. Using these papers eliminates the need to cover the surface completely, as they inevitably show through in places, helping to consolidate the work. Pastels drawn on white paper tend to look pale and insipid, and lack bite and sparkle. Pastels are made from pigment mixed with just enough binder to hold them together. Their very nature makes them delicate and dusty which means finished works can be easily smudged or damaged. The solution is to fix the work at various stages or when it is finished. Fixative can also be used as a creative tool itself, as it tends to deaden colours to a slight degree. You can extend a limited palette by using fixative in certain areas and not in others.

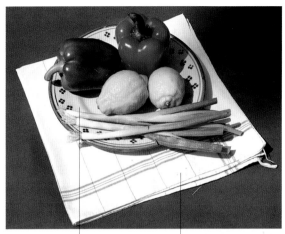

Placing the dish towards the back of the cloth breaks what would have otherwise been a near-symmetrical arrangement

Tilting the cloth within the picture frame gives the composition a sense of visual dynamism

Still Life with Fruit and Vegetables

A few vegetables, a cloth and a plate make a simple subject for a still-life drawing, and they are also a perfect match for the colours found in an inexpensive box of pastels. Placing the objects on a dark-coloured background brightens the colours to a considerable degree.

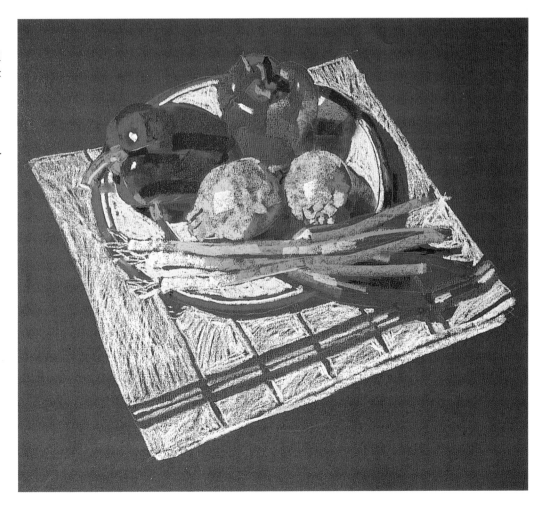

MATERIALS

- Dark green pastel paper
- White pastel pencil
- Pastels: cadmium red, crimson, pink, range of greens and yellows, orange, white, Naples yellow, purple, ultramarine
- Fixative

1 Sketching the outline
Use a white pastel pencil to establish the basic position of the objects. The dark green pastel paper gives a density in the shadow areas and helps the colours to appear vivid and bright in contrast.

2 Blocking in the red pepper
Use cadmium red and crimson, together with pink for the highlighted areas, to draw in the red pepper. Utilize the chiselled edge of the pastel to make firm and direct strokes to the surface of the pepper.

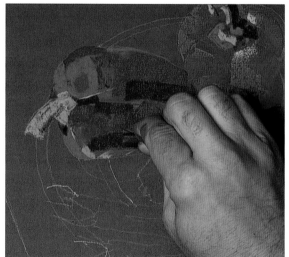

3 Blocking in the green pepper
Using a range of greens, add the pepper stalks and the pepper itself. The pastels will probably not match exactly the colour of the objects, but this is not important. Choose colours which are close; once the work is finished, it is surprising how correct they can appear.

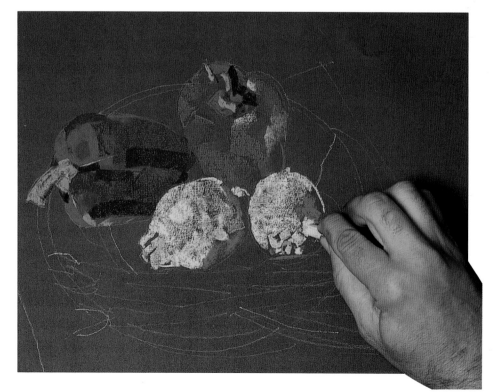

4 Creating special effects
Mix a range of yellows together with a touch of orange to suggest reflected red from the pepper, then apply a dull green colour for the deep shadows.

5 Drawing in the spring onions

This time using acid greens, make long strokes for the stalks of the spring onions. White mixed with a touch of Naples yellow suggests the small bulb and its roots.

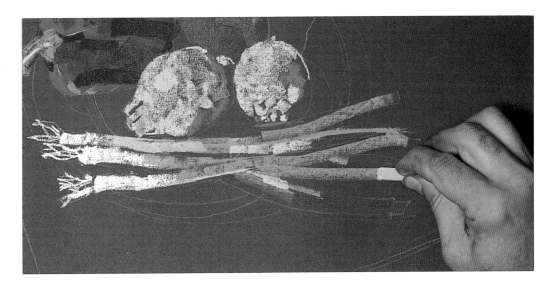

6 Establishing the shadows

Once the fruit and vegetables are complete, draw in the shadows on the plate with a dull purple. Block in the plate itself with Naples yellow.

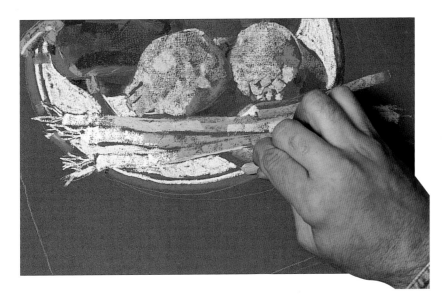

7 Maintaining separate colours

Paint in the pattern on the cloth with the crimson pastel, and then block in the cloth itself with scribbled white. Work around the red linear pattern, rather than placing the white first and then drawing the red lines over it. This keeps the red colour strong as it does not pick up any of the white, thus turning the red to a shade of pink.

8 Final painting

A touch of ultramarine in the shadow area completes a sketch which has used very few different colours. The careful choice of colour for the pastel paper, and the direct strokes, result in a solid picture which belies its simplicity.

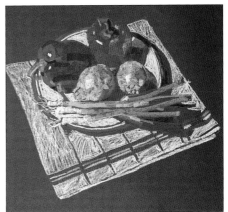

Still Life

Simple Still Life

ACRYLIC PAINT IS a relatively new invention, and was first offered for sale in the early 1960s, so unlike watercolour and oils, acrylic painting does not have a tradition of techniques. However, it was introduced at a time when artists were fervently experimenting and moving into abstraction, or using popular imagery. In addition, its versatility has meant that it can borrow many techniques from both oil and watercolour disciplines.

The main attribute of acrylic paint is the speed with which it dries, coupled with its ability to be used thick as an impasto, or thin like watercolour. Once the paint is dry, it becomes insoluble and cannot be removed. It does, however, have very good covering power, and mistakes and alterations can easily be rectified by overpainting. In recent years manufacturers have introduced a range of additives which alter the characteristic of the paint, extending its versatility.

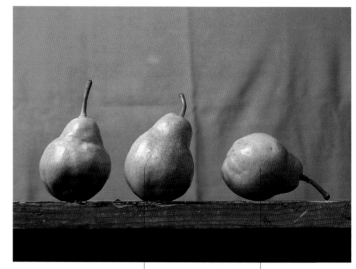

A strong red background gives maximum colour contrast to the green of the pears

The pears' round forms are enhanced by the flatness of the cloth in the background

Placing the third pear on its side complements the upright position of the other two

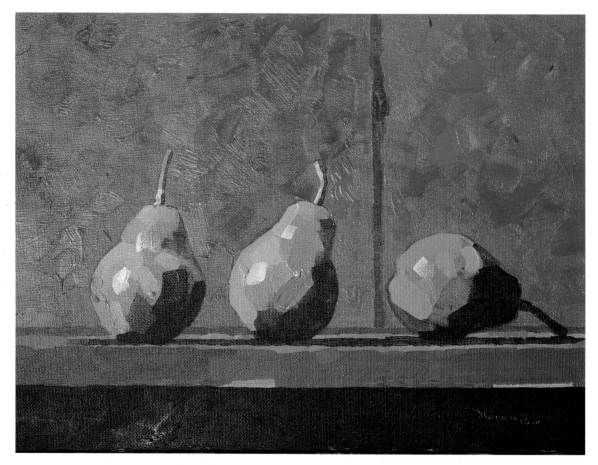

Still Life with Pears

Arranging the pears separately on the tabletop gives them an almost sculptural quality, with the background accentuating shape and colour. The arrangement also avoids the conventional manner in which fruit is usually painted as a still life.

MATERIALS

- Canvas painting board
- 3B pencil
- Flat No 2 and No 4 bristle brushes
- ¼in synthetic flat brush
- Acrylic matt medium
- Acrylic paints: sap green, phthalo green, alizarin crimson, cadmium red, yellow ochre, cadmium yellow, burnt umber, Paynes grey, titanium white

1 Sketching in the outline
Make a simple drawing on the canvas board using the 3B pencil. The crease in the red background cloth runs from top to bottom, acting as a compositional device which both divides the picture and engages the eye.

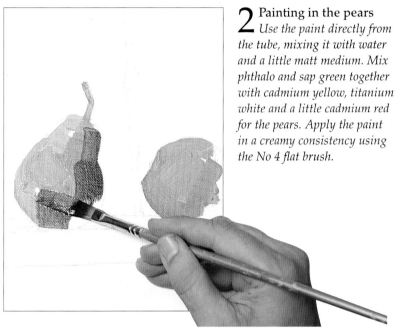

2 Painting in the pears
Use the paint directly from the tube, mixing it with water and a little matt medium. Mix phthalo and sap green together with cadmium yellow, titanium white and a little cadmium red for the pears. Apply the paint in a creamy consistency using the No 4 flat brush.

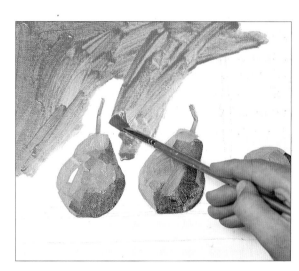

3 Blocking in the background
Use the same brush to paint in the colour of the background with a thinner mixture of cadmium red.

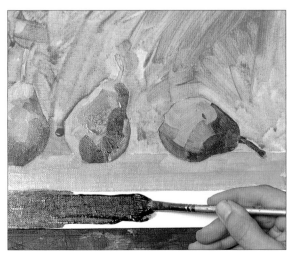

4 Painting in the table top
Mix yellow ochre, cadmium red, burnt umber and titanium white for the wooden table top. Paint the dark area beneath it with a mixture of burnt umber and Paynes grey.

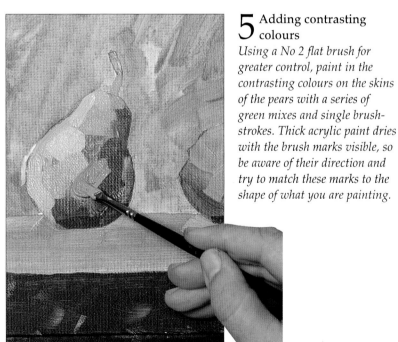

5 Adding contrasting colours
Using a No 2 flat brush for greater control, paint in the contrasting colours on the skins of the pears with a series of green mixes and single brushstrokes. Thick acrylic paint dries with the brush marks visible, so be aware of their direction and try to match these marks to the shape of what you are painting.

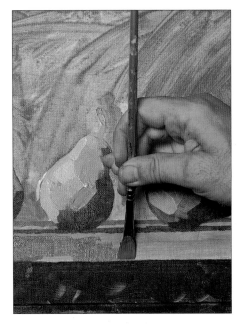

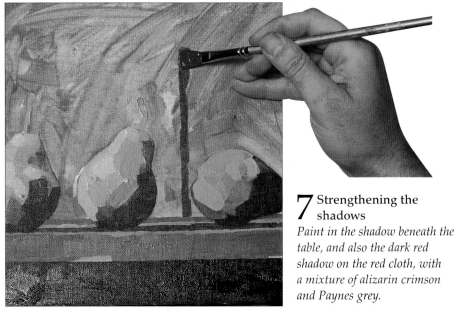

7 Strengthening the shadows

Paint in the shadow beneath the table, and also the dark red shadow on the red cloth, with a mixture of alizarin crimson and Paynes grey.

6 Establishing the shadows

Fill in the shadows cast by the pears and the darker front edge of the table, using paint of a creamy consistency.

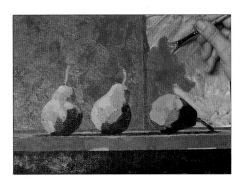

9 Adding the finishing touches

Paint in the detail on the stalks and the highlights on the pears with a ¼in synthetic flat brush that aids control and precision.

8 Consolidating the background

Mix cadmium red and alizarin crimson together into a fairly thick consistency, and apply this with multi-directional strokes that act as a foil to the eye. Brushstrokes which lead in one direction tend to lead the eye in that direction.

10 Final painting

It was a quick and simple matter to produce the end result. The drying speed of the paint enabled overworking in a matter of minutes, and the strong composition helped to create a dramatic work.

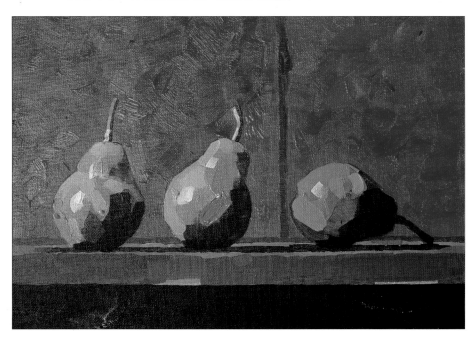

Light to Dark

WATERCOLOUR is not an easy medium to use well. However, once the basic techniques have been mastered, it has enormous potential and can be used for every subject. The medium has a long tradition, and numerous techniques have developed which make it a versatile one.

True watercolour uses no white paint. The paint is mixed with water and applied to the white paper in a series of washes. The more water that is added the thinner the mixture becomes; this allows more light to reflect back from the surface of the paper through the wash, which makes the colour appear lighter or paler. These semi-transparent washes are built up one on top of the other, each qualifying, or altering, the one beneath. The lightest washes are applied first, gradually progressing to the darkest washes which are applied last. When used with assurance, watercolours can produce works which have the power and solidity of more physical materials such as acrylic or oil paint.

The light colour and intricate texture of the petals contrast well with the plants' seed-heads

Strong shadows throw the flowers into sharp relief

Still Life with Dried Flowers
The parchment-like, dried sunflower heads offer the perfect subject to show how a limited range of colours and tones carefully painted one on top of the other, wet on dry, is all that is needed to create a strong image of a simple subject.

MATERIALS

- Stretched NOT watercolour paper
- H pencil
- ¼in flat sable and No 6 round sable brushes
- Paper towel
- Watercolour paints: Naples yellow, raw umber, burnt umber, burnt sienna, raw sienna, sap green, Paynes grey, ultramarine
- Scrap paper
- Water

1 Sketching in the outlines
Begin the work with an H pencil. This sketch needs only to be light and loose, and will act simply as a guide for the subsequent washes.

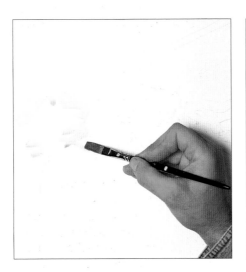

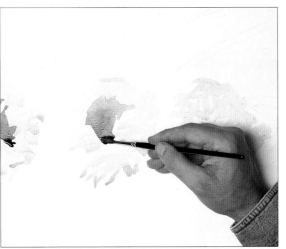

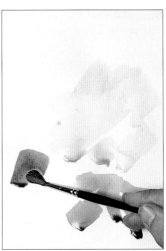

2 Painting in the petals
Using a light mixture made with Naples yellow and raw umber, paint in the dried yellow petals of the sunflowers. Use the flat chisel-shaped brush as the marks it makes are perfect to suggest the twisted, angular nature of the dried petals.

3 Colouring in the flower centres
Use a mid-tone wash of burnt umber, reddened a little using burnt sienna, with the No 6 sable brush to wash in the colour of the flower centres. Note how the yellow petals cut across these centres, and work around the shapes accordingly. When mixing colours first test them on scrap paper, to assess their strength and colour before committing yourself to the actual painting.

4 Strengthening the colours
If you are worried about the strength of a pigment, test the colour on a scrap of paper before applying.

5 Adding the leaves and stems
Make a green mixture using sap green and a little burnt umber. Then paint in the dull green leaves and stems. Use the flat brush, as its shape makes a mark which corresponds well to the shape of the areas being painted.

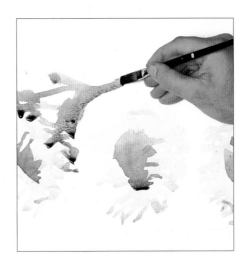

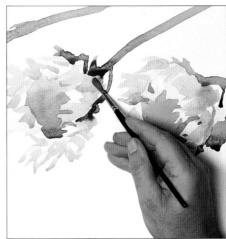

6 Painting in the yellow petals
Prepare a mixture of raw sienna and raw umber, and paint the darker yellow petals. Use the round brush, which enables the precise matching of marks to those made in step 2.

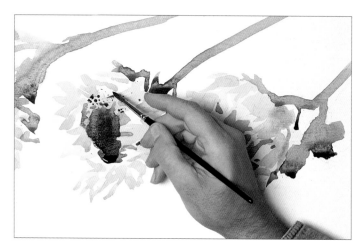

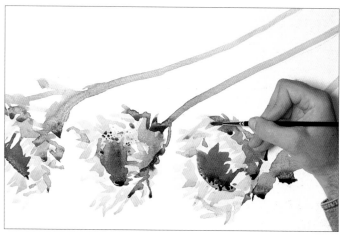

7 Detailing the seed circles
Use burnt umber to make up a darker version of the brown used for the flower centres. Tap the brush to spatter this onto the flower centres to represent the dried circles of seeds. Blot up stray blobs with a clean sheet of paper towel.

8 Separating the petals
Add water to lighten the same mixture as before, and then paint in the darkest petals at the base of the flower head around the stems.

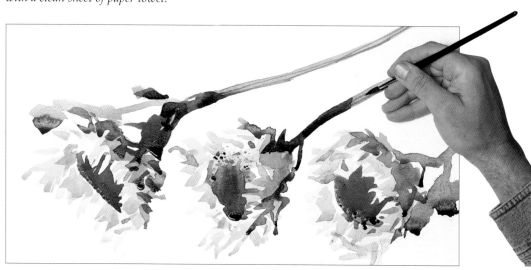

9 Painting in the shadows
Mix sap green, Paynes grey and burnt umber together to indicate the shadows on the stems and leaves. Use the point of the round brush to make the linear marks on the stems.

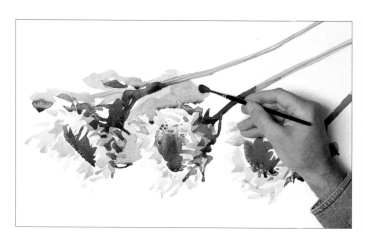

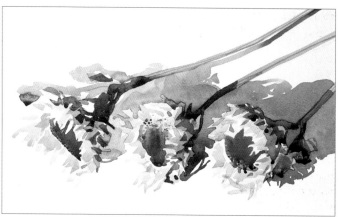

10 Adding the finishing touches
Cut in carefully around the shapes of the leaves and petals to indicate the cast shadow. Use Paynes grey mixed with ultramarine to give the colour a bluish tone.

11 Final painting
The result is a work which, although using a limited range of relatively neutral colours, has depth and a luminous intensity. Never overwork watercolours, and always try to achieve the desired effect by using a maximum of three layers of overlying washes.

Varying the Line

THE ARTIST WHO LIVES in the city need not look far for inspiration, with even the committed landscape artist finding plenty to draw. Buildings and roads may replace trees and fields, but all other considerations remain the same.

That said, for most artists working in a big city is not as quiet and as stress-free as working in the country. You will inevitably draw a crowd of onlookers, so being shy about your work is not an option. Even if you can find a quiet corner amidst the bustle, you may feel that speed is of the essence for your work.

Very few materials are as quick to use, and as easy to carry, as a few sticks of charcoal in a box and a pad of cartridge paper. Keep your hands clean by wrapping the charcoal sticks in silver foil, and apply a spray of fixative when you have finished the work.

Variety of light and shadow adds interest to what otherwise could be a dull and uniform view

Seen from a distance, these huge buildings seem like an abstract collection of simple, rectilinear shapes

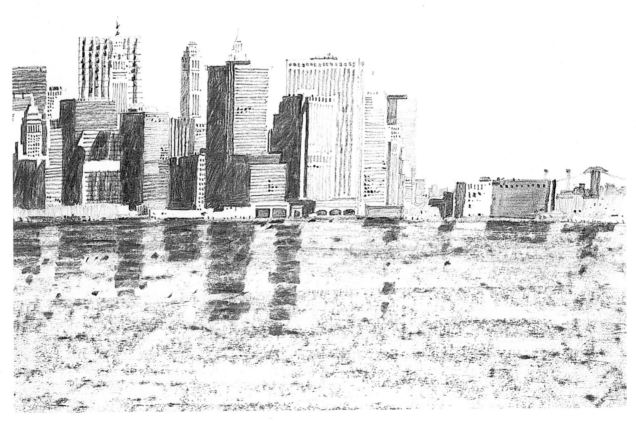

Urban Landscape
At first glance, this city scene appears to be daunting and highly complex. However, once you have analysed the drawing, it becomes clear that it is in essence a series of interlocking rectangles covered in a series of parallel lines.

MATERIALS

- Cartridge paper
- Medium and thick charcoal sticks
- Charcoal pencil
- Eraser
- Fixative
- Fine sandpaper

1 Establishing the skyline
Use the dense consistency of the charcoal pencil to sketch in the skyline. Position the line so that it runs across the drawing about half way down the paper.

2 Locating the windows
Using the same pencil, begin to draw in the linear pattern of the buildings' windows. Vary the pressure on the pencil to alter the tonal density and thickness of the lines.

3 Working across the drawing
As you proceed across the drawing, you will see how effectively this simple drawing technique can represent a fairly complex subject.

4 Filling in the shadows
Use the sharp edge of a medium stick of charcoal, made by rubbing the stick on fine sandpaper or by snapping it into two pieces, to establish the deep shadows. Where the shadows across surrounding buildings fall at an angle, ensure that they appear consistent across the drawing.

5 Inserting lighter areas
Continue the drawing process until all the shadows have been established. Note how a few lights are left shining out of these dark areas.

6 Indicating the windows
Use the sharp edge of an eraser to cut back into the darker areas to represent the lines of windows. Apply fixative to the completed areas.

7 Adding in the sea
Use a thick stick of charcoal to draw a series of lines horizontally across the water. Allow the texture of the paper to show through, to represent the feeling of waves and undulations on the surface of the water.

8 Adding the reflections
Draw in a few dark lines, again with a thick stick of charcoal, to represent the reflections of the towering blocks in the water. Once the drawing is complete apply fixative.

9 Final drawing
Using a simple technique can often be far more successful than adopting a more complex one when trying to represent a far from straightforward subject.

Cross-Hatching

Technical pens have a thin tube through which ink is delivered to the paper. Fineliners deliver the ink through a tube to a nylon tip. Both types are available in a range of sizes and make good drawing tools. They differ from traditional pens in that their design enables you to make only a single, standard thickness of line – if a line of different thickness is required, then you need to use a pen with a different-sized nib.

To make a tonal drawing using one of these pens, you will need to use a series of hatched and cross-hatched lines. The density of the lines dictates the density, or depth of tone. Cross-hatching the lines by making a line, or a set of lines, run in a different direction is easily to control, and is in addition a quick way to build up density within the drawing. The direction of the lines can also show any contours and the direction of surfaces.

An interesting juxtaposition to the solidity of the bridge is given by the liquid quality of the reflections in the water

The simple geometry of the bridge's arches is reinforced by the strong shadows beneath

Human interest is added by the two bicycles

Amsterdam Bridge
The linear qualities of fineliners and technical pens make them ideal for rendering the hard lines found in architectural subjects.

Landscape

MATERIALS

- Smooth cartridge paper
- 4B pencil
- Fineliner or technical pen

1 Sketching in the outline
Use a 4B pencil to make your initial marks on the paper, as any major mistakes will be difficult, if not impossible, to correct once you begin working with the pen.

2 Working out the general directions
Using the pen, draw in the lamp post, followed by the railing and bollards. Follow the general direction of each object when making your marks, and do not overdo the drawing – you can always make areas denser by adding more lines later on.

3 Building up density
Sketch in the tree and cross-hatch to build up the density of the foliage. Then add the bicycles, giving them a darker tone by again concentrating on the hatching and cross-hatching.

4 Adding in the bridge
Draw in the arches of the bridge, focusing on the lines which run parallel to the water level. Then follow the curve of the arches, showing their surface direction, or contours.

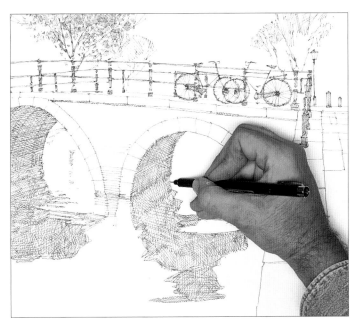

5 Creating reflections in the water
The dark reflections of the bridge are distorted by the movement of the water. Make the hatching multi-directional so that the reflections, although they are similar in tone, look different from the underside of the actual bridge.

6 Detailing the bridge
Continue to build the bridge's reflections with lightly cross-hatched lines. Indicate the courses of brickwork with a series of hatched parallel lines.

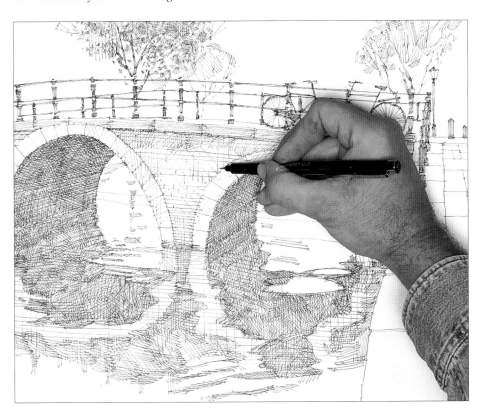

7 Adding overall tone
Apply some widely-spaced cross-hatching to give the bridge and its reflection an overall tone, and to darken the density of the area beneath the arches.

8 Final drawing
The web of lines results in surprising depth and tonal range. This could be extended further by reworking the area beneath the bridge, and filling in the background; however, in a drawing such as this, where corrections can be difficult to make, it is often better not to overwork.

The Shapes Between

THE CHILD'S IDEA of a tree resembling a lollipop is not far removed from the truth. However, trees can, and do grow to look like lollipops, especially when several of the same species grow together. When drawing trees, first draw in the structure of the tree, then its trunk and branches, followed by the shape of its leaf canopy. You can establish this by looking for the areas of light and shade in the foliage. However, this is not always possible as there may be no definite shapes in view. In this example, the shape of the trees has been established by observing the sky through the foliage, the shape of the light patterns falling on the tree trunks, and the dark hedge which appears in the background. Note that the statues in the view here were not included in the drawing, so as to concentrate on the trees.

The contrast between the strong horizontal of the towpath and the vertical aspect of the trees gives this simple image its dynamic appeal

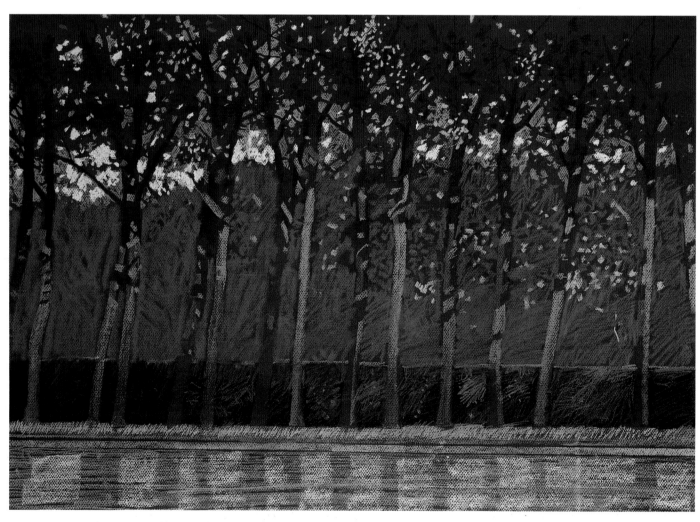

Landscape with Trees
The trunks of these trees are distinct enough when seen against the dark hedge behind them. But the upper branches and leaves all join to present a block of foliage through which only an occasional glimpse of sky is visible.

MATERIALS

- Dark green pastel paper
- Pastel pencils: black, light blue, light grey, light green, yellow ochre, dark blue, dark green, mid green, lemon yellow, orange
- Ruler

1 Establishing the positions
Use a black pencil to sketch in the approximate position of the trees and the patches of shade on their upper branches.

2 Searching out the sky
Establish the network and pattern of the sky, as seen through the leaf canopy, with a light blue pencil. By drawing in these so-called 'negative' shapes, the positive shape of the actual tree becomes increasingly apparent.

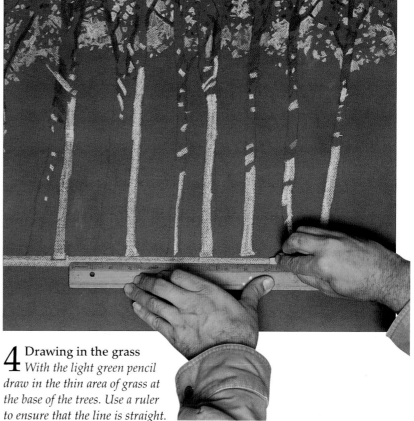

3 Blocking in the light
Use the light grey pencil to block in the varied patches of light which fall onto the trunks and the main branches of the trees.

4 Drawing in the grass
With the light green pencil draw in the thin area of grass at the base of the trees. Use a ruler to ensure that the line is straight.

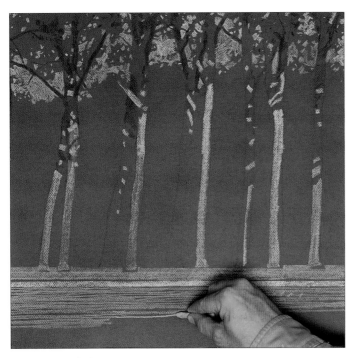

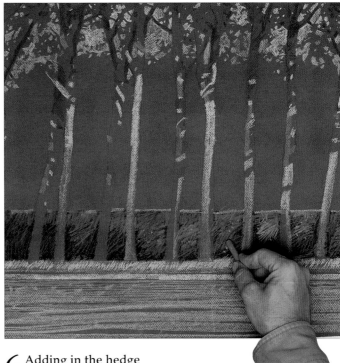

5 **Creating water ripples**
Suggest the pathway and side of the pond with a yellow ochre line, followed by a strip of light grey. Then use the dark blue pencil to draw in a series of loosely parallel lines to represent the slight rippling effect on the surface of the water.

6 **Adding in the hedge**
Use the dark green to establish the position of the hedge, with a little light green where the light catches its top. Then suggest the texture of the foliage on the side of the hedge with the mid green pencil. Use the light green pencil again to pick out any further highlighted areas in the hedge itself.

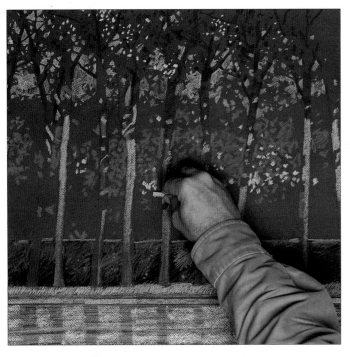

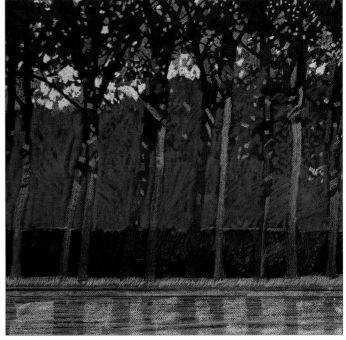

7 **Picking out the leaves**
Use the light blue pencil to show highlights on the sky and the water, then lemon yellow and orange for a few leaves with autumnal colours. Add the foliage between the trees with the mid green pencil.

8 **Final drawing**
The dark green colour of the background paper provides much of the skeletal tree structure, and also serves to harmonize the work overall.

Exploiting Texture

CREATING TEXTURAL EFFECTS in a painting can enhance areas which may otherwise lack interest. Textural effects are usually made with a brush, using a variety of techniques that represent texture as a pattern or a paint effect.

Acrylic paint can also be applied thickly, or you can add sand or sawdust to increase its textural possibilities. Manufacturers have developed a number of mediums, each with a different texture, which can be used directly from the jar or tub and painted over when dry, or mixed with the paint prior to its application. Use these texture mediums with restraint, and don't let them become an end in themselves.

Note that the furrows in the foreground of the painting here were added to draw the viewer's eye into the composition.

A high horizon leads the eye into the scene

The semi-abstract shapes of trees on the skyline act as a focal point within this composition

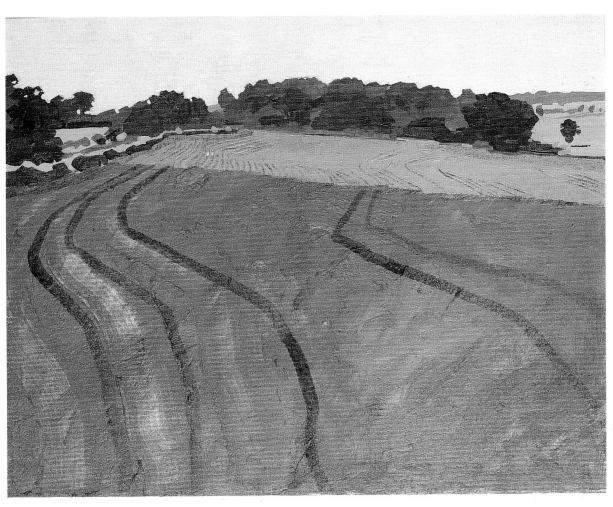

Farmland and Fields
The large expanse of ploughed field in the foreground of this rural scene offers something of a representational problem. The addition of a textural medium, however, gives a physical texture to the paint which echoes that of the field in reality.

Landscape

MATERIALS

- Canvas board
- Flat bristle brushes
- Flat synthetic brush
- Natural sand texture gel
- Acrylic paints: burnt umber, sap green, yellow ochre, Paynes grey, titanium white, lemon yellow, cerulean blue
- Piece of stiff cardboard
- Water

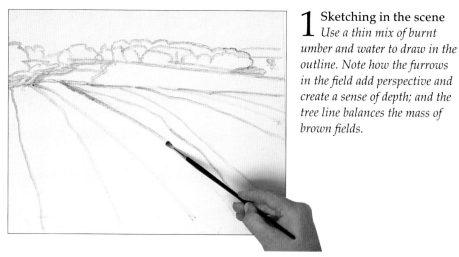

1 Sketching in the scene
Use a thin mix of burnt umber and water to draw in the outline. Note how the furrows in the field add perspective and create a sense of depth; and the tree line balances the mass of brown fields.

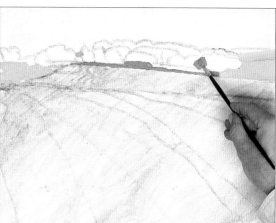

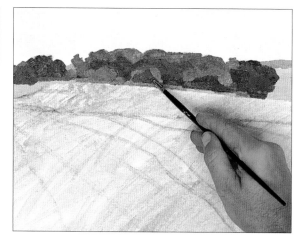

3 Painting in the trees
Make up a range of dark and mid greens with sap green, yellow ochre, burnt umber, Paynes grey and titanium white for the trees.

2 Colouring in the fields
Apply a thin, loosely brushed-out wash of burnt umber to the area covered by the fields. Once this is in place, begin to establish the line of trees using a mid-green paint.

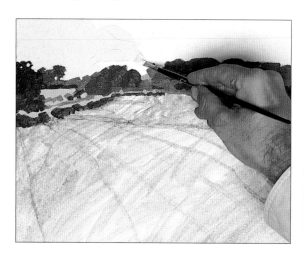

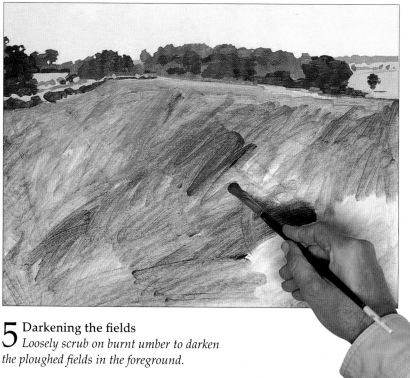

4 Establishing the sky
Mix cerulean blue, titanium white and a little lemon yellow together, and use this to paint in the pale blue sky.

5 Darkening the fields
Loosely scrub on burnt umber to darken the ploughed fields in the foreground.

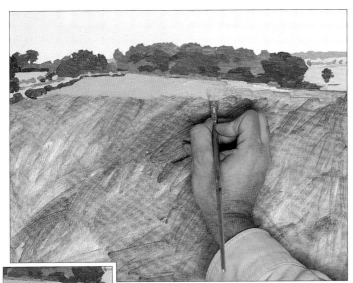

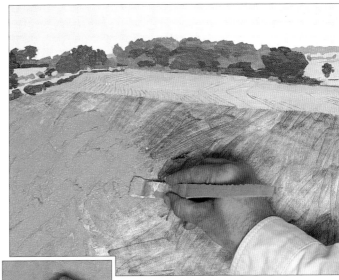

6 Developing textural effects
Make up a pale brown colour with titanium white, burnt umber and Paynes grey. Then add a little natural sand texture gel and paint in the far field. **Inset:** *Before the paint dries, use the wooden end of the brush to scratch into the paint to describe the curve of the furrows.*

7 Building up the detail
Mix up a darker brown, using burnt umber, Paynes grey and titanium white, and add more of the texture gel. Then, using a painting knife or spatula made from a piece of stiff cardboard, plaster the mix onto the field in the foreground. **Inset:** *Cut a small piece of cardboard and use this to describe the ruts in the field. Pay attention to the direction of the marks.*

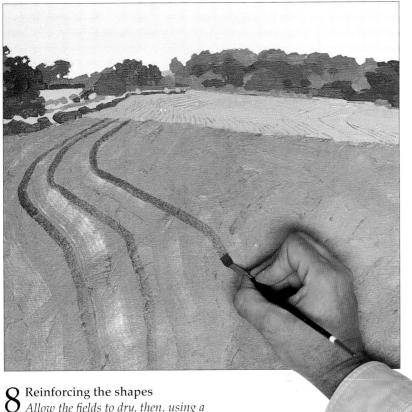

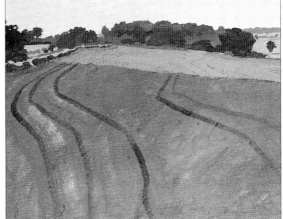

8 Reinforcing the shapes
Allow the fields to dry, then, using a darker brown mix and a softer synthetic flat brush, repaint over the field the pattern of ruts, following the flow and curve of the land.

9 Final painting
The sand texture gel adds a subtle quality to the picture, and gives the foreground a physical presence which would be lacking if a 'flat' painting approach were adopted.

Masking Out

ONE OF THE MAIN watercolour techniques is how to manipulate the white of the paper, as no white paint is used in traditional watercolour painting. The artist needs to think well ahead, as certain techniques need to be done in a specific order so that they have the desired effect, and are not obliterated by subsequent washes – or that they do not impede or prevent subsequent washes from being made.

While it is easy to work paint around large areas, smaller areas can present difficulties. Protecting the area with masking fluid solves this problem. It can, however, damage the bristles, so use an old or inexpensive brush. Masking should not only be considered as a way to protect a particular area but, as shown here, it can also be used as a means to give an edge quality which would be difficult to achieve in any other way.

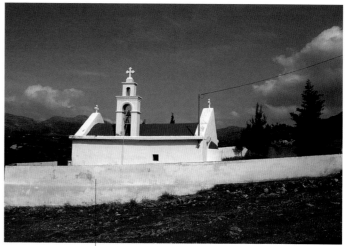

The speckled texture on the wall, contrasting with the plain white walls of the church, provides a strong visual starting point to this simple image

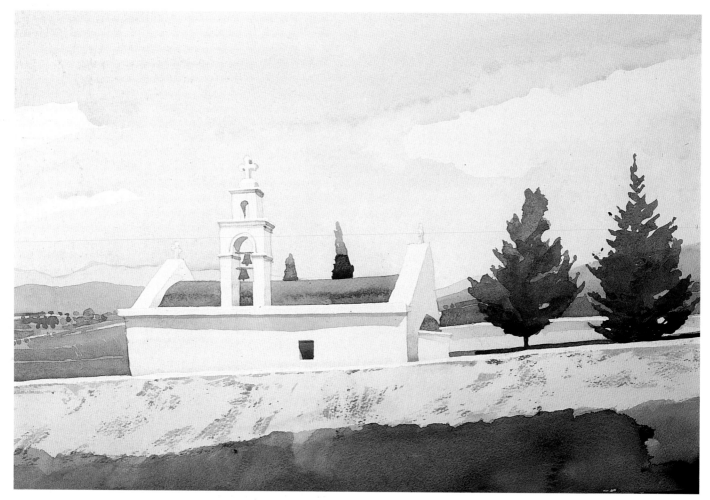

Landscape with Greek Church

The main subject is predominantly white and, given its relative size, is easy to paint around, so there is no need to mask out the whole of the church. Masking fluid is used on the fine white lines where the sun hits the top of walls, and to provide the texture on the wall itself.

MATERIALS

- Stretched NOT watercolour paper
- 2B pencil
- No 6 and No 12 round sable brushes
- ¼in and 1in flat bristle brushes
- Old brush for masking fluid
- Masking fluid
- Paper towel
- Watercolour paints: Paynes grey, ultramarine, cerulean blue, yellow ochre, burnt umber, brown madder alizarin, sap green
- Water

1 Sketching in the outline
Use a 2B pencil to make a guide for subsequent work. If you wish you can simplify the scene and omit the clouds from the sky.

2 Masking out the lighter areas
Use masking fluid to paint out the areas on the church and wall which are directly lit. If possible, use an old brush for this task. Always allow masking fluid to dry completely before painting washes over it.

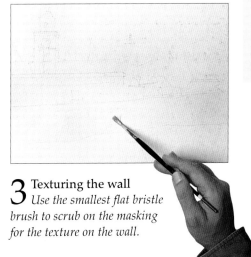

3 Texturing the wall
Use the smallest flat bristle brush to scrub on the masking for the texture on the wall.

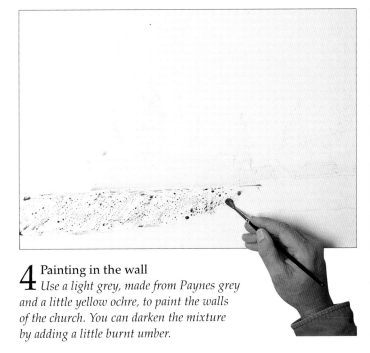

4 Painting in the wall
Use a light grey, made from Paynes grey and a little yellow ochre, to paint the walls of the church. You can darken the mixture by adding a little burnt umber.

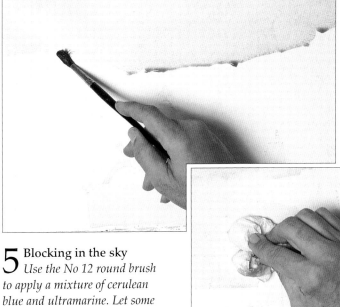

5 Blocking in the sky
Use the No 12 round brush to apply a mixture of cerulean blue and ultramarine. Let some of the white paper show through to represent clouds. **Inset:** *Blot off some of the blue paint using a sheet of paper towel to soften the edges of the clouds.*

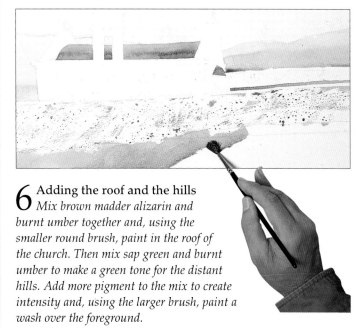

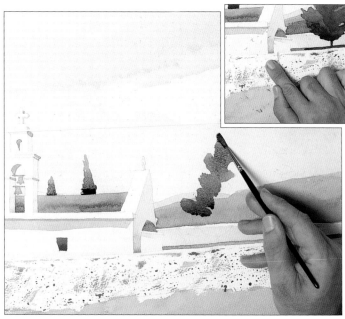

6 Adding the roof and the hills
Mix brown madder alizarin and burnt umber together and, using the smaller round brush, paint in the roof of the church. Then mix sap green and burnt umber to make a green tone for the distant hills. Add more pigment to the mix to create intensity and, using the larger brush, paint a wash over the foreground.

7 Adding more details
Paint the shadows on the church walls with a mix of ultramarine and Paynes grey, and add detail to the bell tower. Paint in the trees with a sap green, Paynes grey and burnt umber mix. **Inset:** *Once the paint is dry, remove the masking fluid by rubbing with your finger.*

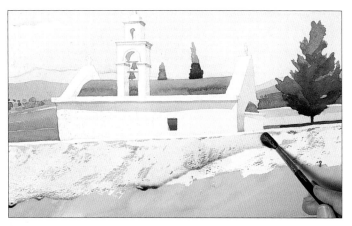

8 Focusing on the wall
When you have removed the masking fluid, apply a wash, consisting of a mixture of burnt umber and Paynes grey, to the wall in the foreground.

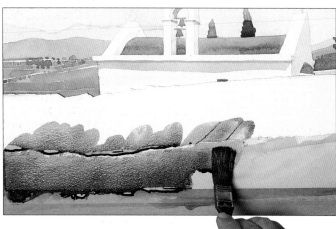

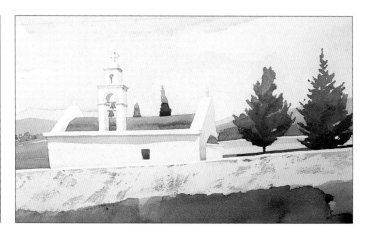

9 Adding the foreground
Use a dark mixture of sap green and burnt umber to paint in the foreground. Tear a mask from a sheet of thick watercolour paper to give an interesting line between this area and the wall. Work the paint away from the edge to help prevent it from bleeding beneath.

10 Final painting
Several masking techniques have been used to achieve the final result. These do not overpower the picture, and are barely noticeable, but they do contribute qualities which would be difficult and time-consuming to achieve in any other way.

Squaring Up

F AN ARTIST wishes to make a copy of a small painting, drawing or photograph, the easiest and most precise way to achieve this result is to make a tracing. However, this method limits you to making a copy which will be identical both in content and in size.

If a larger or smaller copy is required, the solution is to square up the original first, then square up the drawing paper, using either a larger or smaller measurement, and copy the original image virtually square by square. This may seem tedious and time-consuming, but once the grid has been made, the process is surprisingly quick and should result in a more or less exact copy. A short cut, and one which eliminates the need to draw lines on the original artwork or photograph, is to draw a grid on a thin acrylic sheet which can then be placed over the original.

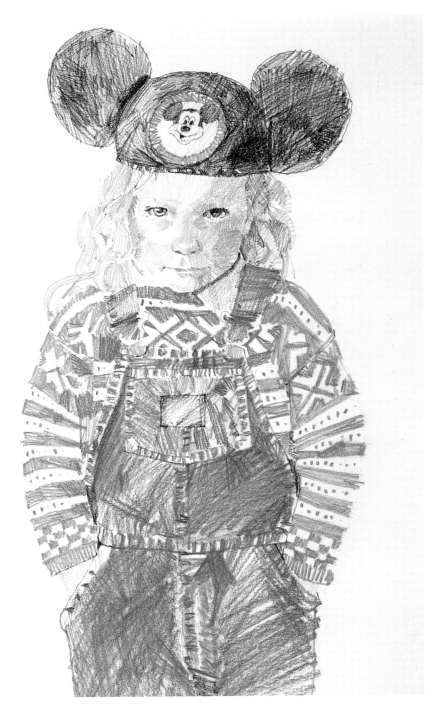

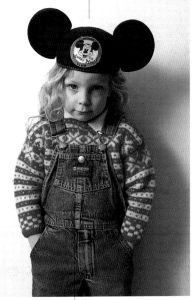

A humorous contrast is created between the jokiness of the headgear and the child's serious expression

Plain washed blue denim helps set off the complexity of the pattern in the knitwear

Portrait of a Child
Candid poses of children are always a seductive subject. But they are rarely simple, as working from life can be frustrating and the results are sometimes disappointing. However, these problems can be overcome simply by enlarging your favourite snapshot.

Figure

MATERIALS

- Cartridge paper
- Metric ruler
- B pencil
- Indelible marker pen
- Soft putty eraser
- Cell or thin acrylic sheet
- Pastel pencils: black, yellow ochre, pink, cadmium red, burnt sienna, ultramarine, crimson, cobalt blue
- Fixative

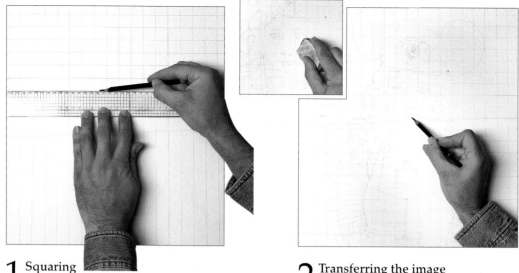

1 Squaring up the overlay

Using a thin, indelible marker pen, mark up the cell overlay in 10mm squares. The size of the grid squares can be larger or smaller, but if smaller than 10mm, you will have more work to do, and if larger, your accuracy may be compromised.

2 Transferring the image

Place the overlay on the original. For a double-size copy, draw a 20mm grid. Copy the lines in each square of the original into the squares. **Inset:** *With the drawing transferred, erase the grid lines with a putty eraser, working around lines which are part of the drawing. Apply fixative.*

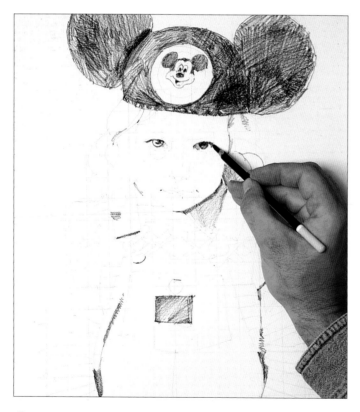

3 Drawing in the basics

Use a black pastel pencil to sketch in the basic features of the drawing, starting with the black hat, eyes and dark shadows. Try to keep the pencil work open, and relatively loose, as trying to fill in an area with flat, heavy colour results in a static drawing.

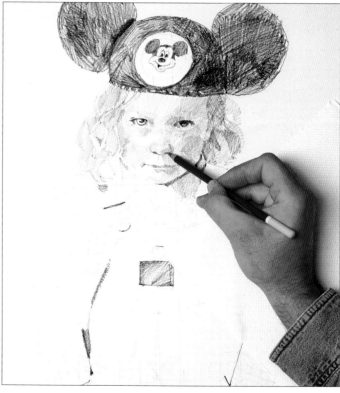

4 Adding facial detail

Combine yellow ochre, pink, cadmium red, burnt sienna and ultramarine pencils to fill in the detail on the child's face and hair.

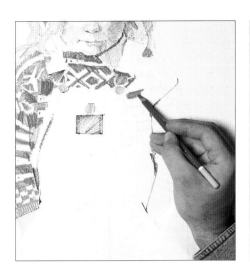

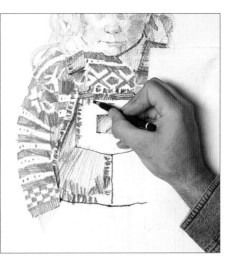

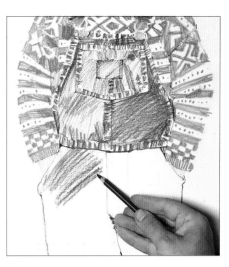

5 **Colouring in the sweater**
Using the cadmium red pencil, work carefully around the pattern of the sweater, leaving it to show through as white paper in the same way as if using watercolour. Work the crimson pencil over the top of the cadmium red to define areas in shadow.

6 **Focusing on the dungarees**
Work around the light pattern of bleaching that can be seen on the seams of the denim dungarees, this time using a cobalt blue pencil.

7 **Avoiding flatness**
As you fill in the rest of the dungarees, try to keep the work looking fresh and lively. To achieve this, do not apply the pencil strokes in too dense a manner.

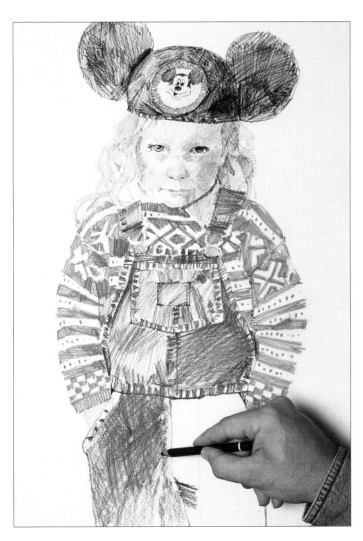

8 **Adding intensity**
If you use ultramarine over the top of, and in conjunction with, the cobalt blue, this can add intensity and variation to the image.

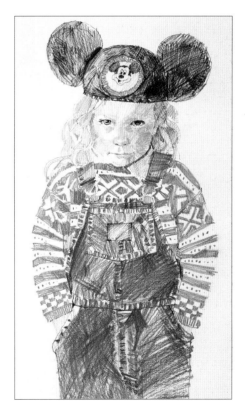

9 **Final drawing**
The end result is a very accurate copy of the original photograph – however, the loose technique creates a sense of immediacy which seems to belie the considered way in which the image was transcribed.

Self-Portrait in Mirror

I T IS NOT ALWAYS easy, or convenient, to find a model for portrait drawing or painting, so why not practise on yourself? Working on your own also means that there are no distractions, thus making it easier to concentrate on the task in hand.

The main priority when drawing or painting a portrait is to achieve a physical likeness. This requires accuracy and the correct positioning of the facial features relative to one another. An easy way to do this when working from photographs is to use a grid, but the same technique can also be used when working from life.

You can make a grid on a sheet of transparent perspex and position it between yourself and the model or, if you are planning a self-portrait, then draw the grid onto the surface of the mirror itself. When using a grid you must position your head in exactly the same way each time you move or look away, otherwise the image will lack accuracy.

Always draw your first self-portrait head on; it's the view you know best

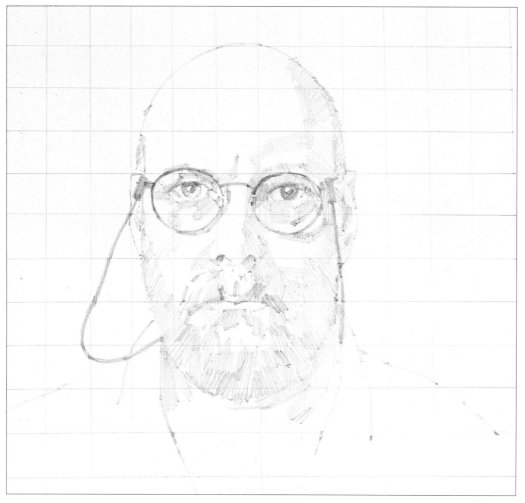

Self-Portrait of the Artist
Position yourself comfortably in such a way that you only need to glance down to one side to see your drawing. This makes it quite easy to move your head back to the original position.

MATERIALS

- Cartridge paper
- 2B pencil
- Mirror
- Ruler
- Chinagraph pencil or marker pen

1 Sketching in the main features
Draw a grid onto the paper with a 2B pencil, and another one onto the mirror with a chinagraph pencil and a ruler. Look at the mirror and draw a few lines onto the paper for the top of the head, chin and other features. Position the left eye.

2 Positioning the glasses
Making sure you keep your head in the same position, draw in the rest of the glasses. Use the shape of the glasses as a means to judge the accuracy of the other facial features.

3 Defining the features
Add a little light shading to act as a guide to the contours of the feature, and the direction of the light.

4 Building up the image
Work one square at a time, relating the position and direction of the pencil line back to previously drawn areas.

Figure

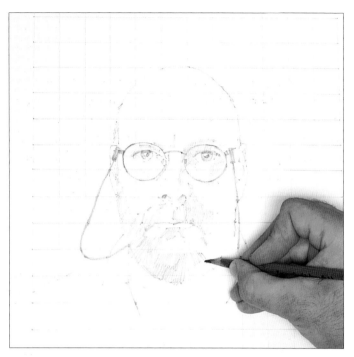

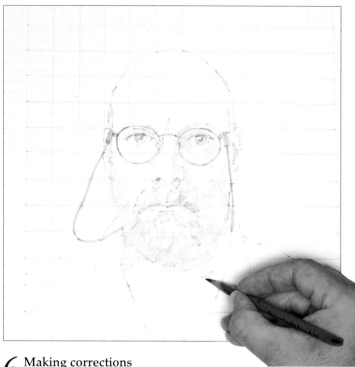

5 **Adding the finer details**
Once the main features have been drawn in, concentrate on the more detailed areas such as, in this example, the moustache and beard.

6 **Making corrections**
You can make any necessary corrections as you are working through the drawing, or wait until it is almost completed.

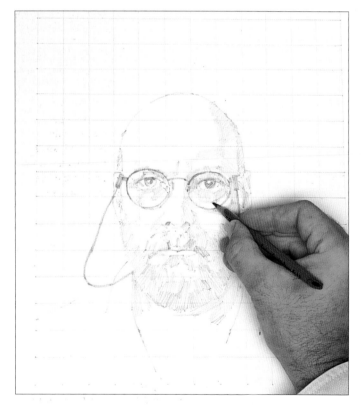

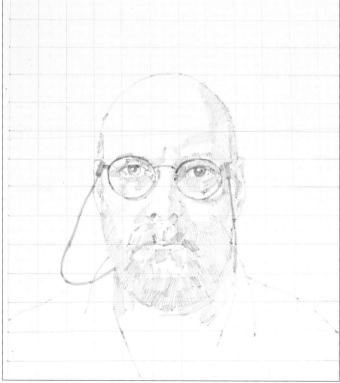

7 **Adding the finishing touches**
Once you consider the basic drawing to be correct, add in some careful shading.

8 **Final drawing**
The grid does not have to be erased. Many artists use a grid for preparatory work prior to making actual portrait paintings and, if left intact, these grids give interesting clues as to the creative process.

Mixing Colour

Colour mixes using pastel are achieved in a number of ways. Colours can be placed next to each other and then blended or smoothed together using a finger, a paper torchon or a blending stump. This is the traditional way of using pastel, and the result is a very smooth transition from one colour or tone to another. However, care needs to be taken not to overdo the blending or the work can look bland, with the colours becoming subdued and flat.

The alternative is to allow the colours to work with each other by mixing them optically on the paper itself. Each colour or tone used is scribbled onto the paper with open strokes, which allows the background colour, or previously applied pastel, to show through to a lesser or greater extent. For example, red and white blended on the paper produce a pink colour. The same two colours scribbled loosely over one another produce a similar pink colour.

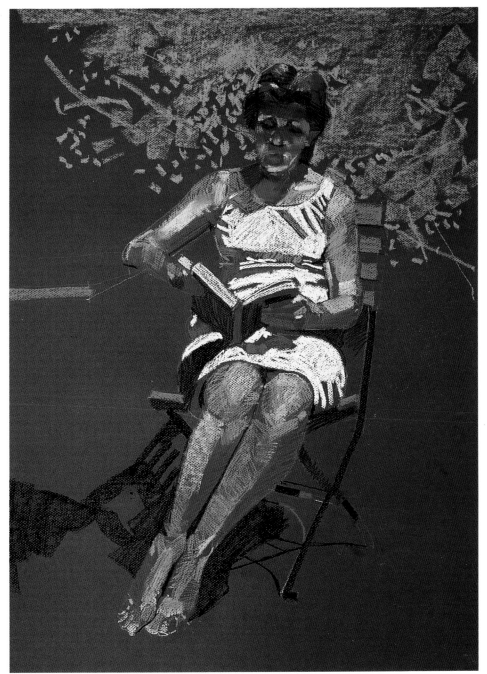

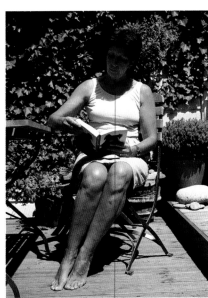

Strong sunlight falling on the sitter's blouse is reflected upwards, causing the face to be underlit

Seated Figure
The atmosphere of a warm summer afternoon, and a relaxed subject, are captured by paying special attention to the intensity of the colour, and the warm and cool areas of reflected light.

Figure

MATERIALS

- Dark brown pastel paper
- Pastels: white, black, terracotta, mid pink, mid-yellow and light-yellow ochre, light cadmium red, light orange, deep violet, light Naples yellow, purple grey, mid sap green
- Fixative

1 Sketching in the outline
Work on a brown pastel paper, which acts as a dark tone and gives the colours brilliance and the work its colour harmony. Sketch in the position of the figure with a white pastel, aiming to capture the pose. Pay special attention to the angle made by the legs and feet.

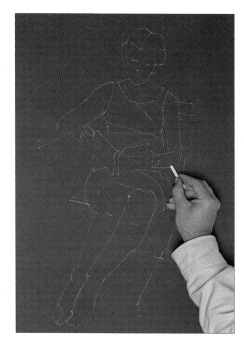

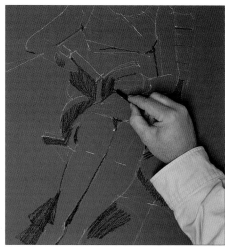

2 Drawing in the dark areas
Scribble in all the areas which appear to be in deep shadow, and the dark hair of the woman, with a black pastel.

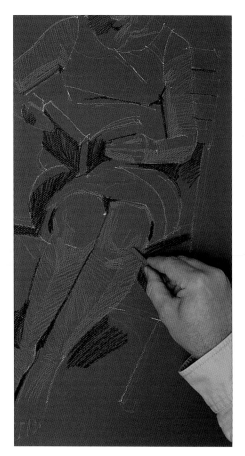

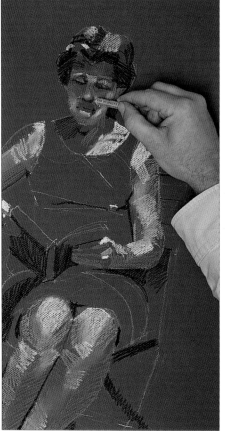

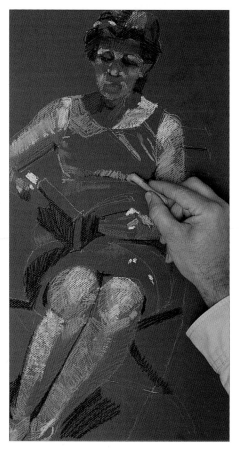

3 Colouring in the skin
Use a mid-toned, bright terracotta pastel to scribble in the warm colour of the skin. You should use open strokes in the lighter areas, and apply the colour more densely in areas in deep shadow.

4 Identifying the different tones
Apply a combination of colours, including mid pink, ochre and light cadmium red, to search out the different skin tones. Work the pastels around the body's contours, and make the strokes in a direction sympathetic to the body's surface.

5 Introducing highlights
Add orange and light ochre touches to the arms, legs and neck. Avoid the face, as this is in shadow, and also receiving reflected light from the model's light-coloured top. Apply a spray of fixative to prevent smudges.

6 **Enriching the shades of colour**
Block in the model's top and skirt with light Naples yellow, and add touches of deep, cool violet to the shadows. Work around those areas in deep shadow which are left to show through as the dark brown of the paper. Select a purple grey for the weathered wood on the chair.

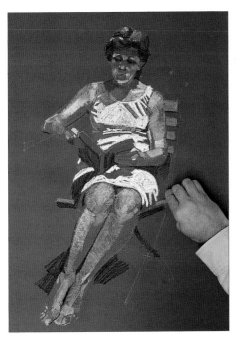

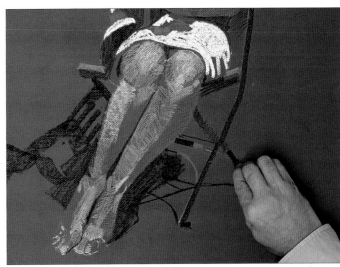

7 **Positioning the chair legs**
Use firm single strokes with a black pastel for the legs of the chair and the shadows beneath it.

8 **Drawing in the background**
Finally, use mid sap green to add a suggestion of foliage and bring the seated figure into the foreground of the drawing.

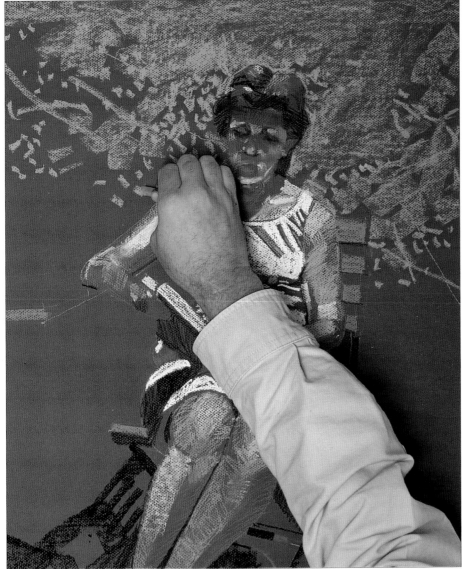

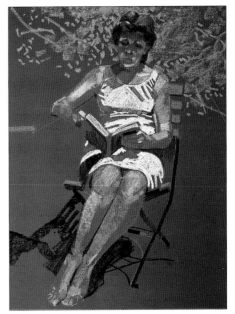

9 **Final drawing**
The brilliance of the pastels, together with the dark, rich colour of the paper, produces a strikingly atmospheric work. The contrasting warm and cool colours successfully create a feeling of warmth on a summer afternoon.

Figure

Blocking in Tone

W HEN FIGURE PAINTING, establishing shape and proportions can be difficult enough, yet mixing and using convincing skin tones and colours can be equally challenging. If you use a white background the task is made more difficult, as a single colour is greatly affected by the colours which surround it, and we rarely, if ever, see colours in isolation.

To solve this problem, artists work on a prepared background which has been stained or tinted to a colour sympathetic to the overall colour of the work. Alternatively, they can work over a monochrome underpainting which establishes the picture tonally. A third option is to block the work in relatively loosely in order to establish the image. This is then reworked by manipulating colour and tone until they appear to the artist's satisfaction.

Acrylic paint is ideal for blocking in, as it dries quickly. Making the transition from establishing the image with an underpainting to finishing it with finer, more considered flourishes, thus becomes seamless.

The pale bedclothes can be converted to three tonal areas: highlight, mid-tone and soft shadow

The subtle tonal changes over the model's body can be simplified and reduced to broad areas

Sleeping Figure
The reclining nude figure is a classic pose which, for the model, is very relaxing and can be held for long periods of time. For the artist, the shape of the bed provides a pleasing frame-work in which to place the figure.

MATERIALS

- Canvas board
- 4B pencil
- ¼in flat synthetic brush
- Acrylic paints:
 burnt umber, Paynes grey,
 cadmium red, cadmium
 lemon yellow, yellow
 ochre, white, ultramarine,
 opaque green, alizarin
 crimson
- Water

1 Sketching in the outline
Loosely draw in the figure on the canvas board using the pencil. If you do not fix the drawing at this stage, the soft pencil marks may be moved around by the initial layers of paint. However, this presents no problem, as the drawing is only there to act as a guide for the final painting.

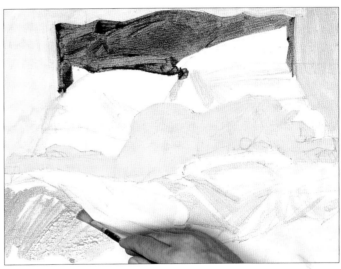

2 Blocking in the major elements
Paint in the headboard using the flat brush and a mixture of burnt umber and Paynes grey. Then block in the figure with a mixture of cadmium red, cadmium lemon yellow, yellow ochre and white.

3 Continuing the major elements
Mix Paynes grey, white and yellow ochre for the wall. Paint the creases on the sheets with a mixture of Paynes grey, white and ultramarine blue. Opaque green, white and Paynes grey produce the bed cover.

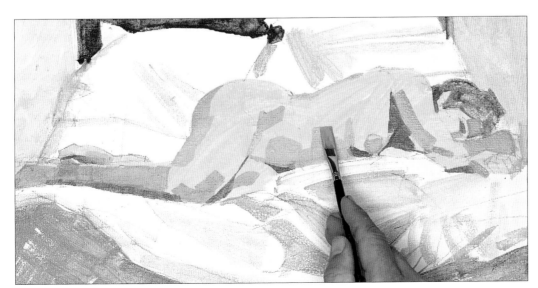

4 Filling in the darker areas
Paint in the hair with a mixture of Paynes grey and burnt umber, then use burnt umber for the darker shadows beneath the arm, breast, stomach and legs. Make a dark skin tone with alizarin crimson, yellow ochre and burnt umber mixed together with a little white.

Figure

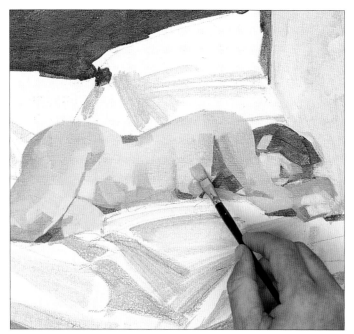

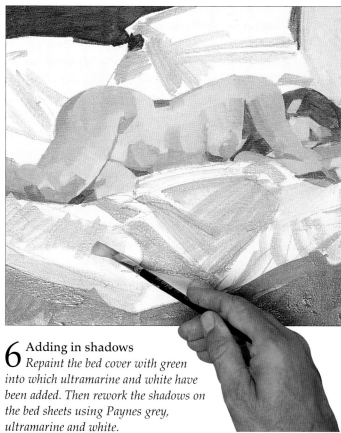

5 **Filling in the mid-tones**
Lighten the existing mixture with white, yellow ochre and a little cadmium red. This acts as a mid-tone which softens the transition from the darker tones to the first, lightest tone used on the figure.

6 **Adding in shadows**
Repaint the bed cover with green into which ultramarine and white have been added. Then rework the shadows on the bed sheets using Paynes grey, ultramarine and white.

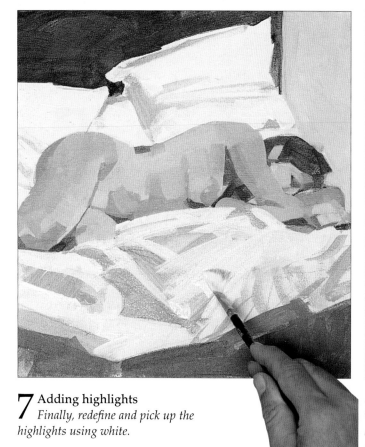

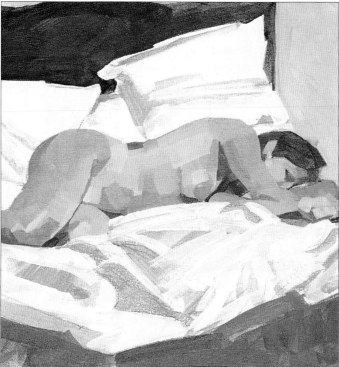

7 **Adding highlights**
Finally, redefine and pick up the highlights using white.

8 **Final painting**
The painting is quickly and convincingly established using a few simple mixes. At this point you can either leave it as a sketch, or work over it and bring it to a finer finish.

Using Glazes

THE TRANSLUCENT NATURE of watercolour makes it an ideal medium for capturing the delicate features and subtle colour of a child's skin. The gentle nature of the watercolour medium also adds considerably to the charm of the subject, but care needs to be taken with the washes.

Working from light to dark allows you to take a more cautious approach, which should prevent colours being painted which later prove to be too dark, or even in the wrong place. Watercolour paints, once they have dried, cannot always be easily removed by re-wetting. However, adding a few drops of gum arabic into your paint mixtures ensures that the paint can be removed. The gum also adds impact to the colour, which can look duller when dry than it did when wet. This makes it especially useful for lifting out sharp highlights, as in this example, when you are painting the young girl's eyes. This technique is also useful when painting highlights on hair, or when trying to capture a light pattern on a dark surface.

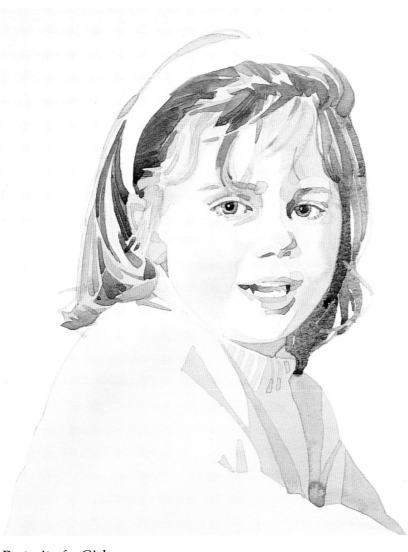

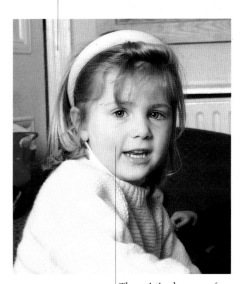

A cluttered background, which could distract from the immediacy of the portrait, can always be eliminated or omitted

The subtle changes of hues in skin are ideally suited to the delicacy of watercolour washes

Portrait of a Girl
Painting children demands a delicate approach, with subtle colour and tonal transitions, both of which can be achieved using watercolour. Children find it difficult to sit still for long, so, unless you are making a sketch, you may find it easier to work using a photograph as reference.

Figure

MATERIALS

- Not surface watercolour paper
- 4B pencil
- No 4 round sable brush
- Gum arabic
- Water
- Watercolour paints: yellow ochre, cadmium lemon, Naples yellow, cadmium red, burnt umber, Paynes grey, ultramarine blue, raw umber
- Paper towel

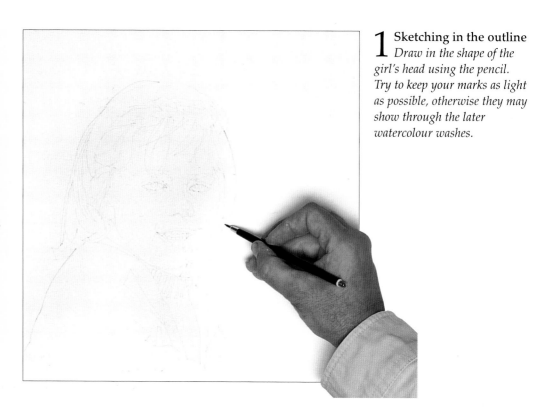

1 Sketching in the outline
Draw in the shape of the girl's head using the pencil. Try to keep your marks as light as possible, otherwise they may show through the later watercolour washes.

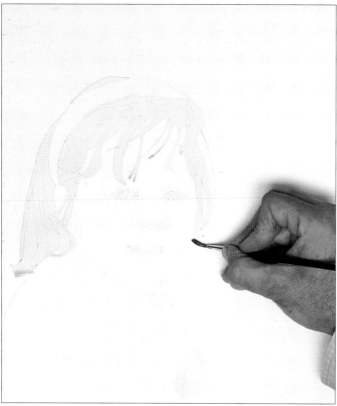

2 Painting the hair
Mix yellow ochre and a little cadmium lemon to make a suitable light tone for the hair. Use the brush to paint in this wash. Do not add any gum arabic to the initial washes, as subsequent ones might disturb those lying beneath.

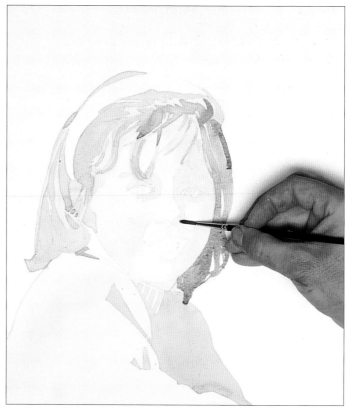

3 Painting the face
Mix Naples yellow with a little cadmium red to make light washes for the face. Darken the hair using burnt umber and yellow ochre, and paint the sweater with a mixture of cadmium lemon and yellow ochre.

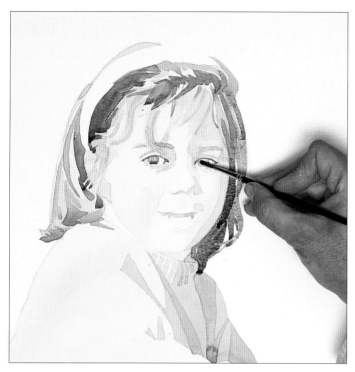

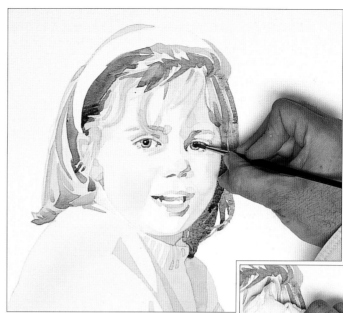

4 Building up the details
Add a little gum arabic to the increasingly darker mixes that develop the colours and tones on the figure. Paint in the detail around the eyes, and mix Paynes grey and ultramarine together for the iris.

5 Adding highlights to the eyes
Once the iris is dry, paint the dark part of the eye with a mixture of raw umber and a little gum. When this is dry, touch in the dark of the eye with a little water to loosen the paint. **Inset:** *Use paper towel to blot off the dissolved paint, leaving a highlight in the eye. Lighten each iris in the same way.*

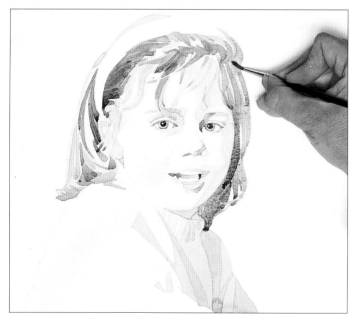

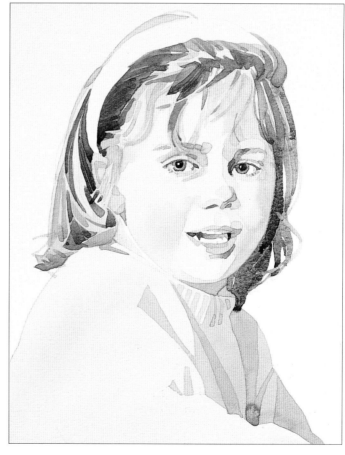

6 Adding shadows
Work darker washes into the shadows and the hair. If you think any areas are too dark, lighten them using the same blottting-off technique described in step 5.

7 Final painting
The combination of the crisp, wet-on-dry and softer, wet-on-wet washes works very well. Adding gum increases the intensity and translucency of the colours and lets them be manipulated by re-wetting.

Still Life

Using Frottage

THERE ARE SEVERAL drawing techniques, which although not used extensively, can be applied on occasion to great effect. One such technique is frottage, which is derived from a French verb meaning 'to rub', and resembles brass rubbing. Frottage works best when it is introduced subtly so that it blends into, and looks a part of, the actual drawing, rather than a glaring addition to it.

The technique is simple: the textured surface from which the image is to be taken is placed beneath the thin paper, and a soft, dry material like charcoal, graphite or pastel is rubbed over the paper. The drawing material picks up on the textured surface underneath, and shows up as a dark impression. It is worth while having a few trial runs on various weights or thicknesses of paper before beginning the drawing.

There are many surfaces from which you can take impressions, including brick and stone, wood, corrugated card, textured wall coverings and leaves.

Materials such as wood, which have a physical as well as visual texture to their surface, are ideal subjects for frottage

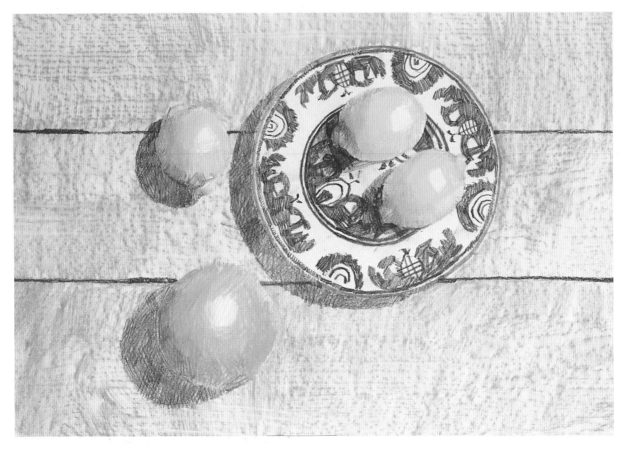

Fruit on a Table
The overhead viewpoint here allows the patterned and distressed wooden table top, which is replicated perfectly using the frottage technique, to become an important element within the relatively simple overall composition.

MATERIALS

- Thin cartridge paper
- Pastel pencils: lemon yellow, cadmium yellow, burnt sienna, light and dark orange, cobalt blue, terracotta, dark grey, yellow ochre, black
- Plank of rough wood
- Fixative

1 Sketching in the outline
Using a range of pastel pencils sympathetic to the colours of the objects being drawn, sketch in the composition on the cartridge paper. At this stage, disregard the pattern of the wood on the surface of the table.

2 Drawing in the lemons
Using a combination of lemon yellow, cadmium yellow and a darker burnt sienna, establish the colour of the lemons. Apply a combination of hatched and cross-hatched strokes.

3 Drawing in the orange
Establish the colour of the orange using light and dark orange pencils. Keep the pencil work open and loose, and vary the direction of your strokes.

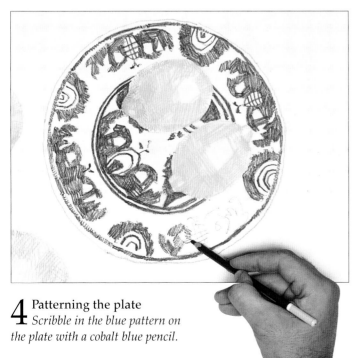

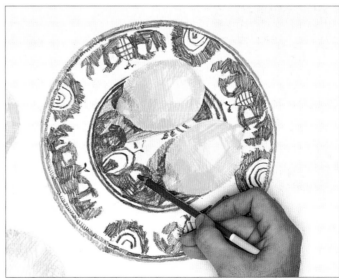

4 Patterning the plate
Scribble in the blue pattern on the plate with a cobalt blue pencil.

5 Adding the darker tones
Draw in the edge of the plate with a terracotta pencil. Then use a dark grey pencil to indicate the shadow thrown onto the surface of the plate by the lemons.

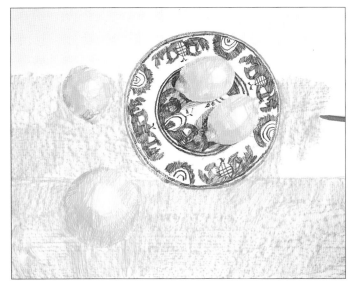

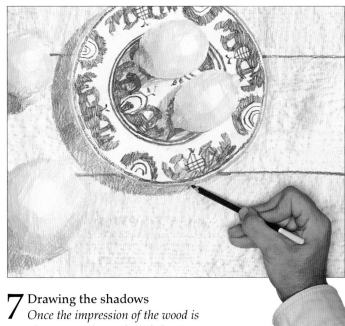

6 Drawing the background

Slide a plank of wood between the paper and the drawing board. Scribble onto the paper over the wooden plank with a yellow ochre pencil. Once one strip of wood has been coloured in, reposition the plank and fill in the next one. Repeat the process until the whole of the paper surface is covered.

7 Drawing the shadows

Once the impression of the wood is complete, spray the work with fixative to avoid losing the effect by possible smudging, then use a black pencil to draw in the gaps between the wood and the shadows on its surface. Note how the shadows include a little reflected colour from the objects.

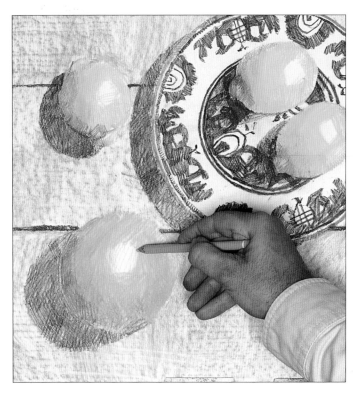

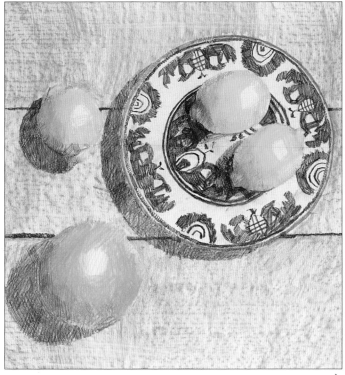

8 Deepening the colours

Add more colour to the various pieces of fruit, to give them greater form and make them appear much more solid.

9 Final drawing

The table top works convincingly without overpowering the rest of the drawing. It would have been difficult to recreate it effectively by drawing, and it would also have taken far longer.

Mixing Media

MATERIALS CAN BE extremely effective when combined, and few go together as well as charcoal and chalk. Coupled with a mid-grey paper, works of remarkable subtlety and realism can be achieved. This is far easier than trying to judge the depth of a tone against white, and is a technique which can be practised in all mediums except watercolour.

The tones are applied using different marks, including scribbling and hatching, together with the firm precise marks made by using a stick of chalk on its side. Drawings made using this technique can look surprisingly life-like. The actual amount of detail included is relatively small, with what little there is being made with sharpened black and white pastels.

The dark shadow inside the jacket contrasts with the light canvas bag

The strong shadows connect the subject to the ground plane and add perspective and depth

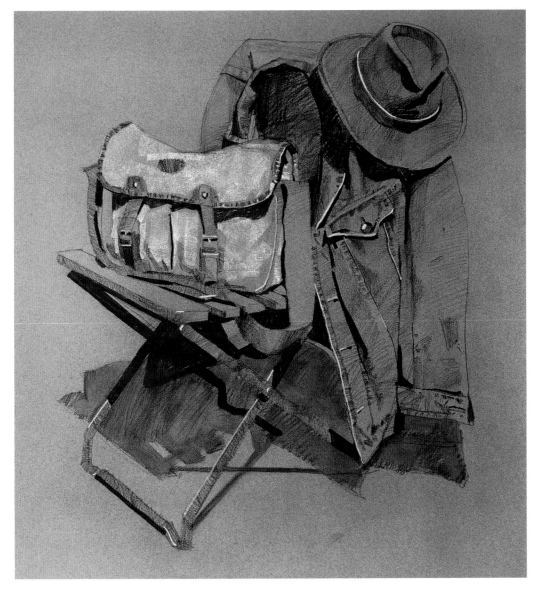

Arrangement with Hat, Coat and Bag

Any combination of clothing – hats, bags or shoes arranged carefully on a hook or chair, or even thrown casually on the floor – offers a readily available and interesting still-life subject. The fall of light on the folds and creases, the pattern and texture of different fabrics, and the variety of shapes – all these offer the artist an enthralling challenge.

Still Life

MATERIALS

- Mid-grey paper
- Medium charcoal stick
- Pastel pencils: black and white, white chalk
- Putty eraser
- Fixative

1 Drawing the outlines
Position and sketch in the outlines loosely, using light charcoal marks. This drawing can be corrected later using the flick of a cloth or a stiff brush.

2 Discovering the shadows
Search out and scribble in the darkest shadows using a medium-sized stick of charcoal. Follow the shape of these shadows carefully as they curve in and out of the folds of the hat, coat and bag.

3 Sketching the mid-tones
Scribble in the mid-tones using the charcoal stick and black pastel pencil.
Inset: *Pay particular attention to the washed-out effect on the seams of the denim jacket; lighten these tones using a putty eraser.*

4 Adding detail to the major objects
Using the pastel pencil and the same technique, work up the detail on the hat and bag. Scribble in the tones lightly at first, then gradually apply more pressure to darken them. Always angle the scribbled marks to match the direction of the cloth.

5 Adding further detail
Concentrate on the wooden chair and metal legs, and work up the tones on both. Make sure you are satisfied with the work so far, and then apply a spray of fixative.

6 Adding more shadows
Using the stick of charcoal, scribble in the shadows cast on the ground beneath the chair. These are not as dark as the shadows on the clothes and bag, so keep the marks much lighter. **Inset:** *To soften the tone, rub the charcoal with the end of your finger.*

7 Adding highlights
Using white pastel pencil, draw in the fine highlights on the hat band, the jacket buttons, the seams, the detailing on the bag and the legs of the chair.

8 Adding lighter tones
Block in the lightest tones on the canvas bag with side strokes using a square stick of white chalk. Make these marks using light pressure so that the chalk is only glazed onto the paper surface. Make sure that the marks follow the folds of the bag.

9 Final drawing
Once the drawing is complete, apply a coat of fixative to prevent smudging. This technique is a relatively quick way to produce drawings which are surprisingly lifelike. Do not, however, overwork the piece – keep the marks open and loose, and allow the support to show through and work for you.

Combining Line and Tone

WHEN USED with a dip pen and nib, ink is strictly a linear medium; any dense tonal or coloured areas are shown by building up a web of dots, dashes or lines. When ink is diluted with water and used with a brush, it is possible to cover are as with washes of tone and colour.

Both waterproof and water-soluble inks are available, and using a combination of these for pen and brushwork enables you to achieve more interesting effects. The line work can be done first, with the colour, or tonal, brush-work coming later. However, there can be a tendency to simply work between the lines. A freer way of working is to apply the washes of colour or tone first. Once these are dry, the pen is then used to search for the outline and any linear details.

The lemon's flesh offers a range of tones, perfect for a light wash

The langoustines have very solid outlines that can be picked out with careful lines or dashes of ink

Still Life with Langoustines and Lemons

The graphic precision of the line produced by a medium-nibbed pen is ideal for rendering the sharp, spiky shells of a langoustine. It is a wonderful subject to draw, as its shape is made up of a pleasing combination of flowing curves and sharp angles. The langoustines and lemons are contained and held together by the blue band of the plate.

MATERIALS

- Hot-pressed watercolour paper
- 6B pencil
- Dip pen with medium nib
- No 6 sable watercolour brush
- Inks: sepia, cadmium yellow, crimson red, cobalt blue
- Water
- Paper towel

1 **Making the initial marks**
Make a pencil drawing which will act as a guide for future work. The coloured washes will cover this drawing, making it impossible to erase, so keep them as light as possible; indicate only the position and major shapes of the objects.

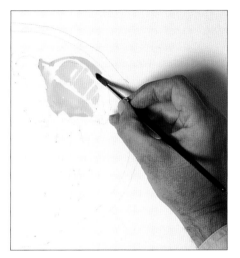

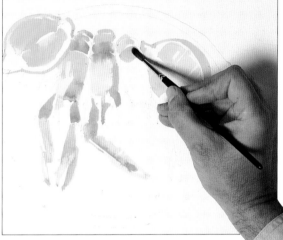

3 **Adding legs and claws**
Mix together a little yellow and crimson ink diluted with water; this will give you a pink-orange mix for the legs and claws of the langoustines. Work around any light or highlighted areas, allowing these to show through as white paper.

2 **Painting the lemons**
Using the No 6 brush, paint in the lemons. Dilute the ink with water for the centre of the fruit; use the ink at full strength when painting the peel.

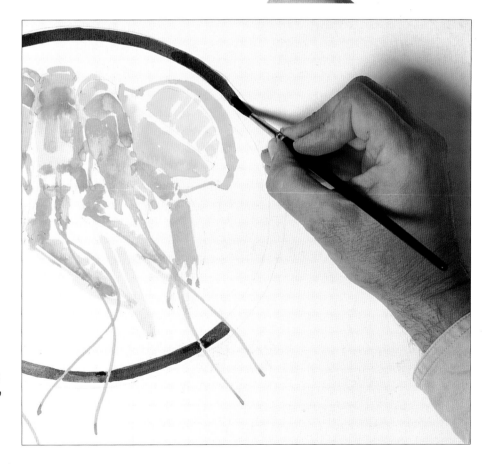

4 **Adding the feelers**
With fluid strokes brush in the antennae or feelers, allow to dry, then paint in the blue line around the edge of the plate.

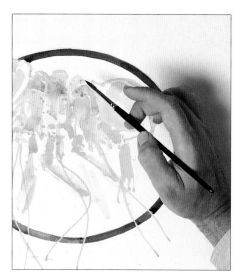

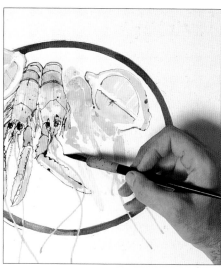

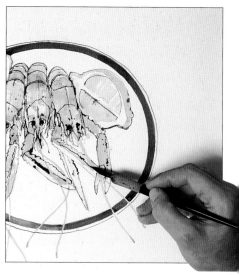

5 Adding texture and pattern
Once the blue ink is dry, add texture and pattern to the langoustines by spattering the relevant areas with the orange mix. Load the brush, hold it over the area to be spattered and then tap it sharply to dislodge drops of ink. Blot up any unwanted droplets with a paper towel.

6 Beginning the line work
Using the sepia ink diluted with a little water, redefine the shape and textures of the lemons as soon as the wash work is dry. Use full-strength ink to draw the edge of the plate and work over the langoustines, containing and defining their shapes.

7 Defining the langoustines
Complete the outer edge of the plate, and work on the langoustines in a fluid and loose manner. Capture the smooth and jagged surfaces and lines by turning the nib and applying varying pressure to release more ink and alter the thickness of the lines.

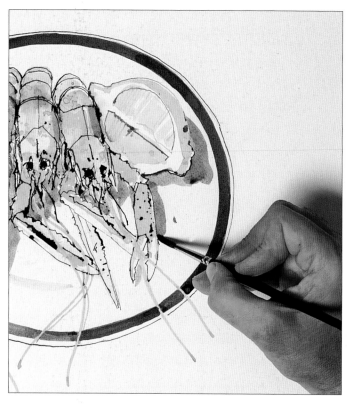

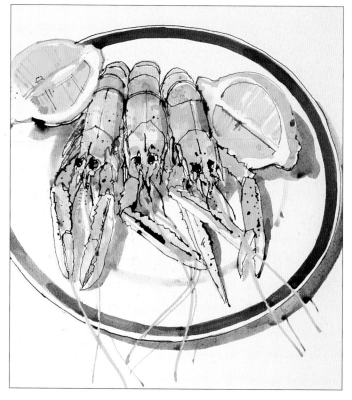

8 Painting in the shadows
Once the line work has been completed, paint in the shadow areas with a mixture of cobalt blue and sepia thinned with water.

9 Final drawing
Complete the drawing by adding a dark shadow beneath the plate. This helps to create the illusion of lifting the plate from the paper.

Colour and Tone

ASSESSING COLOUR and tone together can sometimes be problematic and confusing. Concentrating on tone without becoming absorbed in colour can simplify the work, and gives an underlying unity or harmony to the image. It is also useful in that it helps you to ignore the often intimidating white colour of the background material.

A grey underpainting was traditionally used as a starting point when painting in oils. However, as long as it is in monochrome, an underpainting can be made using any dark colour, such as raw umber or terre verte. The choice should be dictated by, and sympathetic to, the subject.

When using acrylic, build up the underpainting using transparent washes, as with watercolour, working in a sequence which moves from light to dark. The thin paint will not have any effect on the subsequent application of colour, but it adds depth which is difficult to achieve when using the paint in other ways. Use acrylic matt medium to thin the paint and impart a slight surface sheen to the finished work.

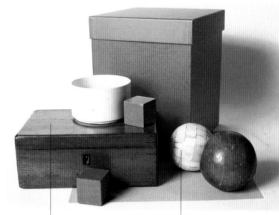

Soft, diffused side-light gives form to the elements within the composition

The simple shapes of the objects make this still life an exercise in basic geometry

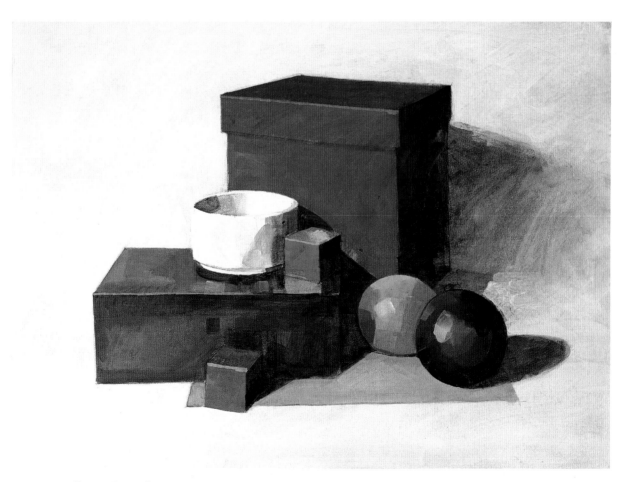

Boxes, Balls and Bricks
Still life is the perfect subject for learning about painting tone, as not only can the colour of the objects be controlled, but also the direction of the light source and the relative strength of the light cast on the objects.

Still Life

MATERIALS

- Canvas board
- 6B pencil
- Water
- No 4 and No 10 flat bristle brushes
- Acrylic matt medium
- Acrylic paints: Paynes grey, cadmium red, raw umber, viridian, yellow ochre, cadmium yellow, ultramarine, titanium white

1 Drawing the shapes
Using the pencil, draw in the objects. Pay attention to the perspective, and note how, due to their orientation, each of the objects have different vanishing points.

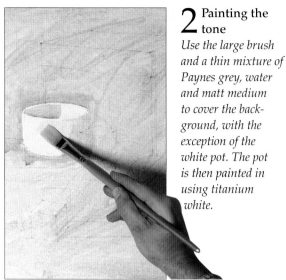

2 Painting the tone
Use the large brush and a thin mixture of Paynes grey, water and matt medium to cover the background, with the exception of the white pot. The pot is then painted in using titanium white.

3 Blocking in the mid-tones
Use the large brush to add a light mid-tone of Paynes grey, and to establish the position of the objects. The first, lighter tone shows through on the pot, brick and lightly coloured ball.

4 Darkening the tone
Add more Paynes grey to the mix used in step 2 and, with the smaller flat brush, paint in the top and side of the red box, the front and side of the wooden box, the shadows and the wooden ball.

5 Painting in the shadows
Darken the mix with more Paynes grey, and once more repaint the side of the red box, the shadows cast by the bricks, and the wooden ball.

6 Starting the colours

Working with the smaller brush, cover the red box with a moderately thin coat of cadmium red; brush this out over the shadow area, which receives a little red in reflected colour. Give the wooden box and dark wooden ball a coat of raw umber mixed with a little cadmium red. Paint a little of this red-brown mix onto the side of the white pot and the top of the green brick.

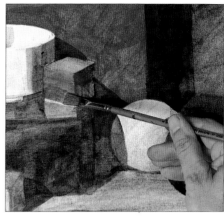

7 Adding the green

The green for the brick is made with viridian, cadmium yellow and a little white.

8 Adding the blue

Paint the blue brick using ultramarine taken straight from the tube.

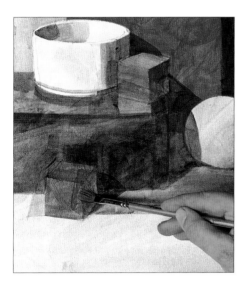

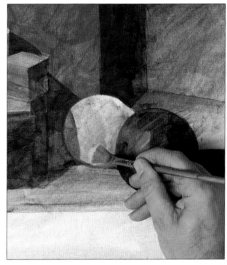

9 Painting the light ball

Establish the colour of the lighter ball using a mixture of yellow ochre and a little raw umber.

10 Adding the paper

Make a neutral grey-brown using raw umber, Paynes grey and white, and use this to paint in the sheet of grey paper on which the objects are arranged. Use a little of this colour on the side of the pot. Add yellow ochre and a little cadmium red to warm the colour, and use this mix to block in the light reflection on the top of the box.

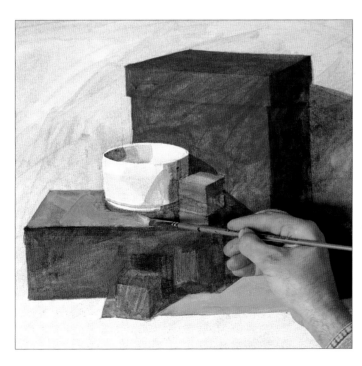

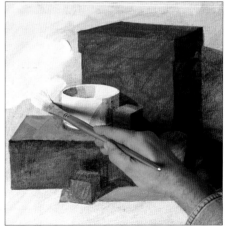

11 Painting the background

Squeeze a little titanium white out onto the support and use the large brush to block in the light background.

Still Life

ASSESSMENT

Smooth surfaces
Now the tone is established the colours can be intensified and the surfaces smoothed

Increase highlights
Once the background is lightened the objects will stand out more. White needs to be added to the highlights on the objects to suggest the soft side light

Note how the uneven layers of paint and the noticeable brush strokes add interest and texture to the shapes.

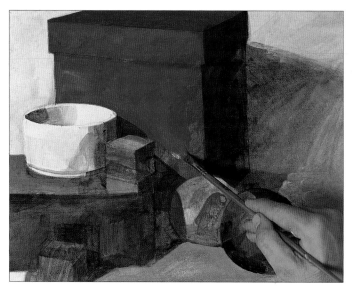

12 Strengthening the red box
Paint the front of the red box with a mix of cadmium red and titanium white, taking care not to make the red into pink by adding too much white. Leave the underpainting where the box lid casts its shadow.

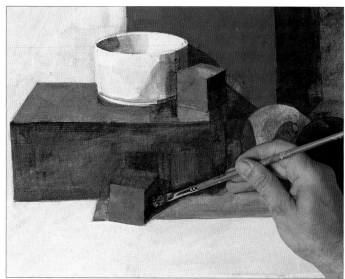

13 Lightening the bricks
Turning your attention to the small coloured bricks, lighten the front of each one by mixing a little white into the mixes previously used to establish them. Darken the side of each brick with Paynes grey.

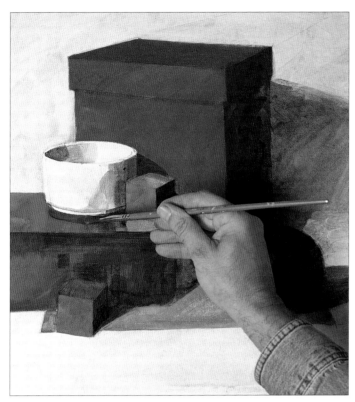

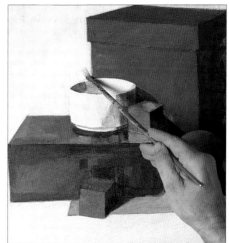

15 Finishing the background
Apply a coat of white acrylic paint which, as it is semi-transparent, consolidates the white colour that is already present in the painting.

14 Adding the browns
Mix a warm brown from cadmium red, raw umber and yellow ochre with a little white added. Paint in the reflections on the shiny surface of the box. Use a dark brown made with raw umber, a little cadmium red and a little Paynes grey for the shadows beneath the pots and the darkest ball.

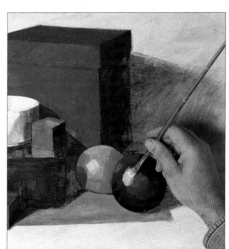

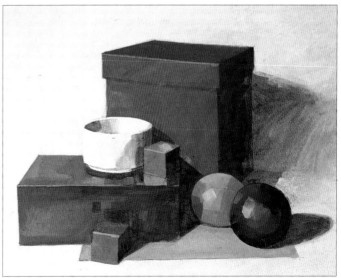

16 High-lighting the balls
Rework the lightest ball with light brown made from yellow ochre, raw umber, cadmium red and white. Add highlights to each ball with white mixed with this light brown.

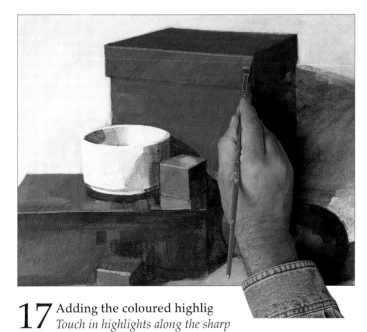

17 Adding the coloured highlig
Touch in highlights along the sharp front edges of each of the objects with small strokes from the small brush. Make the colour for the highlights by mixing the base colour of the individual objects with a little white.

18 Final painting
The painting in of the highlights on the sharp edges completes the work and helps suggest the illusion of three dimensions and the change of surface direction.

Linking Subject and Material

WHENEVER POSSIBLE, try to match the subject of a work to the materials, such as the drawing tools and type of paper, which you intend to use. The bright colour of the toys, coupled with the furry and reflective surfaces, calls for an equally bright choice of materials.

Pastels are an excellent choice since, with minimum mixing and blending, the colours retain their purity and intensity. The pastel board echoes the predominant colour of the bear, yet does not compete with the colours present in other objects, such as the train. The light tone of the board makes it easy to paint in the background colour while providing overall harmony.

Placing the teddy close to the centre of this arrangement gives it a classic pyramidical composition

The bright colours of the painted wooden train are a strong contrast to the subtle colouring of the teddy

Still Life with Children's Toys
Brightly coloured toys make excellent subjects for still-life drawing. Try several variations and arrangements before you start work. When choosing a range of objects for your composition, ensure that they vary in size, shape and colour.

MATERIALS

- Light ochre pastel board
- Pastel pencils: white, ochre, black, pink
- Pastels: burnt umber, raw sienna, yellow ochre, cadmium yellow, viridian green, cadmium red light, cadmium red deep, alizarin crimson, cadmium orange, cobalt blue, ultramarine, dark prussian green, white, dark olive green, Naples yellow, light olive green
- Paper towel
- Soft cloth
- Fixative

1 Establishing the composition
Sketch in the main elements using the black pastel pencil. Resist any temptation to make the drawing too dark; if it does seem overly dense, lighten it by dusting over the pastel board with a soft cloth.

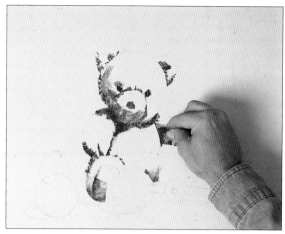

2 Blocking in the shaded areas
Use a dark burnt umber pastel to block in the shaded areas on the teddy bear, making precise strokes with the side or end of the pastel.

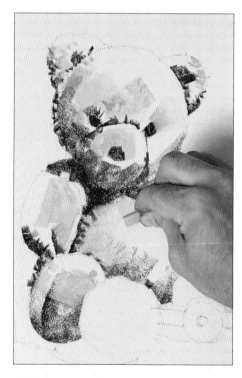

4 Drawing the tennis balls
Following the shape of the seams on the tennis balls, block them in using a cadmium yellow pastel. The shadows consist of reflected colour from the dark green cloth mixing with the bright yellow of the balls; use a viridian green pastel for them.

5 Colouring the train
Establish the overall colour of the train using cadmium red light. Use a darker shade to pick out the deeper tones, with alizarin crimson for the darkest.

3 Sketching the mid-tones
Use a raw sienna pastel for the mid-tones, then a yellow ochre pastel. Keep the strokes firm and precise, following the direction of the fur.

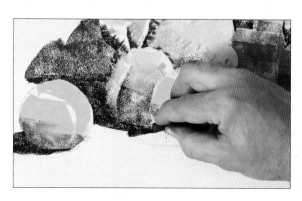

6 Adding more colours
Use a light cadmium orange for the wheels of the train, cobalt blue for the funnel, and yellow ochre for the pot. Pick out the shadow cast by the teddy on the white wall with ultramarine, and the shadow beneath the balls, the train and the teddy with a dark prussian green.

FIRST ASSESSMENT

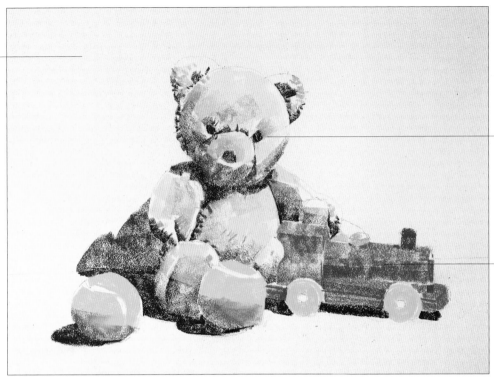

Background colour
Note how the colour of the background is used to represent the overall colour of the teddy bear

Pastel marks
Firm, precise marks are made using varying pressure to change the colour density

Building up
Dense, flat colour can be built up in a series of glazes rather than in one thick, heavy application

You can now apply a spray of fixative if all seems correct.
This allows you to continue developing the drawing without altering the initial pastel work.

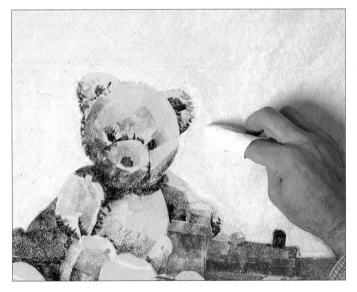

7 Creating the background
Using the side of a white pastel and firm strokes, block in the white background. Work around the bear, keeping a ragged edge to represent the tufted fur. Use dark olive green for the cloth. Blend both areas by using paper towel wrapped around a finger.

8 Adding detail to the teddy
Using a combination of yellow ochre pastel and pencil, introduce a little detail to the fur. This helps give character and distinguishes its surface from the smoother surfaces of the yellow tennis balls and red train.

SECOND ASSESSMENT

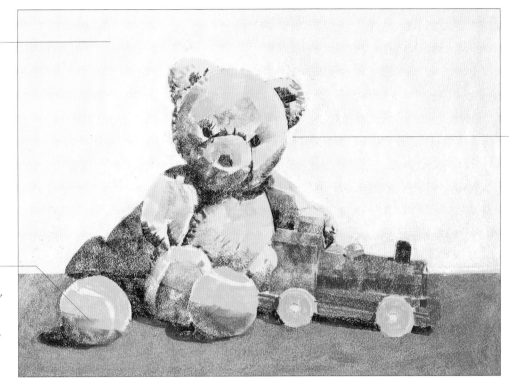

Adding depth
Adding white to the background has the major effect of pushing the bear out from it and closer to the viewer

Blending
Do not overdo finger blending, as the colours tend to become flat and muddy

Redefining shape
When blocking in the background, use the white pastel pencil to redefine the outside edge of the teddy

Once the background is established, the objects seem more solid and appear to sit firmly on the green cloth, rather than floating in a sea of ochre.

9 Adding detail to the balls and train
Use the yellow ochre pastel pencil for the seams on the tennis balls. Glaze over the green shadows with Naples yellow, then draw in the highlights on the red train with a pink pastel pencil.

10 Introducing highlights
Glaze a light olive green over the cloth and smooth it out using a finger. Add pure white highlights using hard, direct strokes with the sharp edge of a white pastel. Add these touches to the face of the bear, the train and the seams of the tennis balls.

11 Final drawing
The highlights bring the whole drawing to life. Fixing, whilst essential to protect the delicate surface of the work from smudging, can make lighter colours look dull. To keep the highlights bright, fix the work before applying them.

Wet on Dry

MUCH OF THE CHARM and enjoyment of using watercolour lies in its unpredictability. This is especially true when very loose wet-into-wet washes are made, and stems in part from the paint continuing to move and mix on the support until it is completely dry.

Watercolour paint can also be controlled by working in layered washes wet on dry, where each wash is allowed to dry before the next one is applied. Light washes are painted first, with each subsequent wash becoming darker. Works made using this technique are crisp and have a sharp focus. To avoid the results looking hard and clinical, mix tones and colours carefully, separating the work into carefully considered light medium and dark tones; soften any edges which look too hard by rewetting and allowing the paint to subtly blend one colour into the next. This technique is perfectly suited to painting flowers, especially those flowers which have strong colours and precise, intricate shapes, such as anemones or tulips.

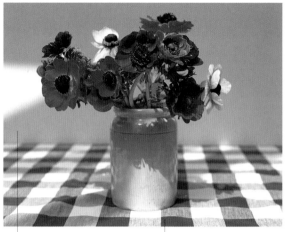

The background colour has been carefully chosen to harmonize with both the red and blue flowers

The simple perspective on the pattern of the tablecloth gives immediate depth to this uncomplicated arrangement

Still Life with Anemones
Anemones are an excellent still-life subject as they are very colourful and offer the artist a precise, and challenging, shape to paint. Using a wet on dry technique ensures that the distinctive shape and colour of each flower remains separate.

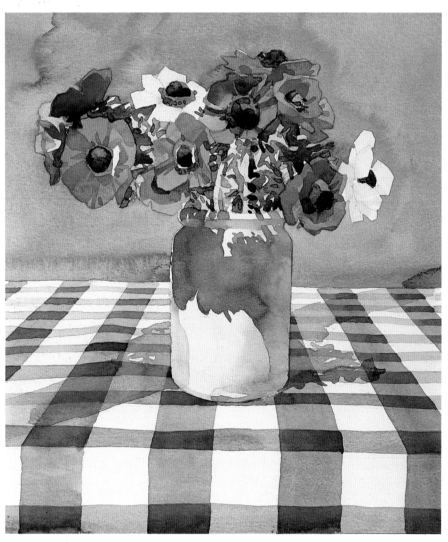

MATERIALS

- Stretched NOT watercolour paper
- 6B pencil
- No 6 round sable watercolour brush
- Watercolour paints: Paynes grey, yellow ochre, sap green, alizarin crimson, cadmium red, Winsor violet, monestial (phthalo) blue, burnt umber
- Hair dryer
- Water

1 Finding the shapes
Make a precise drawing, not only to indicate the position and shape of the flowers and pot, but also to show the shadows and detail on the petals.

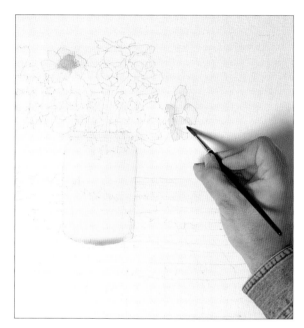

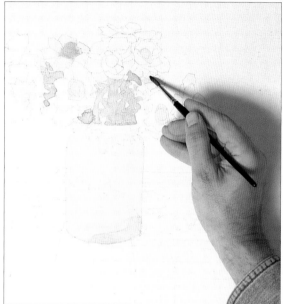

3 Painting the petals and stems
Establish the petals and stems using a pale green made by mixing together sap green and yellow ochre with plenty of water. Allow this to dry; you can speed up the drying process with a hair dryer.

2 Making the first brushstrokes
Mix Paynes grey and yellow ochre for the petals of the palest anemone, then paint a thin dilution of Paynes grey into the centre of the flower. Use a mix of yellow ochre and water for the pot, and block in the pink on the right with a mix of alizarin crimson and the grey and yellow wash used on the first flower.

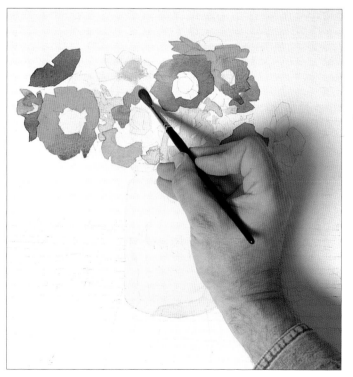

4 Finding the base colours
Next, paint the light base colours of the petals: cadmium red and alizarin crimson for the red flowers; monestial blue and alizarin crimson for the blue; and alizarin crimson with a little Winsor violet for the pink.

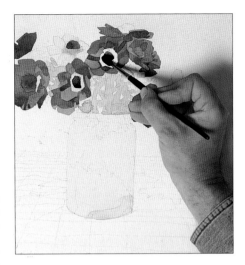

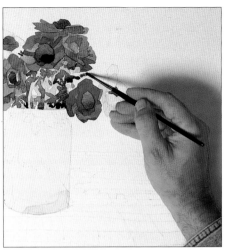

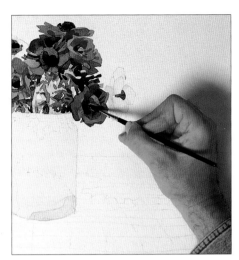

5 Intensifying the mixes
Allow the flowers to dry before working over them with a mid-tone. In each case the mixes are intensified by adding more of the same colours plus a little Paynes grey. Once this work is dry, add the dark centres of the flowers using neat Paynes grey.

6 Adding darker green
The mixture for the darker green foliage is made from sap green, Paynes grey and yellow ochre.

7 Painting the flower centres
Use the mixes for step 5 with a little added Paynes grey for the darkest flower tones. Use careful, precise brushwork to paint the shadows. Darken the flower centres with an intense mixture of Paynes grey with a little burnt umber.

ASSESSMENT

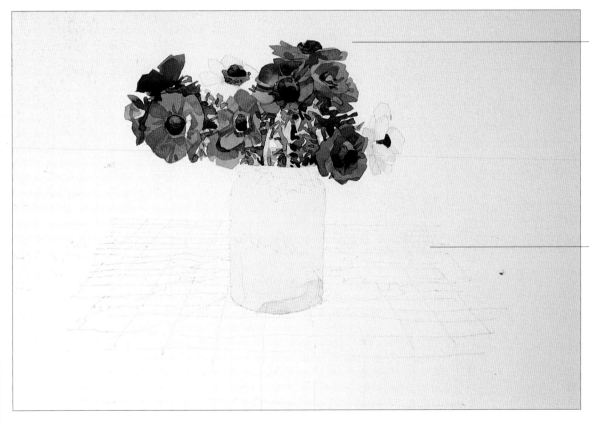

Adding background
The colour intensity of the flowers will increase dramatically once the darker background has been added

Unfinished edges
The tablecloth and blue background have been left unfinished to heighten the sense of perspective

The flowers have almost been completed with only three tones being used, yet already look convincingly three dimensional.

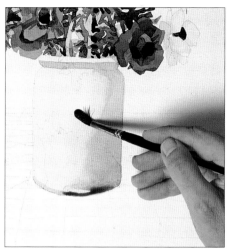

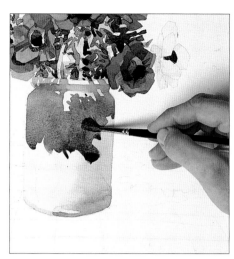

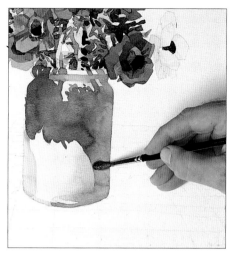

8 Starting the jar
Wash a mixture of yellow ochre, burnt umber and Paynes grey beneath the rim of the pot and on the side away from the light, allowing it to puddle around the pot base. To soften the transition from light to dark, scrub a little water into the centre of the pot.

9 Painting the shadows
Dry the painting thoroughly with the hair dryer and, using a dark mixture of burnt umber, yellow ochre and a little Paynes grey, paint in the dark shadow cast onto the pot by the anemones.

10 Lessening the intensity
Whilst the wash is still damp, wet the brush and run in a little water onto the right side of the pot away from the light source. This has the effect of lessening the intensity of the shadow. Allow to dry.

11 Adding the tablecloth pattern
Use a medium-intensity mix of Paynes grey, burnt umber and water to paint in the pattern on the check tablecloth. Paint in the horizontal lines first, allow them to dry, and then paint in the lines which run from front to back.

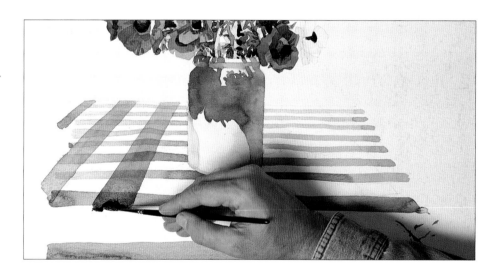

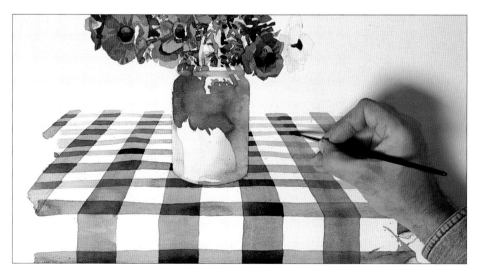

12 Darkening the checks
Once the patterns are dry, darken the darkest squares still more by painting them with Paynes grey mixed with a little more burnt umber to make a black.

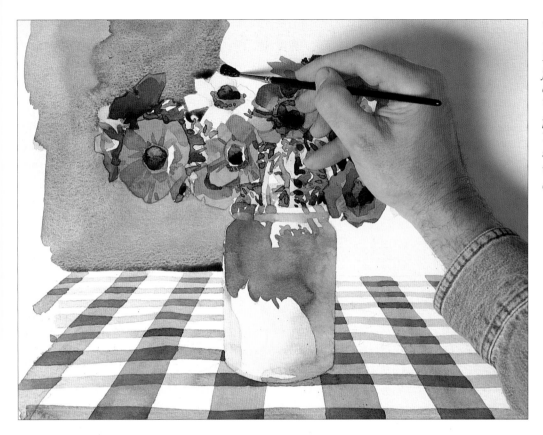

13 **Adding the background**
Paint the background to the flowers using an intense mix of Paynes grey and water. Work carefully to cut out the precise shape of the flowers. The colour of the flowers seems immediately brighter when viewed against the dark background.

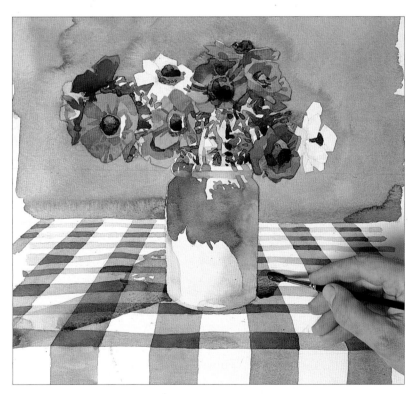

14 **Painting the shadows on the tablecloth**
Complete the work by painting in the shadow cast onto the check tablecloth by the flowers and pot.

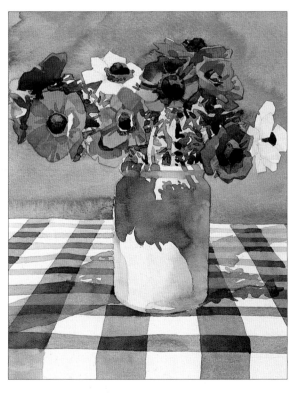

15 **Final painting**
The material used matches the subject and recreates the colour and sparkle seen in the original set up.

Dramatic Monochrome

TREES IN WINTER are a marvellous subject for the artist as, devoid of foliage, the skeletal network of branches revealed by falling leaves provides added interest. At first glance, however, the subject is complex: how can you represent the chaotic jumble of shapes convincingly?

The technique used in this project allows the true character of the subject to show through. In the first place, working on a toned support, in this instance a dark grey pastel board, gives the work a feeling of solidity – one that might be more difficult to achieve if the drawing had been made on white paper. Second, the tree itself is treated more as a portrait than as being just another, not very interesting, tree within a landscape; and third, making the decision to place it centrally in the picture area increases its importance to the viewer.

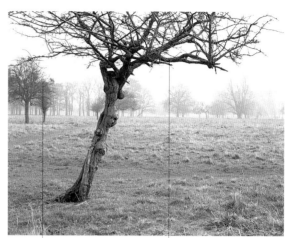

The wintry atmosphere softens the trees in the background, giving depth to the image

Seen in near-silhouette against the sky, the bare branches of the tree are a tangled linear pattern

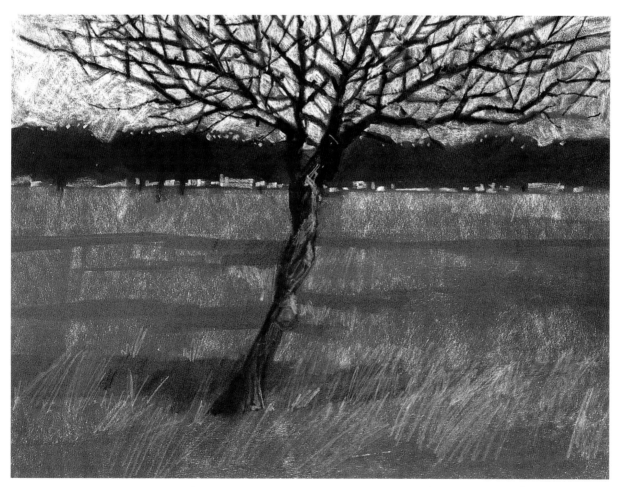

Landscape with Winter Trees

Winter is the best time to learn how deciduous trees are constructed. Each tree is different, and many often just look like a knotted mass of branches. But beneath the apparent jumble of criss-crossing branches, and gnarled bark, there is a solid design which is best shown by stripping the trees back to their bare essentials and focusing on these.

MATERIALS

- Dark grey pastel board
- Thin and thick charcoal sticks
- White chalk
- White pastel pencil
- Fixative

1 Positioning the tree
Use the thin stick of charcoal to draw the tree centrally on the pastel board. The network of branches should fill the upper part of the drawing. At this stage, only indicate the main branches and the darker parts of the main trunk.

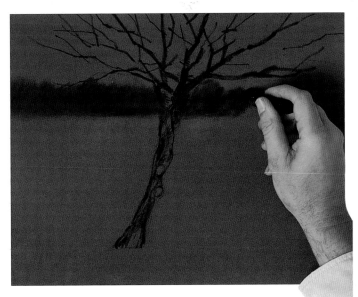

2 Adding dark tone
With the thick stick of charcoal, scribble in a simple band of dark tone to represent the line of trees on the horizon. Once this is in place, use the side of a finger to blend and soften it, then apply a light coat of fixative.

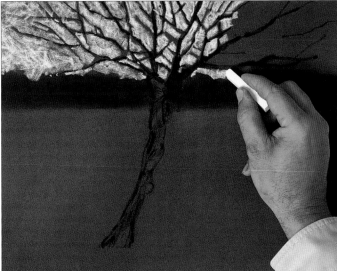

3 Adding light tone
Scribble in the light tone of the sky with the stick of white chalk. Work by cutting in and around the branches, and searching out the spaces between them; also cut out branch shapes by allowing the dark grey pastel board to show through in places.

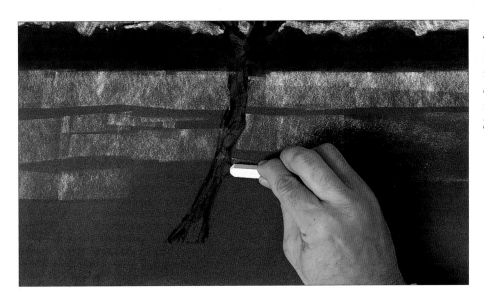

4 Glazing in the grass
With the same stick of white chalk turned on its side, glaze in the tone which represents the grass. Once again, leave areas of the grey pastel board showing, to represent the pathways which cross the park. Apply another spray of fixative.

5 Adding texture

Use the thin stick of charcoal to extend further the network of branches. Work up some of the textures and marks seen on the rough trunk of the tree. Add further texture by using linear marks on the grass around the base of the tree.

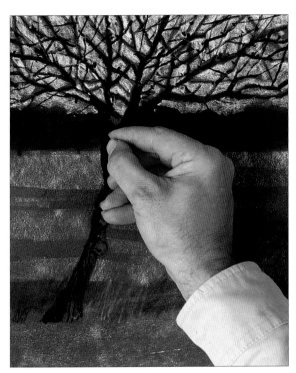

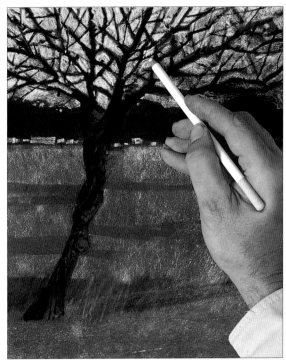

6 Sharpening the focus

Lighten the tone of the sky further with the white chalk. Keep the work open, and do not try to cover every part of the pastel board which may show through. Work between the branches with the white pastel pencil to bring them into sharper focus.

7 Sharpening the horizon

With the white chalk sharpen the detail of the light coming through the trees on the horizon. Draw in the light catching the textured bark.

8 Final drawing

The simple marks result in a stark quality which suits the subject perfectly, while the choice of chalk and charcoal gives an almost palpable feeling of cold weather.

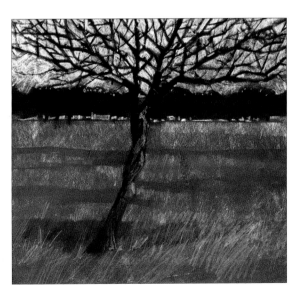

Glazing with Ink

I NK LINE coupled with ink wash is a drawing technique favoured for many years by illustrators. The wash techniques are very similar to those used in watercolour painting. Coloured inks are very translucent, mix easily with each other, and can be thinned with water; they can be waterproof or water-soluble when dry. Their one major disadvantage is that they are made from dyes rather than pigment and so will fade over a period of time when exposed to strong light – they are, however, very quick to use and are ideal for sketchbook work.

Ink colours are very strong and need to be used carefully. They are ideal for working on location; only a few colours are needed, as they mix cleanly to produce a wide range of tones. Coloured inks stain the paper easily, and working on a hot-pressed, flat, smooth paper not only helps the dip pen travel more easily across the surface, but also results in a livelier, more exciting, drawing, as ink washes on absorbent paper can lack brilliance.

The rich patterning in the brickwork is an ideal subject for tackling with glazes

The dark shapes of the yew trees give both depth and drama to this scene

Church
Architectural subjects are always challenging to draw, and none more so than old churches, which offer the artist a combination of weatherbeaten stonework and strong lines; and they may be surrounded by interestingly shaped old trees.

MATERIALS

- Hot-pressed watercolour paper
- 2B pencil
- Steel-nibbed dip pen
- Bamboo pen
- No 6 and No 12 sable brushes
- Small flat synthetic brush
- Inks: raw sienna, cobalt blue, vermilion, lemon yellow, olive green
- Plain white candle
- Water

1 **Sketching in the general outline**
Draw in the outline of the buildings with the pencil on the paper. This pencil work should be fairly simple and light, as it only acts as a guide.

2 **Drawing the church**
With the dip pen draw in the outline, roof details, windows and doorway of the church, using slightly diluted raw sienna ink.

3 **Adding darker line work**
Use undiluted ink, made from raw sienna and a little cobalt blue, to add the darker line work. As in step 2, use the dip pen, but switch to the chisel-shaped bamboo pen when you are drawing the thicker lines.

4 **Filling in detail**
Mix cobalt blue with raw sienna, then dilute to make a brown wash for the upper wall and one side of the tower. Apply using the No 6 brush. Add a little more raw sienna to the cobalt blue to make a dark grey for the window and doorway. Then add water to lighten the mix and create a blue grey for the stonework on the church and the pathway.

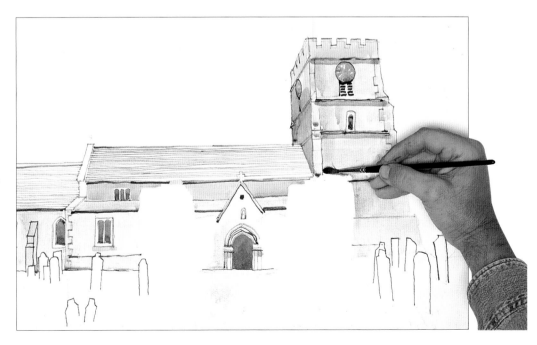

5 **Washing in the sky**
Add a little vermilion to the dark grey mixture to colour in the roof. Then, using the No 12 brush and cobalt blue diluted with water, wash in the sky, leaving patches of white paper to represent the clouds.

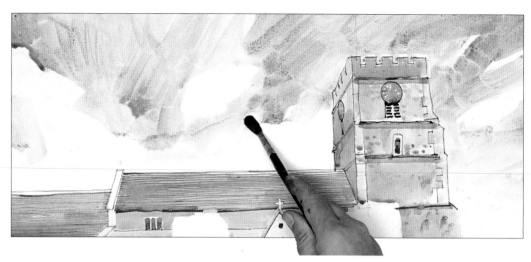

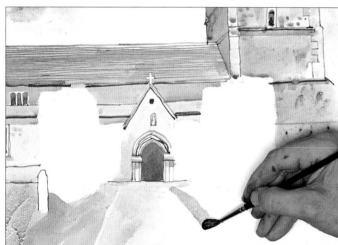

6 **Adding the grass**
Using the No 6 brush, colour in the grass with a mixture made from a little lemon yellow added to olive green ink.

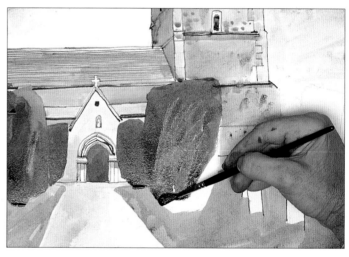

7 **Washing over the trees**
Scribble over the area occupied by the yew trees with a plain white candle which acts as a resist. Then, using the No 6 brush, apply a wash over the trees with undiluted olive green ink.

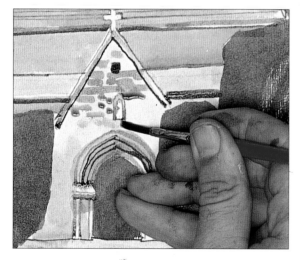

8 **Adding the brickwork**
Using the flat, synthetic brush, and a dark grey colour produced by mixing raw sienna with cobalt blue ink, make chisel-shaped marks on the walls to suggest the detail of the actual brickwork.

9 **Final drawing**
Compared with watercolour painting, the pen-and-wash drawing technique may lack subtlety, but it more than makes up for this in the surprising strength of colour and speed of execution.

Utilizing Impasto

THE SEA AND COASTLINE hold a particular fascination for the artist. The obvious grandeur and vast expanse of the sea, and the drama created by the elements, attract our interest. A small beach or harbour will have more than enough visual material to hold an artist's attention for hours, if not days. The colours are usually bright, yet weathered by the elements over a long period of time. Owing to the reflective qualities of the sea, the light, even on dull days, can be quite intense.

Pastels are a quick medium for capturing these scenes. They enable the image to be built up, as would be the case if working on an oil painting. This example focuses on boats, which are a challenge to paint as their shapes are often very subtle, with many smooth lines and curves. Start with thin glazes to establish the image before completing it with crisp, heavy impasto work to represent the pebbled beach and dappled light on the sea. Never apply thick heavy pastel early on in the process as it clogs the texture of the paper, making the application of subsequent layers difficult, if not impossible.

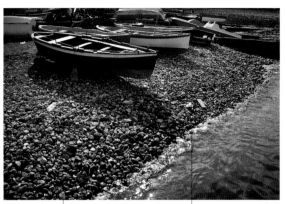

An unusual composition is enhanced by having its main subject close to the top of the image frame

A sense of dynamism is provided by the diagonal division between beach and water

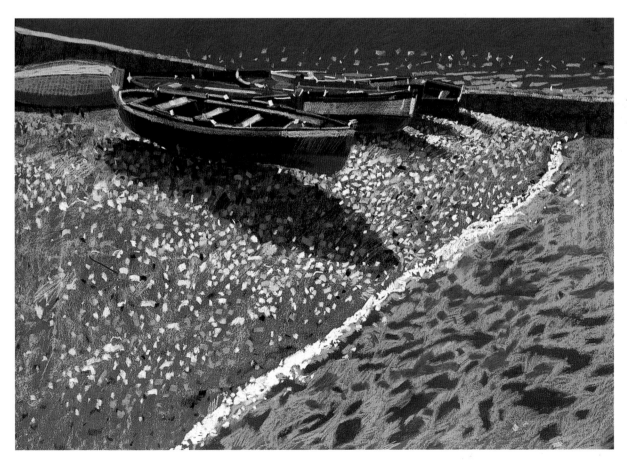

Fishing Boats on Beach
This is an unusual composition. The contrast between the pattern of the pebbles on the beach, the heavy texture of the waves and the view of the far distance at the top of the image creates a dynamism which makes this drawing quite striking.

MATERIALS

- Brown pastel paper
- Black charcoal pencil
- Pastels: black, burnt umber, range of greens, range of reds, light and dark ultramarine, light grey, white, light and dark cobalt blue, yellow ochre, Naples yellow
- Fixative

1 Sketching the outline
Use a black charcoal pencil to sketch in the main elements of the composition. Work lightly and make any corrections by drawing over your previous marks. As all the initial drawing will later be covered, there is no need for you to erase any mistakes.

2 Blocking in the shadows
Use the side of a short length of burnt umber pastel to block in the dark shadows beneath the boats, the dark areas inside the boats, the wall, and the shadows cast by the stones.
Inset: *Add density and detail into the shadowy areas with the side of a black pastel.*

3 Shading the sides of the boats
Establish the shaded sides of each boat, using a combination of several shades of green and red. Scribble one shade on top of another one to give you a rough idea of the correct colour to use.

4 Painting the timbers
Use a selection of light and dark ultramarine pastels to indicate the brightly painted timbers on the far boat.

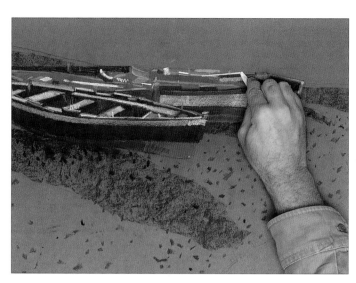

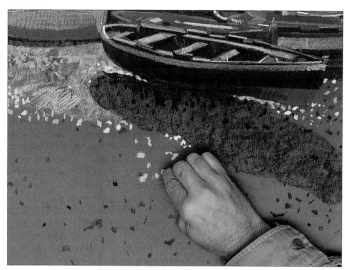

5 Adding the highlights
Use light grey and white pastels to pick out the white paintwork, and some of the highlights, on the boats.

6 Building up the layers on the beach
Using a combination of scribbled yellow ochre and Naples yellow, and harder, more direct marks than before, begin building up the layers of sand and stone on the surface of the beach.

ASSESSMENT

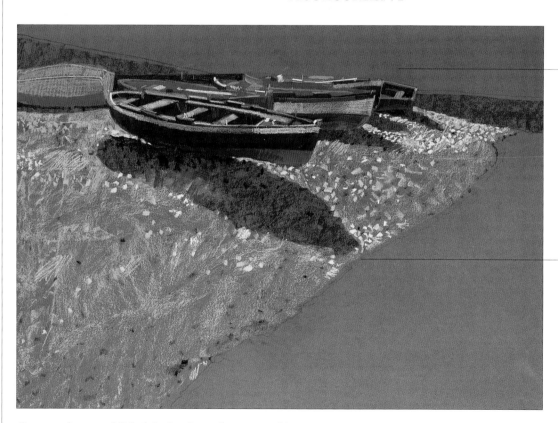

Simplifying the composition
Clutter in the background of the original photograph has been deliberately left out as it would have detracted the eye from the boats

Highlight the diagonal
Texture and highlights for the sea and shoreline have not yet been added. The diagonal of the shore will be a key element in the final drawing

Once you have established the beach, apply a spray of fixative. Already the deep shadows and bright highlights reflect both the intensity of the light, and the warmth of the atmosphere.

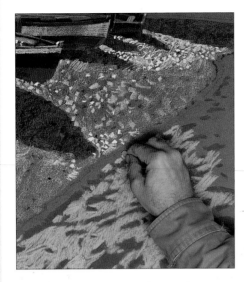

7 Painting the shoreline
Combine light and dark cobalt blues to suggest the shadows and ripples in the sea along the line of the shore.

8 Blocking in the sea in the distance
Use the light cobalt blue to fill in the distant sea at the top of the painting, and also to add in a few highlights. Then add more detail to the rippling sea surface in the foreground.

9 Building up patterns
Mix light grey, yellow ochre and Naples yellow together, then apply them with hard, short, direct strokes to build up the pattern of the pebbles on the beach. Work across the area using one colour before switching to another, and vary the size of the marks.

10 Highlighting the sea
Use a white pastel, applied with heavy strokes, to insert the dappled light along the edge of the sea. Once complete, apply the final coat of fixative.

11 Final drawing
The technique of applying the pastel as thick impasto dabs helps recreate the effect of sunlight catching the rocks and stones littering the beach.

Direct Brushwork

T HE LENGTH OF TIME that oil paint took to dry often made it impossible for the artist to finish a painting in one sitting. *Alla prima*, an Italian term which literally translated means 'at the first', thus developed as a technique. It refers to works painted at one sitting, directly from the subject. The paint was applied with single, direct brushstrokes, and was never modified at any stage. The whole work reached a state of completion at one and the same time. The technique required a high degree of confidence, and it often resulted in lively and exciting works.

Acrylic paint has none of the restrictions of oils, and its drying time means that in reality most paintings, depending on size and complexity, can be finished in one attempt. However, one can still use certain principles from alla prima, such as the immediacy of the brushstrokes, with acrylic paint to produce a successful result. In this example, the fast drying time of the paint even allowed for parts of the work to be consolidated with a second layer.

Although initially the details of the cranes and boat might seem complicated, they can easily be reduced to simple, broad areas of tone and colour

River View with Cranes

Industrial landscapes are a wonderful subject for painting, even though they may not at first appear to be an obvious choice. But, for those who live in urban areas and big cities, they are easier to find and paint than traditional rural landscapes.

MATERIALS

- Canvas painting board
- Charcoal pencil
- ¼in and ⅛in synthetic brushes
- ¼in and ¾in flat bristle brushes
- Acrylic paints: Paynes grey, ultramarine, cadmium red, burnt umber, yellow ochre, dark brown, cerulean blue, titanium white

1 Sketching the outline
Using the charcoal pencil in a loose manner, indicate the position of the main elements of the composition on the cavas painting board.

2 Identifying the darkest tones
Mix a dark grey using Paynes grey, a little burnt umber, and titanium white. Use the ¼in flat bristle brush to establish the darkest tones of the buildings.

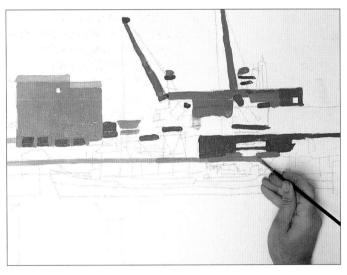

3 Lightening the mix
Add titanium white to the mixture and block in the side of the buildings and the arms of the cranes. Mix a grey-brown by adding a little Paynes grey to yellow ochre, and paint in the hopper and the line of the dockside.

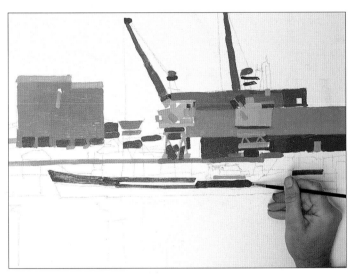

4 Shaping the boat
Block in the sides of the buildings. Add titanium white and yellow ochre to the grey-brown, and paint in the body of the cranes. Add burnt umber to the dark grey mix for the areas beneath the cranes and boat.

5 Painting the sand
Use dark brown to establish the dark side of the dock. Paint in the piles of sand around the hopper and the foreshore with a mixture of yellow ochre, Paynes grey and titanium white.

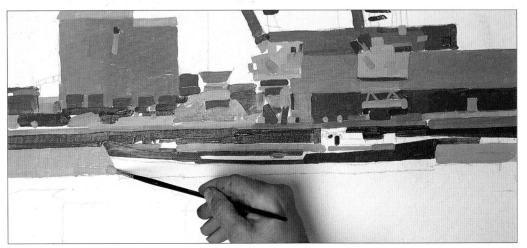

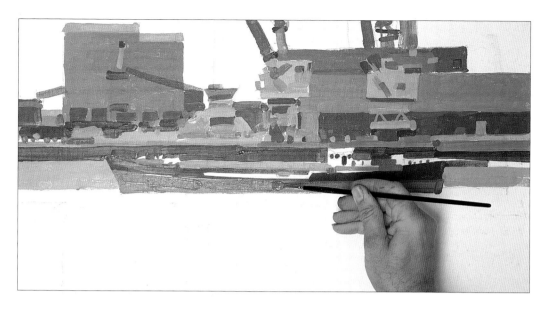

6 Painting the hull
Paint in the weathered colour of the boat hull using a mixture of cadmium red with the same sandy colour used on the riverside in step 5.

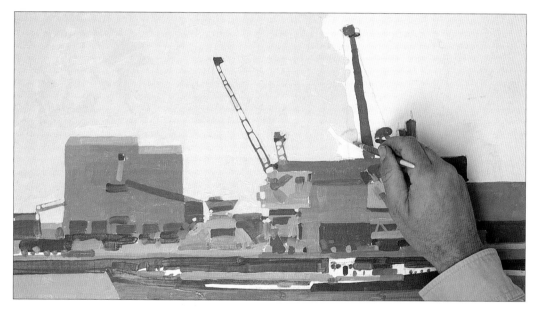

7 Painting the sky
Mix together cerulean blue, titanium white and a little ultramarine for the sky. Carefully cut in and around the buildings and cranes using the ¼in synthetic brush.

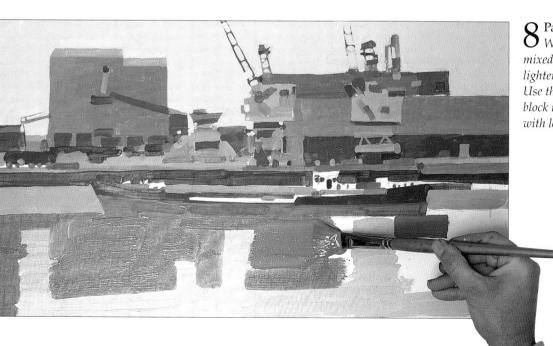

8 Painting the water
With the same colour as you mixed for the sky, add the lighter passages of the water. Use the ¾in flat bristle brush to block in the dark grey reflections with loose, fluid strokes.

ASSESSMENT

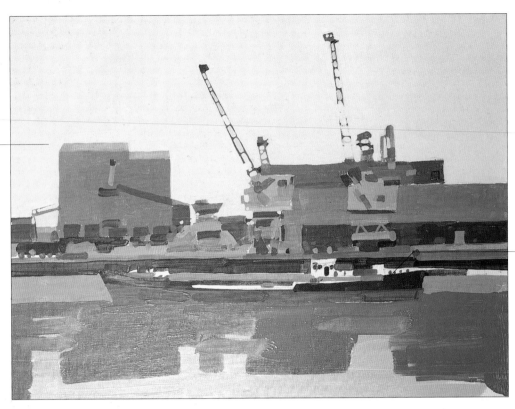

Adding definition
A further coat of paint helps to consolidate the colour of the sky, and to define the skyline

Leaving white space
The canvas painting board has been allowed to show through in places, representing the white paintwork on the boat

All the elements are now established and in position. The colours appear fairly muted, as it was quite early in the morning, and the day was looking dull.

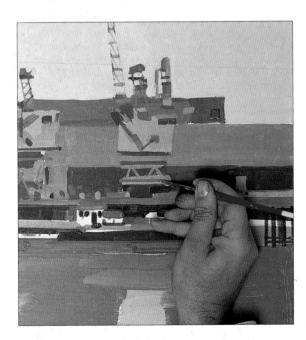

9 Detailing the iron structures
Use the ⅛in synthetic brush to detail the iron structures along the waterfront, and the turning mechanism of the cranes.

10 Strengthening the hull
Touch in details on the deck and the cabins, then consolidate the hull of the boat, using a range of red and brown colours, with the ¼in synthetic brush.

11 Applying a second coat to the sky
Re-mix the colour for the sky, but this time make it lighter and a little less vivid. Paint it on, allowing the previous colour to show through in places to create a broken-colour effect.

12 Adding the ripples
Add a few loose touches of blue and grey to the river to create an impression of its rippled surface, and the reflected scene.

13 Final painting
The scene has been captured quickly, with no laboured work, nor any time wasted in waiting for the paint to dry. This technique is a perfect one to use for painting landscapes on location.

Using Rough Paper

SUCCESSFUL WATERCOLOUR paintings are achieved by using the correct materials and a combination of suitable techniques. The correct choice of watercolour paper is immensely important, as the paper should suit the subject and style of work. There would be little point in trying to paint a precise portrait on a very rough paper, or a loosely worked, highly textured landscape on an ultra-smooth, hot-pressed paper.

Due to the often heavy sizing, achieving a flat wash on smooth papers can be difficult, whilst on NOT or rougher, absorbent papers flat washes are easy to achieve. In a similar way, it is almost impossible to produce subtle, fine linear work on rough papers, but success can be achieved by using smoother, NOT or hot-pressed papers. Here, a rough paper is used to capture a landscape which incorporates a number of textural effects.

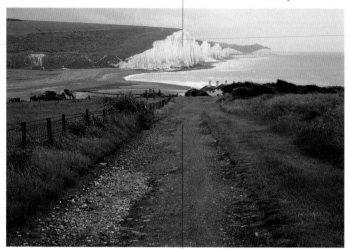

The chalky whiteness of the cliffs gives good tonal contrast to the darker areas of sea, sky and land

The extreme perspective of the path leads the viewer's eye directly to the main subject of the image – the distant cliffs

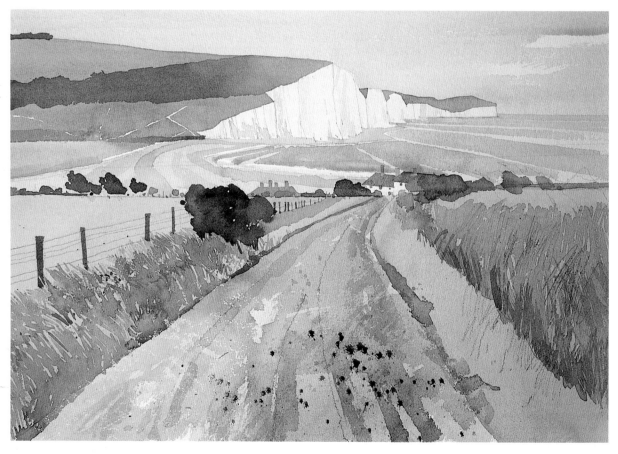

Landscape with Cliffs and Coast
Painting landscapes such as this one, which contains several different surface textures, such as long grass, foliage, chalk cliffs and water, stands a greater chance of success if you use a number of varied textural watercolour techniques.

MATERIALS

- Stretched rough watercolour paper
- 2B pencil
- No 4, No 6 and No 12 round sable brushes
- Plain white candle
- Watercolour paints: ultramarine, cerulean blue, Paynes grey, cadmium red, burnt umber, sap green, yellow ochre, cadmium yellow
- Water

1 Sketching the outlines
Draw in the main elements of the composition on the watercolour paper using the 2B pencil. Note how the track has been used to draw the eye into the middle ground. In the distance the beach continues its journey, with the line of cliffs pulling the viewer's attention further to the horizon.

3 Painting the sand and track
Mix Paynes grey, cadmium red and burnt umber for the strip of sand, then add a little yellow ochre to Paynes grey to colour in the track.

2 Painting the sky and sea
Mix ultramarine, cerulean blue and water to produce a thin, bright blue for the sea and sky. Paint them using the No 12 brush. Let the foam from the waves breaking on the beach, and the clouds, show through as white paper.

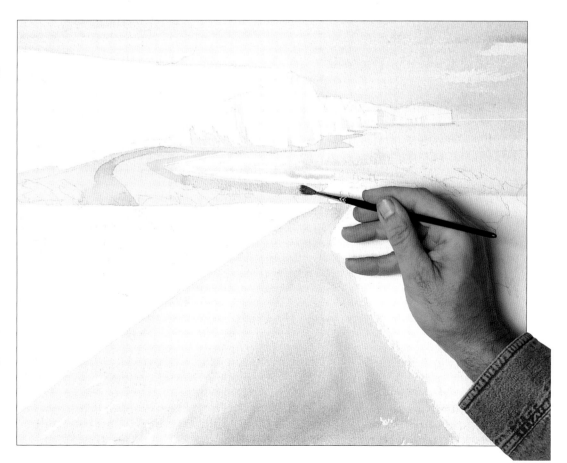

4 Adding the darker tones
Using a No 4 brush, paint in the shadows on the cliffs with a yellow ochre and Paynes grey mix. Add cadmium red to the mixture, and then colour in the tide marks on the beach.

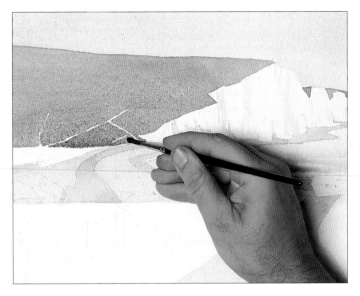

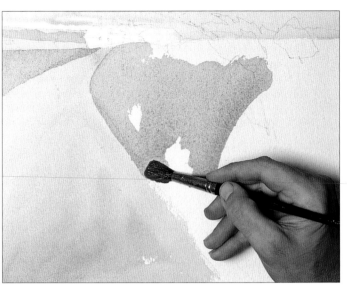

5 Blocking in the hills
Once dry, add the distant green hills with a sap green, yellow ochre and burnt umber mix, using the No 6 brush. Work around the chalk pathways which show through the grass.

6 Establishing the fields
Using a mixture of sap green and cadmium yellow, paint in the fields with a No 12 brush.

FIRST ASSESSMENT

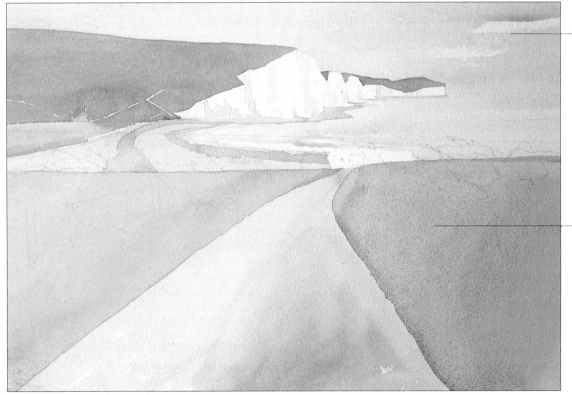

A combined effect
The rough paper has worked with the rapid brush strokes and thin paint to give a pleasant broken edge to the cloud

The right medium
It is easy to to make flat washes of colour on this absorbent paper

All of the main areas of the painting have now been established. Allow the painting to dry before continuing any further, bearing in mind that on very thick, rough paper this process can take a considerable time.

7 Reworking the sea
Use a mixture of cerulean blue and ultramarine, with a No 6 brush, to eliminate the waves which catch the light. The change in perspective and direction of the waves increases the sense of recession.

8 Darkening the hills
Mix a dark green colour with sap green, burnt umber and Paynes grey. Then paint in the dark passages on the hills, again using the No 6 brush.

9 Adding details to the middle distance
Next, paint the buildings with the No 6 brush, using a mixture of Paynes grey and burnt umber.

SECOND ASSESSMENT

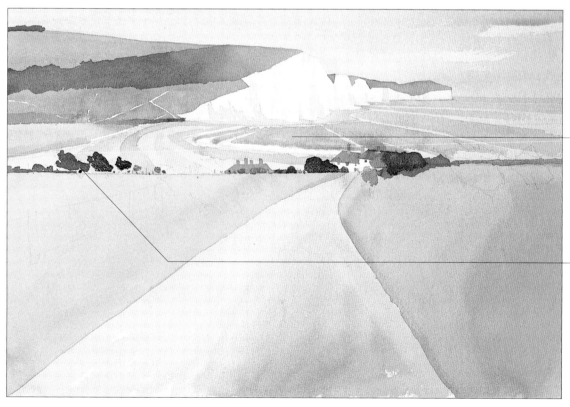

Creating perspective
The receding bands of blue on the sea water create a convincing sense of perspective

A simple technique
Blobs of colour with broken edges suggest trees and shrubs in the middle distance

At this stage in the process, add detail and texture to the middle ground of the painting.

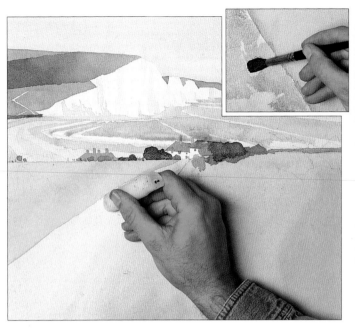

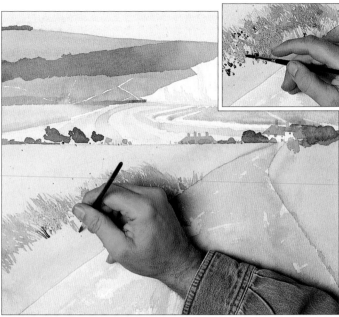

10 Focusing on the track
Rub a plain white candle firmly onto the track. **Inset:** *When you wash a dark mixture of colour over the area, the wax resists the wet paint and forces it to settle elsewhere.*

11 Adding the grass
Use the No 4 brush, with a dark green colour mixture made from sap green, burnt umber and Paynes grey, to scribble in the grass at the side of the track. **Inset:** *Tap the side of the No 12 brush with your finger to spatter paint into this area of grass.*

12 Painting the bushes
Paint in the dark bush and the other side of the track, using the No 4 brush with a dark green mix of sap green, burnt umber and Paynes grey.

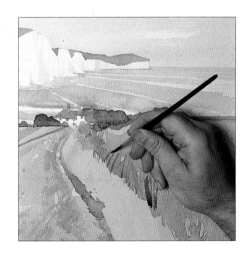

13 Adding the fencing
Paint the wooden fence posts using a mixture made from burnt umber and Paynes grey, and then add the wire fencing using the 2B pencil.

14 Final painting
To add more detail, you can also spatter the track as in step 11, this time with dark grey, to suggest loose stones and pebbles.

Loose Figure Work

FIGURE DRAWINGS, using only a few pastel pencils, are very effective. The pencils are quick and easy to use and, with a little fixing or by working with the hand resting on paper towel, clean.

Character is noticeable not only in the facial features but in the way a person sits, tilts their head, holds their hands or wears their clothes. All of these aspects should be carefully observed, as their combination gives a person individuality. By exaggerating such characteristics, cartoonists make their drawings look uncannily like their subject.

Keep the marks open, and do not fill in colours in a flat or uniform way. Suggest direction by working around the form, and by leaving or showing a few contour lines to give extra clues as to the direction or fall of a surface. Also keep the pencil marks multi-directional, to prevent the eye travelling along them in a single direction.

Always give consideration to your portrait subjects by posing them in a relaxed position

Hands, especially those of older subjects, can be as expressive of character as the face

Portrait of an Elderly Man
Most old people have the patience to sit still for long periods of time, which makes them excellent models for artists. The three-quarter view is a classic pose when drawing or painting a portrait, and is easier to work with than a full-frontal or sideways-on position.

MATERIALS

- Cartridge paper
- Pastel pencils: terracotta, brown, dark pink, cadmium red, light pink, blue-grey, ultramarine, black
- Soft putty eraser
- Fixative

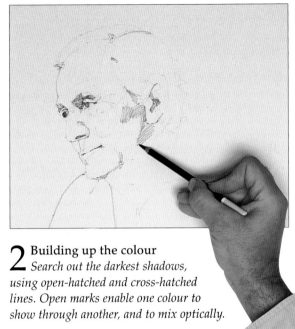

1 **Sketching the outline**
Use a terracotta pencil to map out the position of the figure. Apply pastel pencils lightly to make them easy to remove with a soft putty eraser, and make corrections when necessary.

2 **Building up the colour**
Search out the darkest shadows, using open-hatched and cross-hatched lines. Open marks enable one colour to show through another, and to mix optically.

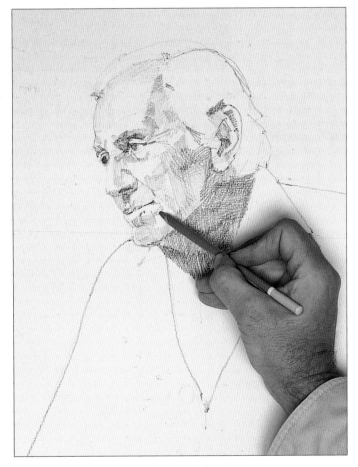

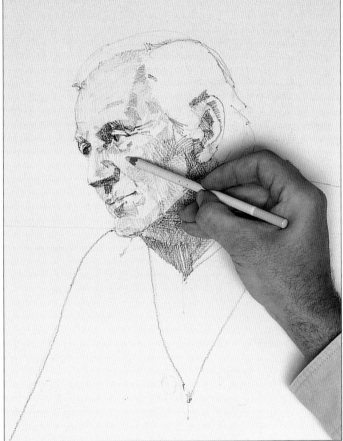

3 **Building up tone and colour**
Combine brown and dark pink pencils to build up the appearance of the face. Keep the hatching and cross-hatching open, and do not allow colours to build up in a block.

4 **Moving from light to dark**
Use cadmium red to add a little colour to the lips, followed by the light pink pencil.

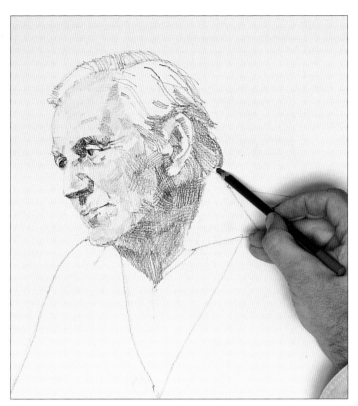

5 Colouring the features
Add a little coolness to the cheek, and colour in the dark grey hair with the blue-grey pencil. Define the direction and fall of the hair with a few linear strokes.

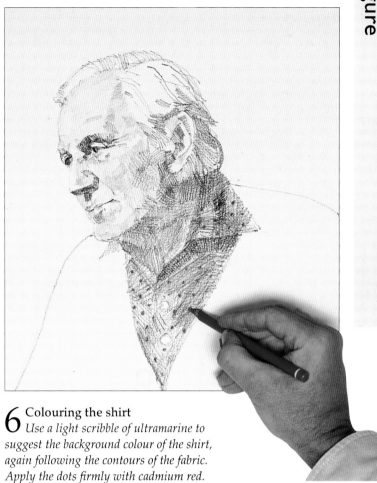

6 Colouring the shirt
Use a light scribble of ultramarine to suggest the background colour of the shirt, again following the contours of the fabric. Apply the dots firmly with cadmium red.

7 Colouring the cardigan
Overwork the shaded area of the shirt using black. Then, again with the black pastel, scribble loosely to show the shape of the cardigan.

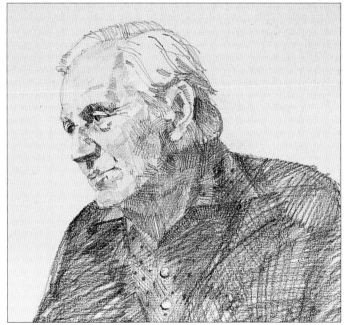

8 Final drawing
The multi-directional linear shading, together with the dramatic colouring from a limited selection of pastel pencils, lends a lively feel to an otherwise static subject.

Bold Figure Work

EVEN COMPLEX SUBJECTS can be successfully simplified and result in an image which has more of an initial impact than if reproduced with every last detail. Every subject has a particular inherent strength, which may be its colour, texture, composition or shape. To increase the impact of a work the artist will even exaggerate one or more of these elements, using what is often called 'artistic licence'.

In this example the light, together with the strong negative and positive shapes, demanded an uncompromising treatment. Texture was almost non-existent. Colour was ignored and, given the sharp contrast between light and dark, the tonal scale was drastically reduced: no exaggeration was needed. This type of visual editing should happen constantly, with the artist always open to ways in which he or she can increase the power and potential of the imagery.

Placing the subject against the window light reduces the image to a near-silhouette

The dramatic shape of the piano gives this composition an almost abstract quality

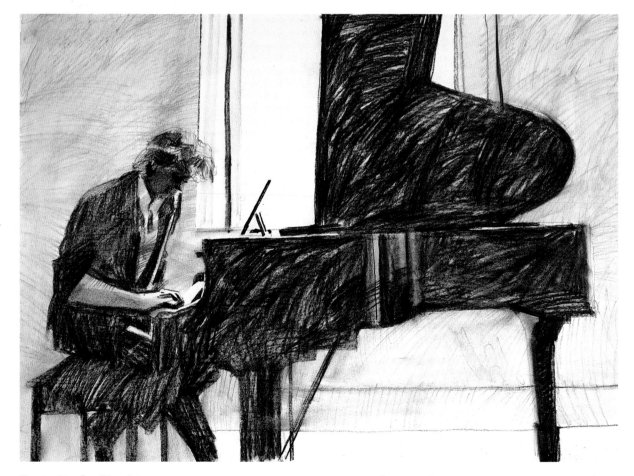

Portrait of a Pianist
The large, solid shape of the piano and the human figure stand out as silhouettes devoid of detail in the glare of light from the large windows. However, the lighter, negative shapes around these more positive elements are of equal importance.

MATERIALS

- Cartridge paper
- Medium charcoal stick
- Scrap paper
- Fixative

1 Mapping out the elements

Draw in the main elements, noting the spaces around the subject, and working lightly to facilitate corrections. Once the dimensions and proportions are correct, apply fixative.

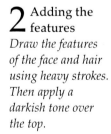

2 Adding the features

Draw the features of the face and hair using heavy strokes. Then apply a darkish tone over the top.

3 Laying down the dark tone

Using fairly dense scribbling, draw the body into the stool and the piano with the same tone. Make the lighter tone on the back of the arm simply by rubbing your finger over the clothing, and also down the arm, to transfer some of the charcoal dust.

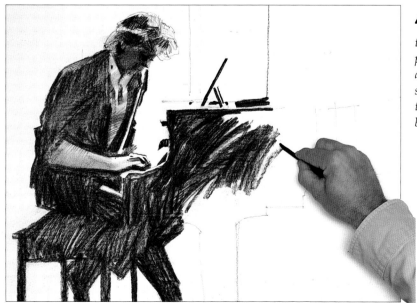

4 Extending the dark tone

Bring the dark tone across the body of the piano. Pay particular attention to those areas hit by the light, as their shape gives important clues as to what is happening in the black, scribbled areas.

Figure

5 Suggesting a curved surface

The body of the piano catches the light at the point where it curves into the background. This point could be scribbled dark, but then it would look like a flat shape. Using your fingers in a rubbing motion, make a slight suggestion of light reflections which will help to create the appearance of a curved piano body.

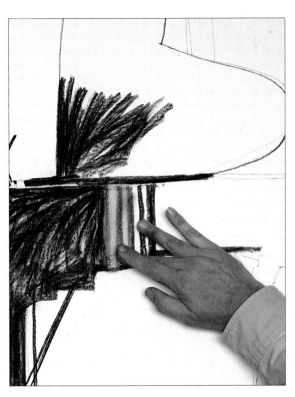

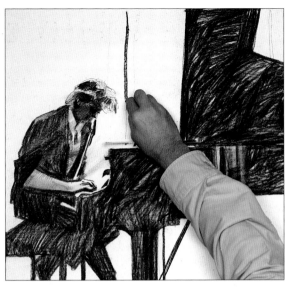

6 Focusing on the background
Draw in the window and its folded-back shutters when you have established the dark mass of the piano.

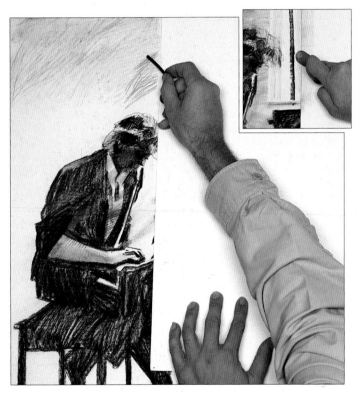

7 Applying tone
Scribble in the tone on the wall with light and loose movements. Use scrap paper as a mask to keep the scribbling loose, but make a straight line where the tone ends.
Inset: *Alternatively, transfer charcoal dust from a heavily scribbled area onto your finger. Then rub down the mask, leaving a lightly-toned line on the drawing.*

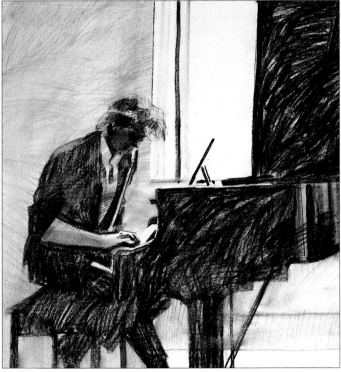

8 Final drawing
This is a strong composition which, despite its apparent simplicity, hints at greater complexity. You can use this technique for dramatic, finished drawings, as well as for capturing the essence of a scene without the need for a time-consuming study exercise.

Figure Distortion

THERE ARE MANY OCCASIONS, some of which occur at the most unexpected times, when people present themselves as suitable subjects for a drawing or a painting. Holidays are a good example, as everyone tends to be relaxed and unselfconsciously enjoying themselves in different surroundings from their everyday lives. As a matter of course artists should always keep a notebook or sketch pad with them in which to record, in a quick and unobtrusive manner, any visual ideas which may catch their imagination. Even if complete drawings are not made, a rough sketch or a few notes function as an *aide-mémoire*, as otherwise images can be easily forgotten.

In this example, the figure of the swimmer was recognized at the time as having interesting potential. Several photographs were taken and a number of sketches made, specifically as reference material for a painting which, in fact, was not finished until over twelve months later.

The pattern of reflections defines the water's surface and gives a sense of depth

What should be a geometrically rigid grid of tiles is thrown into wild confusion by the distortion of the water

Swimming Figure
Water not only magnifies and distorts, but also presents, in this example, the challenging problem of how to represent three distinct layers or surfaces: the bottom of the pool, the swimming figure and the surface of the water.

Figure

MATERIALS

- Mid blue pastel paper
- White pastel pencil
- Pastels: range of browns, mid orange, black, light purple, bright yellow, Naples yellow, cobalt blue, dark blue
- Fixative

1 Sketching the outline
Use the white pastel pencil to draw in the outline of the swimming figure. Lengthen the fingers on the outstretched hand to exaggerate the elongation of the swimmer, and also make the figure span the width of the background paper.

2 Establishing the mid-tones
Apply a range of browns lightly to allow the blue of the paper to show through, and to prevent any build-up of pastel dust, which would make the addition of subsequent layers more difficult.

3 Adding colour to the figure
Block in lighter patches of colour on the swimmer's body with a mid-orange pastel.

4 Reflections and shadows
Colour in the hair with the black pastel. Add more colours to the figure to suggest broken light patterns and the rippling action of the water. **Inset:** *Use bright yellow and black for the swimsuit, and add cool touches of light purple to the shadow areas.*

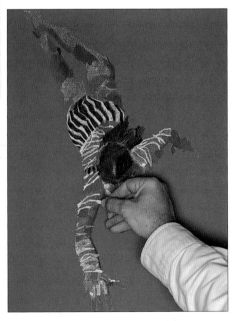

5 Creating reflected colour
Use a light Naples yellow to draw in the linear web of reflected colour caused by the disturbance on the water surface.

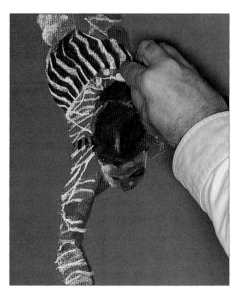 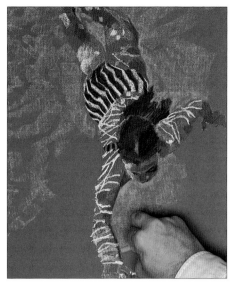

6 Varying the strokes
Draw in a network of crossing, flowing lines using firm, heavy strokes of white. Turn the pastel as you draw, to vary the width of the lines.

7 Blocking in the tiles
Use the side of a cobalt blue pastel to block in the colour of the tiles in the pool seen through the water. Take care when cutting into and redefining the distorted shape of the swimmer.

8 Building the depth of colour
As you continue to colour the pool, cut around the dark reflections; these are made by allowing the colour of the paper to show through.

ASSESSMENT

The figure and the pool are fairly realistic at this stage of the painting, but the image is lacking in depth.

The figure
The thick lines drawn on the figure will work well against the tiles once they have been added to the bottom of the pool

Adding detail
To establish the three separate layers, detail needs to added to both the bottom of the pool and the surface of the water. It is a good idea to apply a spray of fixative at this point

Figure

9 Starting the tiles

Use a dark blue pastel to insert a series of lines to represent the tiles on the base of the pool. The lines flow and curve and are distorted by the disruption and movement on the surface of the water.

10 Adding variation to the lines

Draw in the horizontal lines with the dark blue pastel used in step 10. Alter the pressure applied to the pastel and the angle at which it comes into contact with the paper, to vary the thickness of the lines.

11 Adding sunlight to the surface

Draw in the dappled effect of sunlight catching the top of the water with the white pastel. **Inset:** *Increase this effect by slightly smudging the pastel marks with the end of your finger.*

12 Final painting

The painting has a convincing sense of depth, with the swimming figure rising from the depths toward the surface and edge of the pool.

Blocking and Glazing

G LAZING is a traditional oil-painting technique: semi-transparent layers of paint are laid one on top of the other, and each is allowed to dry before the next is applied. Used with oils this technique takes a long time to complete, as each layer needs to be perfectly dry before the next is applied. Acrylic paint, on the other hand, dries very quickly, so a glazed painting can be completed in one sitting.

Glazed paintings have a very different feel to them than paintings made using only opaque or impasto technique. Glazing is often used over opaque or impasto work, as the colour combinations possible by placing a glaze of one colour over the glaze of another are completely different to when two colours are physically mixed together. A glaze of a suitable colour can also be used over the entire painting once it has been completed. This has the effect of harmonizing the whole work or toning down overly strident or powerful, vivid colours without the need for repainting. Light colours can be glazed over darker ones, but the best effects are achieved when lighter colours are glazed first, with each subsequent glaze becoming progressively darker.

This figure study is given extra visual interest by the careful placement of large plants

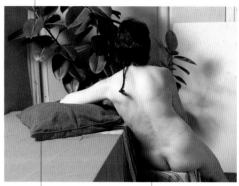

Including a cushion not only increases the model's comfort but gives a strong area of colour to the composition

The striped pattern on this material is effective in describing the forms over which it is draped

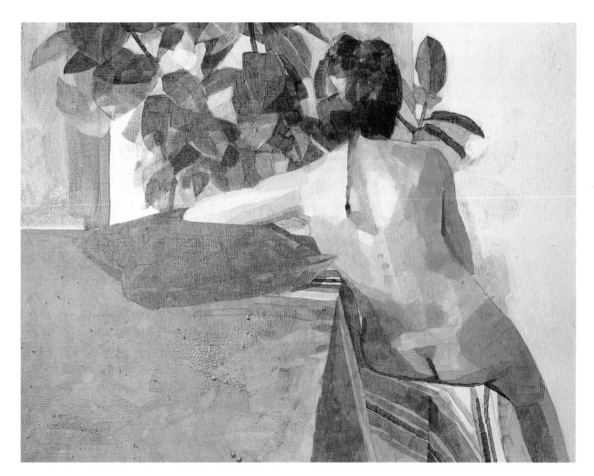

Seated Nude
The nude back view is a classic – if sometimes over-used – pose which, if well lit and positioned, can reveal some wonderful shapes, which the technique of glazing can help to bring out and emphasize.

Figure

MATERIALS

- Canvas board
- 2B pencil
- ¼in and ½in soft synthetic brushes
- Acrylic matt medium
- Acrylic paints: cadmium red, cadmium yellow, titanium white, Paynes grey, ultramarine, alizarin crimson, yellow ochre, sap green, burnt umber, phthalo green
- Water

1 Sketching the outline
Establish the basic composition using the 2B pencil. The angle of the figure, the complex shape of the plant, and the bulk of the red tablecloth all help to keep the eye moving centrally around the picture.

2 Painting the figure
Mix cadmium red, cadmium yellow and a little titanium white together, then add water and a little matt medium. Wash this loosely over the figure, using the ¼in brush, to establish the basic colour of the skin.

3 Painting the shadows
Using the ½in brush and a mixture of Paynes grey and ultramarine, paint in the shadows cast by the plant and the figure itself. Apply the same mixture to the side and base of the head.

4 Painting the fabrics
Use cadmium red and alizarin crimson to establish the red cloth and cushion, bringing the red over the area in shadow on the right-hand side of the cloth.

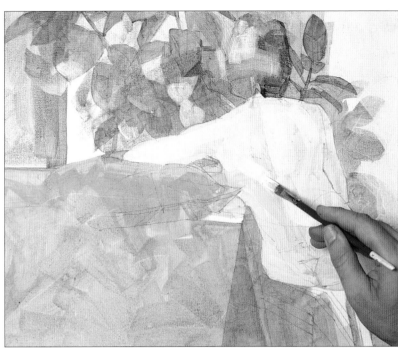

5 Establishing the plant
Add yellow ochre to the shadows on the striped cloth, and a sap green and ultramarine mix for the leaves of the rubber plant.

6 Filling in the background
Apply a coat of titanium white to the background; this cuts out the shadow shapes of the leaves. Then work over the lighter sections of the figure using a pale pink colour which has been mixed using cadmium red, cadmium yellow and titanium white.

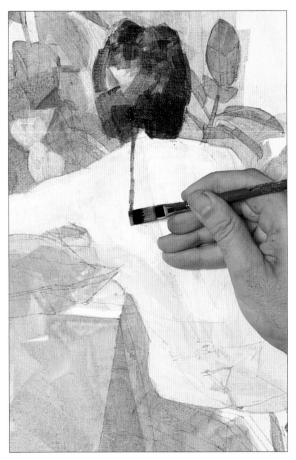

7 Painting the hair
Define the hair using a dark mix of Paynes grey and burnt umber, and paying attention to the thin plait down the back.

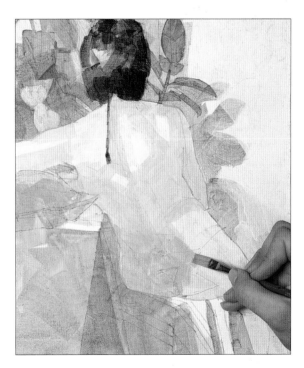

8 Darkening the skin
Mix a darker skin colour using cadmium red, cadmium yellow, a little burnt umber and white. Redden the mixture slightly around the model's buttocks and down the legs.

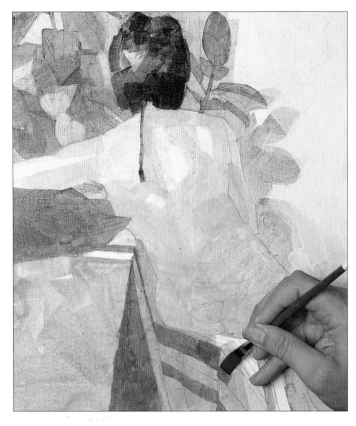

9 Adding the pattern
Use a dark red made from cadmium red, Paynes grey and a little burnt umber for the cushion, the shadow on the cloth and the linear pattern on the cloth beneath the figure.

10 Adding the shadows on the leaves
Paint the dark shadows on the leaves with a mixture of phthalo green and Paynes grey.

ASSESSMENT

Creating shadows
The model lacks depth at this stage, the shadows need to be darkened.

Patterning the cloth
The key lines have been added which reveal the shape under the cloth. Now the other lines can be filled in.

The basic areas are now blocked in and ready to be modified by the glazes.

11 Darkening the shaded areas

Darken the skin mixture in step 8, and redefine and darken the shaded areas on the model. Work around the buttocks and the leg, the right arm and the left underarm and the centre of the back.

12 Glazing the skin

Once dry, darken the flesh colour further and glaze in the darkest colours of the skin.

13 Painting the cloth pattern

Add the pattern on the cloth next, using mixes of cadmium yellow, cadmium red and Paynes grey.

14 Building up the cloth colour

Intensify the colour of the tablecloth with a dull red mixture of cadmium red and alizarin crimson.

15 Finishing the background

Finally, consolidate the background using titanium white, cutting it in carefully around the shadow shapes and leaves.

16 Final painting

The luminous quality is due in part to adding the minimum amount of white paint into the glazing mixes.

Figure

Delicate Washes

THE ARTIST'S SKILL at organizing and manipulating thin washes, and the exact mixing of colours and tones, is tested to the full when it comes to painting detailed portraits using watercolour. All your acquired skills need to be exploited. A good drawing will act as a guide and enable you to concentrate on mixing and placing your washes correctly.

Even though only head and shoulders are shown, try to use the area of the paper in a creative way. Placing the subject centrally, facing full on, is seldom a good idea. Consider the clothes which the model is wearing, and decide whether they help or detract from the image. Also consider the colour and form present in the background.

Try to avoid flat lighting, as nothing reduces interest in a face more than bland, regular light which flattens out the features. Look out for warm and cool colours; these can often be exaggerated to great effect and add interest to the deep shadows. Try to position highlights correctly, but make sure you avoid overstating them.

The addition of a spotted scarf adds strong visual interest to this full-face portrait

Posing the model in a strong side light gives form to the features without causing the model to squint

Female Portrait
Full-face portraits often look awkward, with the features arranged regularly and lacking any convincing sense of depth. In contrast, a three-quarter light source, as used in this portrait, throws strong shadows which allow the nose, chin and hair to push forward into relief.

MATERIALS

- Stretched NOT watercolour paper
- No 4 round sable brush
- 2B pencil
- Watercolour paints: Paynes grey, brown madder alizarin, Naples yellow, yellow ochre, ultramarine, burnt umber, cadmium yellow, sap green
- Paper towel
- Water

1 Sketching the outline
With a 2B pencil, make a careful light drawing. If you are using a grid, work very lightly, and avoid too much erasing, as the surface of the paper can become disturbed, and have an effect on how the washes dry.

2 Applying the first washes
Use the No 4 brush and a mixture of Paynes grey and brown madder alizarin for the first wash on the hair. Cover the entire skin area, including the whites of the eyes, with a mixture of brown madder alizarin and Naples yellow.

3 Painting the hair, scarf and top
Re-mix the hair colour, adding more Paynes grey, a touch of brown madder alizarin and a little yellow ochre. Repaint the hair, working around and cutting out any highlighted patches or wisps of hair. Working around the white pattern, paint in the scarf with a mixture of Paynes grey and ultra-marine, then add more Paynes grey to the mix and paint the blue top.

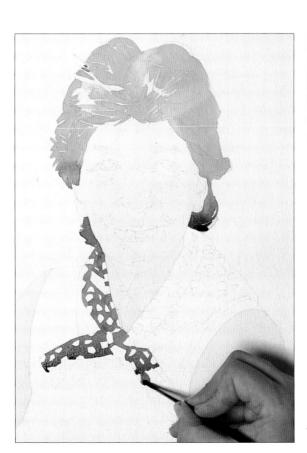

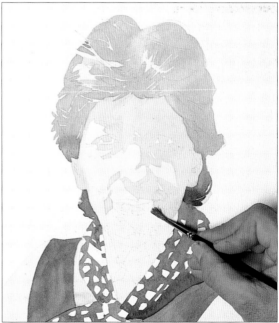

4 Inserting the shadow areas
Add a second light tone, made from brown madder alizarin and Naples yellow, to the face. This tone should follow and define the extent of the shadows. Work the mixture onto the neck and arms.

Figure

5 Adding the darker tones

Mix a darker grey, using Paynes grey and burnt umber. Repaint the hair, working around and cutting out the highlights and lighter strands of hair. Then add burnt umber and brown madder alizarin to the mix. Paint in the upper lids of the eyes, the eyes and a few lower lashes, the dark insides of the ears, the nostrils and the mouth line.

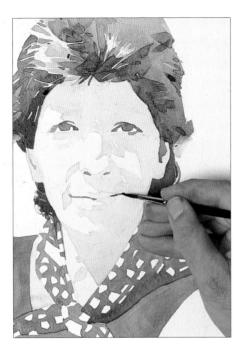

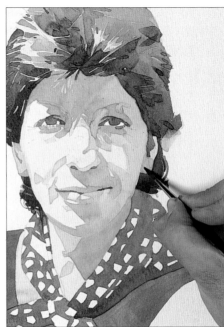

6 Subduing the colour

Create a darker tone for the skin by mixing brown madder alizarin, cadmium yellow, and ultramarine. Work across the shadows on the forehead, around the eyes and ears, and below the nose, mouth and neck. Then make the mixture redder and paint in the dark of the lips and ear lobes.

ASSESSMENT

Judging colour
Wash in the background colour prior to starting work on the figure, as judging colour against a white background is never easy

Softening the edges
If the transition from light to dark appears to be too sudden, soften any paint edges with a brush and water

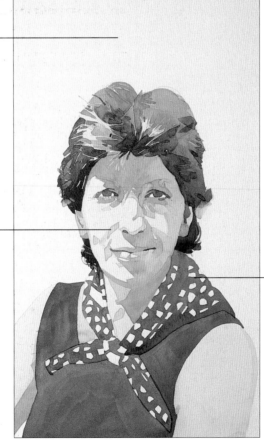

Reinforcing shapes
Although simplified, the pattern still echoes the shape and creases of the scarf as it curves around the neck and sits on the model's shoulders

The painting already works convincingly yet it lacks depth, the colours lack impact, and the eyes have a staring quality.

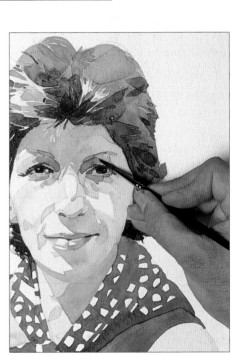

7 Picking out highlights and shadows

Add Paynes grey to the mixture in step 6 to deaden the whites of the eyes and to darken the lashes, eye lines and dark part of the eyes. As soon as the paint is dry, emphasize the highlights on the irises by re-wetting and blotting off the dissolved colour with paper towel. Deepen the shadows in the sockets by painting above the actual eyes with a mixture of brown madder alizarin and ultramarine.

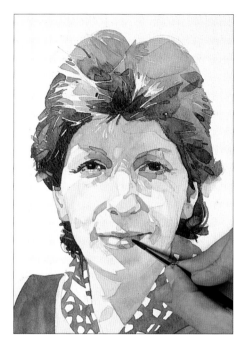

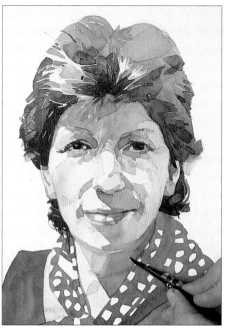

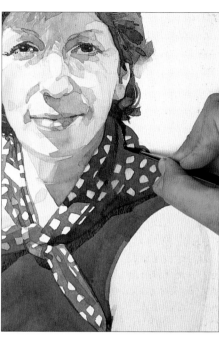

8 Adding more detail
Using a range of red tones, paint the details in the lips and around the mouth.

9 Filling in the darkest shadows
Mix brown madder alizarin and ultramarine together for the very dark shadows. Closely observe the linear shadows from the hair, and those around the nose and mouth, and on the neck.

10 Adding detail to the scarf
Use a dark mixture of Paynes grey to create a shadow beneath the scarf. Apply a mid-grey wash over the scarf, and allow it to dry well before adding a mix of Paynes grey and ultramarine for the shadows in the folds.

11 Painting in the background
Once the portrait is complete, fill in the area above and around the head with a wash of sap green. This places the figure in some kind of context, and also gives the work extra depth.

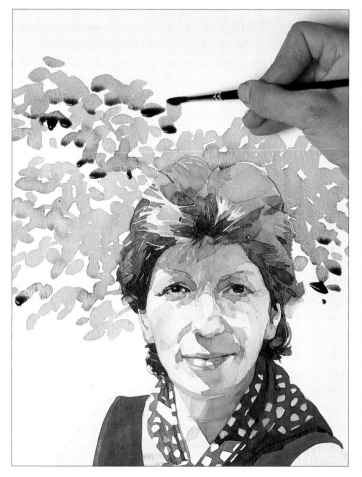

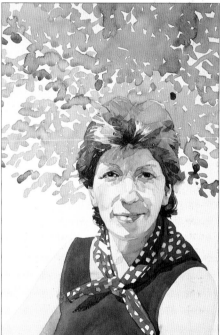

12 Final painting
The finished painting has a luminous quality from the reflected light and the detail in the shadows. If the background had been more fully realized, this would have softened the outline of the figure, and helped it to blend more into its surroundings.

Index

Acknowledgements

Thanks to Lydia and Alice for acting as models and being patient,
Ben Wray for photography and Roger Bristow for the opportunity
and encouragement. Thank you also to Patricia Monahan for
the long phone conversations, the editors and designers
and all at Collins & Brown.

Finally, thank you to my Dad for everything. You will be missed.

IAN SIDAWAY

The publishers would like to thank Green and Stone
of Chelsea, Kings Road, London for kindly providing
the materials featured in this book. They would also
like to thank Denis Kennedy for all his initial
planning and editorial work on this book.